T0094061

OCTOPUS
SEAHORSE
JELLYFISH

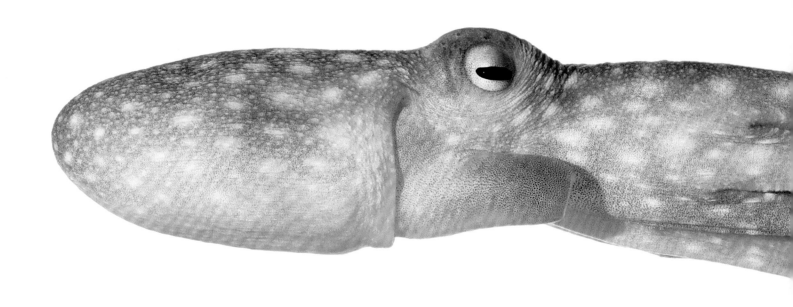

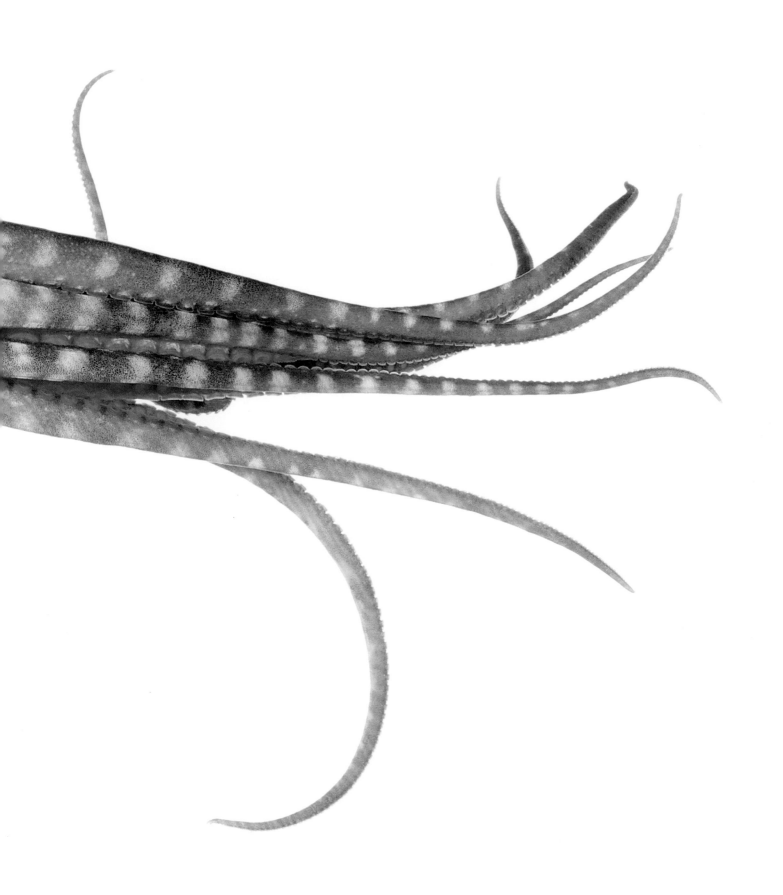

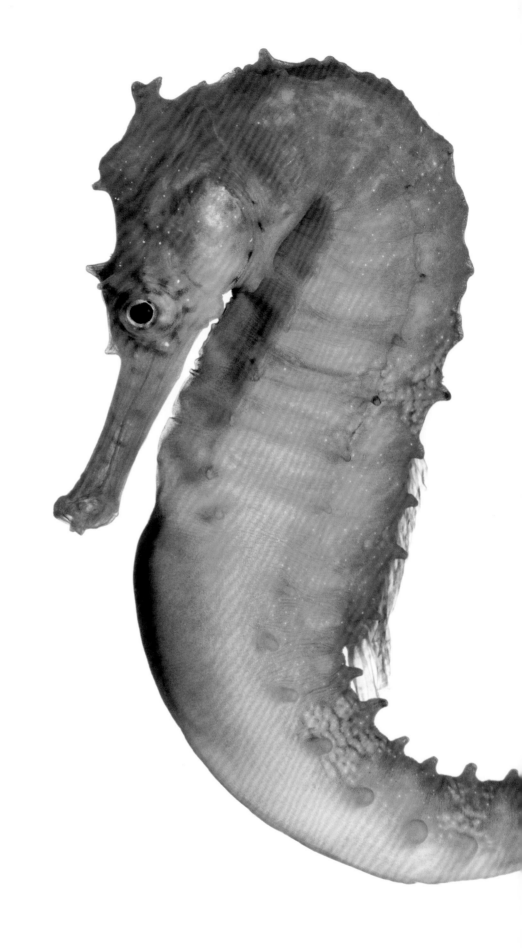

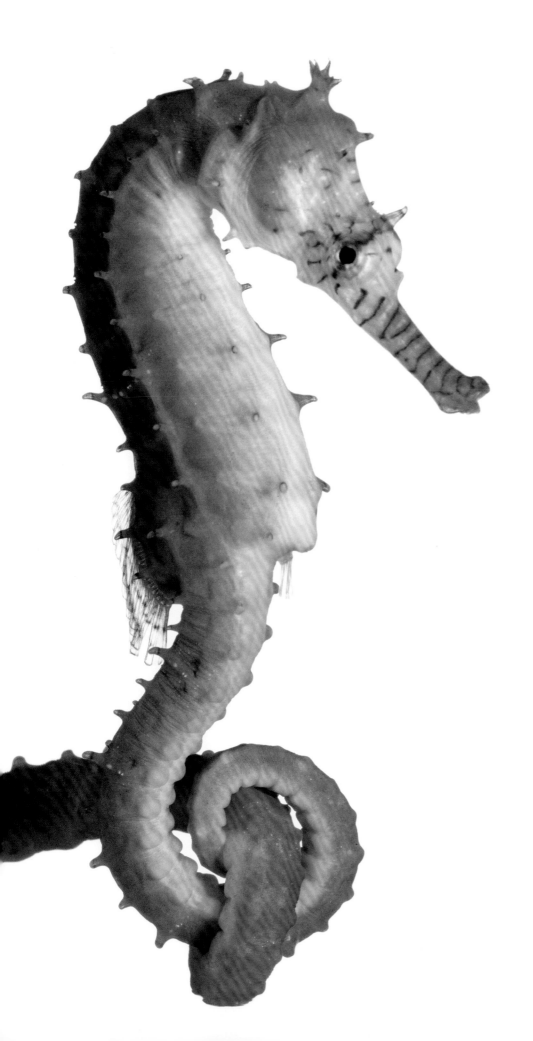

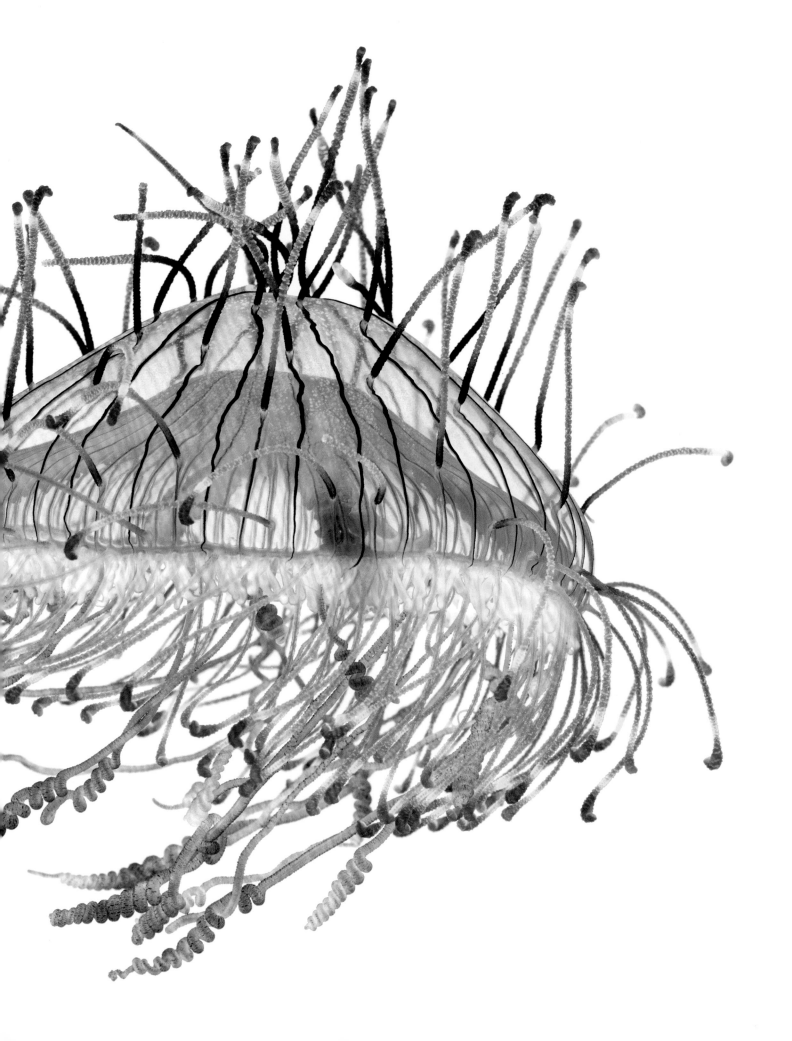

PAGES 2-3

Capricorn Night Octopus

Callistoctopus alpheus

Specimen #1; mantle is 1.75 inches long; Queensland
Sustainable Sealife, Slacks Creek, Queensland, Australia

PAGES 4-5

Western Spiny Seahorse

Hippocampus angustus

Specimens #78 and #79; male and female; 3.25 inches high;
Seahorse World, Beauty Point, Tasmania, Australia

PREVIOUS PAGES

Flower Hat Jelly

Olindias formosa

Specimen #246; bell is 2.5 inches across; Kamo Aquarium,
Tsuruoka, Yamagata, Japan

OCTOPUS
SEAHORSE
JELLYFISH

DAVID LIITTSCHWAGER

ESSAYS BY
ELIZABETH KOLBERT, JENNIFER HOLLAND,
AND OLIVIA JUDSON

NATIONAL
GEOGRAPHIC
WASHINGTON, D.C.

for Suzie, with love

CONTENTS

FOREWORD BY
ELIZABETH KOLBERT 12

INTRODUCTION BY
DAVID LIITTSCHWAGER 14

1. OCTOPUS
ESSAY BY OLIVIA JUDSON 16

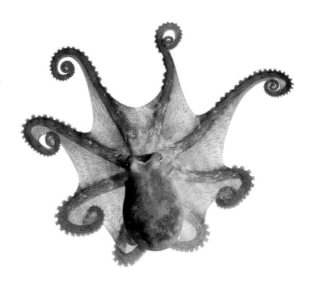

2. SEAHORSE
ESSAY BY JENNIFER HOLLAND 110

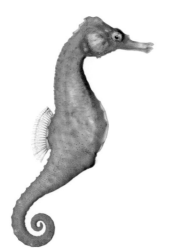

3. JELLYFISH
ESSAY BY ELIZABETH KOLBERT 162

INDEX 252
ACKNOWLEDGMENTS 254

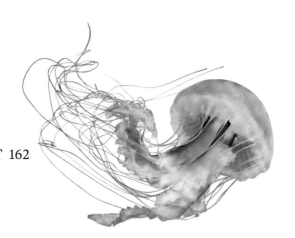

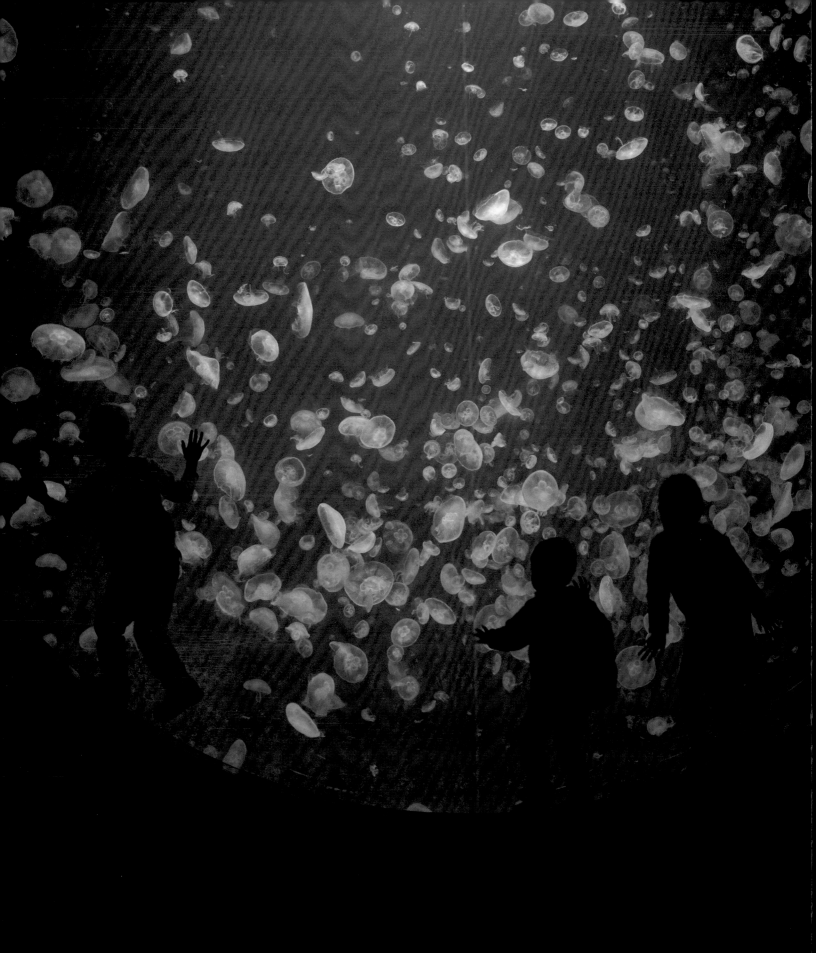

FOREWORD ELIZABETH KOLBERT

"YOU COULD START NOW, and spend another forty years learning about the sea without running out of new things to know," the author Peter Benchley, most famous for his novel *Jaws,* wrote in the mid-1970s. More than 40 years later, the observation still holds. Scientists estimate that 90 percent of the species in the oceans have yet to be classified. In 2020, a team of researchers from the United States and Australia set out to explore the Ningaloo Canyons, in the eastern Indian Ocean. When they returned, they announced that they had discovered up to 30 new creatures. One of the researchers, Nerida Wilson of the Western Australian Museum, pronounced herself "blown away" by what she had seen.

Few people can go searching for new species in remote parts of the ocean. Fortunately for the rest of us, we have David Liittschwager's extraordinary photographs. In the pages that follow, Liittschwager's octopuses reveal their stunning, sinuous beauty. Their intelligence—so different from our own—shines through. Liittschwager's jellyfish pulse with life, and his seahorses regard the world through soulful eyes. The images are an opportunity to explore the fantastic world that exists under the surface of the seas.

Unfortunately, even this underwater realm is now threatened by human activity. Dangers to marine life include, but are not limited to, global warming, overfishing, ocean acidification, oil spills, and plastic waste. Scientists warn that we are probably losing many ocean species before they can be identified. Several species of seahorses are now considered endangered, and one—the estuarine pipefish, from South Africa—is considered critically endangered. In the case of octopuses, fishermen report that numbers for some species are dropping, but the conservation status of most species is unknown. Jellyfish seem to be thriving in some parts of the world and even taking over beaches. However, researchers caution, for every species that's doing well, another is probably declining. All of which is to say, the marvelous creatures in this book need—and deserve—our protection. •

Megatank with moon jellies, *Aurelia coerulea;* Kamo Aquarium, Tsuruoka, Yamagata, Japan

INTRODUCTION DAVID LIITTSCHWAGER

OCTOPUSES. SEAHORSES. JELLYFISH. All are strange and exquisite creatures.

I made the images in this book between June 2008 and March 2020. The work took me from French Polynesia to Tasmania to southern Spain and many places in between. My photographic studio—all 500 pounds of it—was mobile, packed into roughly a dozen cases that were travel-ready for car or plane. I set it up wherever I needed to—in hotel rooms, dive shops, aquariums, research labs, and the occasional parking lot.

I was able to access my subjects thanks to the dozens of aquarists, scientists, and collectors who shared their creatures (and knowledge) with me. The 189 images you'll find in these pages were culled from more than 135,000 exposures of nearly 500 specimens. To create the white background in most of the pictures, I used a pair of condenser lenses that allow light to be focused on the camera's lens to minimize any diffusion. This increases the contrast, allowing me to render the detail of small hairs, translucent tissue, and nearly transparent parts of these creatures that might otherwise remain unseen.

I choose to work in this particular way because I'm curious about the diversity of life. There are 300 species of octopus, 47 species of seahorse, and thousands of species of what are commonly referred to as jellyfish: the gelata, which include comb jellies, box jellies, siphonophores, and the "true jellies."

But I'm also driven by a less quantifiable purpose. "Nature loves to hide," wrote Heraclitus. I want to see. Octopuses are masters of camouflage, as are seahorses. Many jellyfish are literally transparent.

In photographing these creatures, my goal is to show *what's really there*. And while it is impossible to record the entirety of a creature in a single frame, I *can* stop—or at least pause—the river of time for 1/5,000 of a second.

The process is revealing. When I'm editing, I often notice details I didn't see when the animal was right in front of me. Consider the moon jelly on page 242, a very young and small (quarter-inch) creature that, upon close examination, seems to have eight eyes. But as it turns out, those "eyes" are actually rhopalia, proprioceptive balancers that may also have some

Octopuses have very sensitive eyes, so we learned to use only a red light to focus with so their pupils would stay open.

photosensitivity (basic light/dark). So the moon jelly, which has no brain, not only knows what time of day it is; it knows which way is up or down, even in the dark. The rhopalia are invisible to the naked eye when the creature is on the move.

But not only species diversity compels me. I am also interested in the great familial weave of the natural order. I think of the octopus, a mollusk, as a distant cousin. We go back a ways, Cousin Octopus and I—at least as far back as the early Cambrian period, 550 million years ago. Before that, we were probably the same thing: a motile wormlike creature with a mouth. A seahorse is kin, as we are both chordates. At some point 450 million years ago, we were siblings. Farther back in time, some 700 to 800 million years ago, we find a common ancestor with jellyfish. We have all been at this for a very long time.

When I remember that an octopus has a more efficient eye design than we humans have, I am persuaded that humans are maybe not the pinnacle of evolution, but an untidy work in progress.

Finally—and perhaps surprisingly—the creatures I photograph stir in me a mysterious feeling. A pregnant male seahorse, a shape-shifting octopus, and a jellyfish that can cleave off a piece of itself to make another have been wondrous sights to behold. My hope is that this book might encourage more affection for these creatures. ●

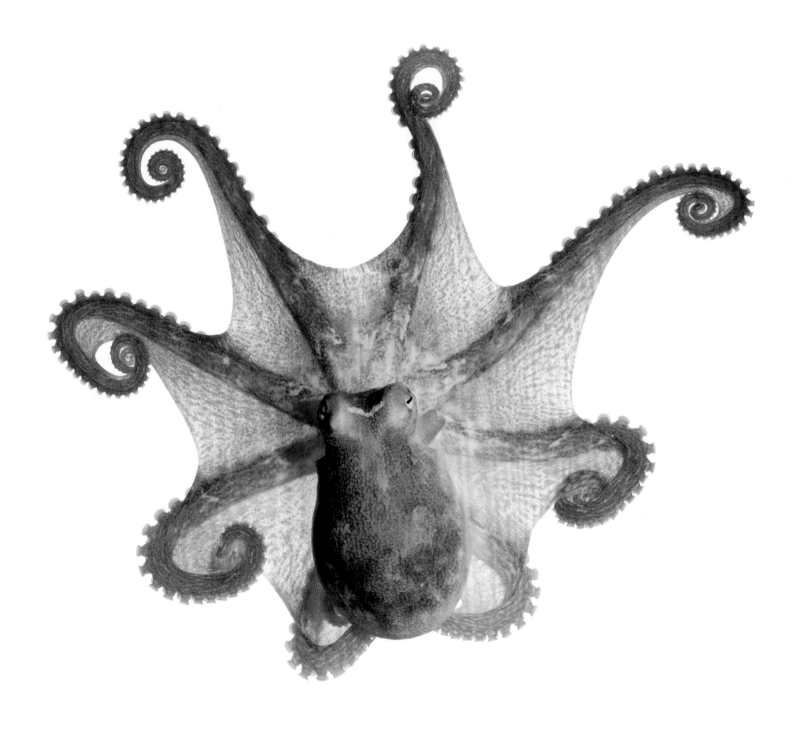

OCTOPUS

Wonderpus Octopus
Wunderpus photogenicus
Specimen #21; male; mantle is 0.625 inch long; Caldwell Lab, Department of Integrative Biology,
University of California, Berkeley, United States of America

PAGE 16

Southern Keeled Octopus
Octopus berrima
Specimen #7; mantle is 2.25 inches long; Moonlight Bay Resort, Rye, Victoria, Australia

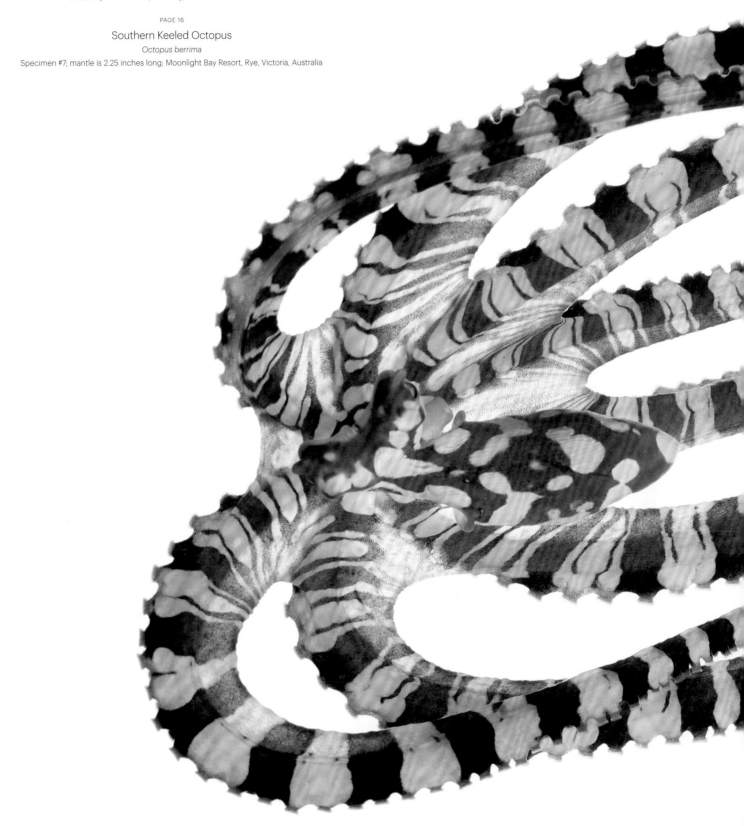

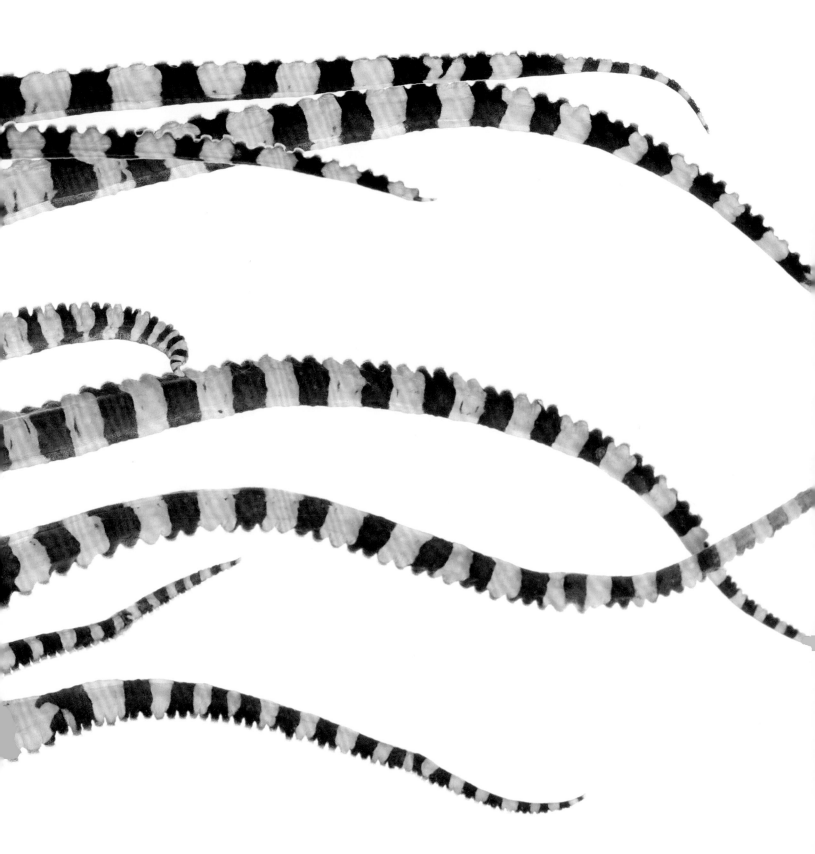

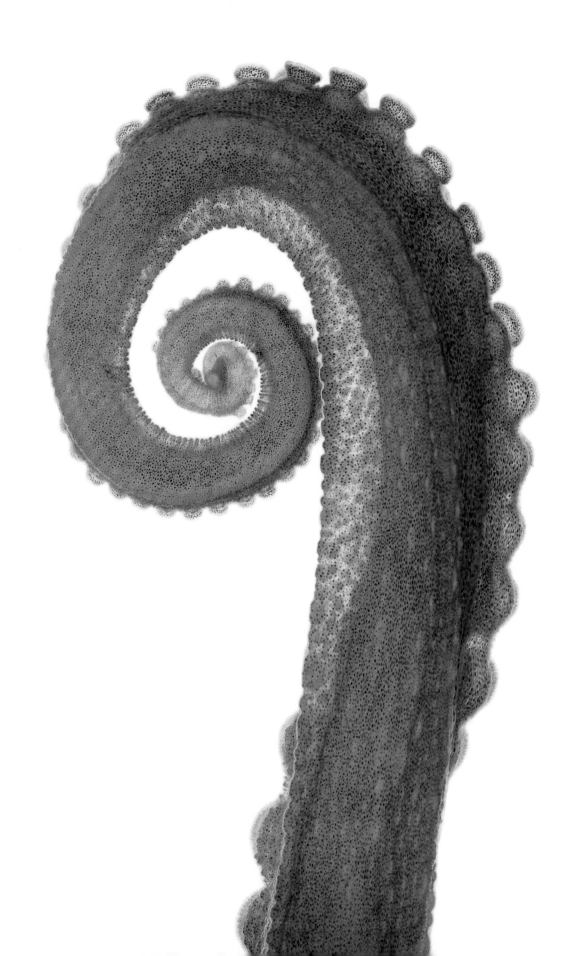

OCTOPUS
THE POWER OF EIGHT
OLIVIA JUDSON

YOU'RE SITTING ON THE SEABED, just off the coast of the Indonesian island of Lembeh. You're not deep—20 feet or so—and there's plenty of light. As you'd expect in such a tropical place, the water is warm. All around, you see ripples of a fine gray-black sand, covered, in places, with a kind of greenish scum. As you explore, you notice a conch shell. Stoutly made, it has six heavy spikes coming off it. Perhaps the maker is within. Or perhaps the maker is long dead, and the shell now belongs to a hermit crab. Curious, you flip it over. A row of suckers. A pair of eyes.

An octopus. In particular, *Amphioctopus marginatus,* also known as the coconut octopus. Its common name comes from its habit of hiding in discarded coconut shells (sometimes it even picks them up and carries them about, for use as an emergency shelter). But, in fact, any big shell will do—such as a conch.

With a few of its suckers, this octopus is holding two halves of a clamshell. As you watch, it drops them and hoists itself up a little. It gives the impression of evaluating the situation. You make like a statue. After a moment, the octopus climbs out of the shell. Its body is the size of your thumb, its arms perhaps three times that. As it moves onto the sand, it turns a matching shade of dark gray. Is it leaving? No. It snakes several of its arms over the sand, and the rest over the shell. With a single heave, it flips the shell back over and flows inside.

Common Octopus
Octopus vulgaris
Specimen #12; portion shown is about 2 inches high; Florida Keys Marine Life, Big Pine Key, Florida, United States of America

OF ALL THE INVERTEBRATES— ANIMALS THAT LACK A BACKBONE— OCTOPUSES ARE THE ONES THAT SEEM THE MOST LIKE US. IN PART, IT'S THE WAY THEY RETURN YOUR GAZE.

Not wanting to disturb it further, you're about to swim off, when you notice a small movement. The animal has squirted a jet of water, clearing sand from beneath the lip of the shell. There's now a small gap between shell and seafloor. In the gap, the eyes reappear. You bring your mask close, and for a moment, you look at each other.

Of all the invertebrates—animals that lack a backbone—octopuses are the ones that seem the most like us. In part, it's the way they return your gaze, as if they're scrutinizing you. (This sets them apart from plenty of vertebrates too: Most fish don't appear to stare at you.) In part, it's their dexterity. Their eight arms are lined with hundreds of suckers; this allows them to manipulate objects, whether to open clamshells, dismantle the filtration system of an aquarium tank, or unscrew lids from jars. This distinguishes them from mammals like dolphins, which, for all their smarts, are limited by their anatomy and cannot easily unscrew anything.

At the same time, octopuses are as alien as any extraterrestrial you might dream up. For starters, they have three hearts and blue blood. When feeling under threat, they squirt a cloud of ink and jet off in another direction. They have no bones. The only hard parts of their bodies are a parrotlike beak and a nub of cartilage around their brain. This makes it easy for them to vanish through tiny cracks—an ability that allows them to escape, Houdini-like, from all but the most octopus-proofed aquarium. Not only can all of their suckers be moved independently, but each one is covered with taste receptors—imagine your body covered with hundreds of tongues. Their skin is embedded with cells that sense light. Most otherworldly of all—but let's wait on that. First, let's meet another octopus.

YOU'RE STANDING IN A SMALL, windowless office in the Natural History Museum in London. In front of you, on a desk crowded with files, lies a slab of pale, fine-grained stone. Beside you, Jakob Vinther, a burly Dane with blond hair and a ginger beard, is pointing at it.

"That thing there is the ink sac," says Vinther, an expert on fossil invertebrates at the University of Bristol in England. "That's actually pigment—chemically preserved melanin."

You lean forward to look. The stone is clearly marked with the impression of an octopus. It's not large: In life, the animal would have been perhaps 10 inches long. You can trace the mantle—the baglike structure that houses its gills, hearts, and other vital organs. Ah yes. That dark stain in the middle there—that's the ink sac. The arms hang down, loosely grouped together, each marked with rows of circles. "And those little round structures," says Vinther, "those are the suckers."

Octopus fossils are rare; animals with soft bodies generally leave no trace. This fossil is about 90 million years old, which makes it one of the oldest known octopuses. When this animal lived, the extinction of the dinosaurs was still 25 million years in the future. "It comes from a locality in Lebanon where you find all kinds of wonderfully preserved soft-bodied creatures," Vinther says. Lampreys. Fireworms. All entombed, long ago, in fine, chalky mud on the floor of a long-vanished sea.

Just as humans are mammals, octopuses are cephalopods. The word is Greek for "head-foot" and refers to their weird anatomy, by which their arms are attached directly to one side of their head while their "torso"—the baglike mantle—is on the other. Cephalopods, in turn, are a type of mollusk—a group that includes snails and slugs as well as clams and oysters.

Cephalopods were among the first predatory animals to hunt in the ancient seas. They evolved more than 500 million years ago—long before fish got going—from a small animal with a shell like a witch's hat. Indeed, if you were to travel back in time 450 million years, some of the fiercest predators in the oceans would have been shell-wearing cephalopods. Some of these were apparently enormous: The shell of the long-extinct *Endoceras giganteum* may have been more than 18 feet long.

Today, there are more than 750 known living species of cephalopods. Besides around 300 species of octopus, these include an array of squid and

YOU CAN FIND OCTOPUSES FROM THE TROPICS TO THE POLES, FROM CORAL REEFS TO SAND FLATS, FROM TIDE POOLS TO THE ABYSS. AT LEAST YOU CAN IF YOU CAN SPOT THEM.

cuttlefish (both of which have 10 limbs) and a few species of nautilus—peculiar animals that have 90 tentacles and live in shells.

Modern octopuses are a diverse bunch. The giant Pacific octopus, *Enteroctopus dofleini*, is, as its name suggests, gigantic. Each arm of a large individual can be six and a half feet long, and the whole animal can weigh more than 200 pounds. Others, such as the star-sucker pygmy octopus, *Octopus wolfi*, are teensy, weighing just a fraction of an ounce. Some octopuses have a tiny mantle but immensely long arms; others are more evenly proportioned. Most clamber around on corals, mud, or sand, swimming only to get from A to B or to escape from predators. But a few have taken to cruising the ocean currents. You can find octopuses from the tropics to the poles, from coral reefs to sand flats, from tide pools to the abyss. At least you can if you can spot them.

BACK IN LEMBEH, it's a sunny morning. You're swimming over a shallow reef. Your guide—a man named Amba—makes a hand sign that shows he's seen an octopus. A big octopus. Where? You look around. No octopus. Just rocks, covered with corals and sponges of different colors. Amba gestures insistently: big octopus! You look where he's pointing. Nope: nothing. Wait. Look again. That patch of dark, velvety coral, that one over there. That's no coral. That's a day octopus, *Octopus cyanea*. Astonishing to have missed it: It's as big as a dinner plate.

Octopuses and cuttlefish that live in shallow water and hunt during the day are the world champions of disguise. Of course, disguise is not unusual: Many creatures have evolved to look like something they're not. That orange sponge over there, for example, is not a sponge but a frogfish, lying in wait for unwary fish. That leaf you see drifting above the sand is not a leaf; it's a fish that's evolved to look like a leaf. That leaf—that one there, scuttling over the sand—really is a leaf, but it is also really scuttling. A crab has taken it and stuck it to its shell. That small anemone is a sea slug that has evolved

to impersonate an anemone. And everywhere you look, patches of sand get up and walk about (tiny crabs with sand-colored shells) or swim off (sand-colored flatfish).

What makes octopuses and cuttlefish (and to a lesser extent, squid) different is that they can disguise themselves on the fly, now looking like coral, now like a clump of algae, now like a patch of sand. It's as if they use their skin to make three-dimensional images of objects in their surroundings. How do they do it?

Octopus disguise has three main elements. One is color. Octopuses generate color through a system of pigments and reflectors. The pigments—usually tones such as yellows, browns, and reds—are kept in thousands of tiny sacs in the top layer of the skin. When the sacs are closed, they look like minute speckles. To show the pigment, an octopus contracts the muscles around the sac, thus pulling it open and revealing the color. Depending on which sets of sacs an octopus opens or closes, it can instantly produce patterns such as bands, stripes, or spots.

The reflecting cells come in two types. The first type reflects back the light that arrives—thus causing the skin to appear white in white light, red in red light, and so on. The second type is like a living soap bubble that presents different colors when seen from different angles. Together, the reflectors plus the pigment organs allow an octopus to create a huge variety of colors and patterns.

The second element of disguise is skin texture. By contracting special muscles, octopuses can change their skin from smooth to spiky. The effect can be extreme. The algae octopus, *Abdopus aculeatus,* generates temporary wispy structures that give the impression that the animal is just a piece of seaweed. The hairy octopus, a creature yet to be scientifically described, has evolved a permanently wispy look and is hard to tell apart from a scrap of red algae.

The third part of disguise is posture. The way an octopus holds itself can make it more or less conspicuous. Some octopuses, for example, will ball

ARMED WITH INTELLIGENCE

In number of neurons, octopuses and their relatives far exceed other invertebrates and put rodents, frogs, and many other vertebrates to shame. An octopus's nervous system processes information not just in the brain but also throughout all eight arms and the suckers that line them.

Pond snail	Mouse	**Octopus**	Human
0.01	80	**500**	86,000

millions of neurons

Nervous system chain of command

Brain: 35 percent **Arms:** 65 percent

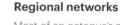

Head office

The brain contains one-third of an octopus's neurons. It handles higher executive functions, such as decision-making, learning, and memory, as well as coordination of complex movements.

Regional networks

Most of an octopus's neurons are in its arms. Each has interlinked control centers, or ganglia, that relay information to the brain and also independently control movements such as extending or twisting an arm.

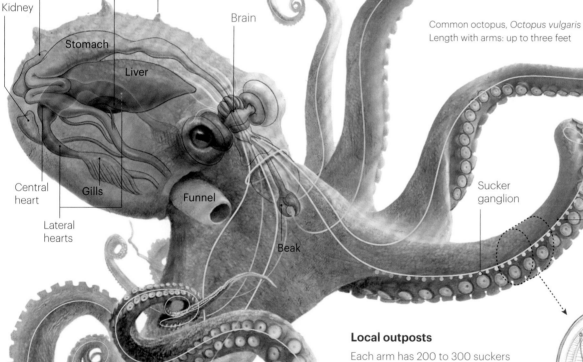

Gonad
Ink sac
Papilla
Kidney
Brain
Stomach
Liver
Central heart
Gills
Funnel
Lateral hearts
Beak

Common octopus, *Octopus vulgaris*
Length with arms: up to three feet

Sucker ganglion
Arm nerve cord

Local outposts

Each arm has 200 to 300 suckers and a bundle of nerves that controls local movement and gathers sensory information, which it processes and relays to the brain.

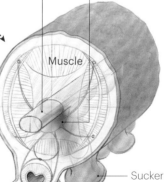

Sucker ganglion
Muscle
Sucker

GRAPHIC BY FERNANDO G. BAPTISTA, NGM STAFF. SHIZUKA AOKI; MESA SCHUMACHER
SOURCES: ROGER HANLON, MARINE BIOLOGICAL LABORATORY; GUY LEVY AND BENNY HOCHNER, HEBREW UNIVERSITY OF JERUSALEM; CLIFF RAGSDALE, UNIVERSITY OF CHICAGO

themselves up like a lump of coral and, using just two of their arms, creep slowly across the seafloor. *(No, no, don't look at me—I'm just a rock . . .)*

How did octopuses get so good at this? The short answer is: evolution. Through tens of millions of years, individuals that were better at disguise were more likely to evade predators and leave offspring. And plenty of animals—including eels, dolphins, mantis shrimps, cormorants, many fish, and even other octopuses—are enthusiastic eaters of octopuses. Because octopuses have no bones, predators can eat the whole animal. As Mark Norman, a world expert on living cephalopods at Museums Victoria in Melbourne, Australia, puts it, "These animals are pure meat walking around—they're filet mignons."

NOW LET'S TURN TO THE MATTER of the octopus's nervous system. A typical pond snail has just 10,000 neurons; lobsters have around 100,000; jumping spiders, perhaps 600,000. Honeybees and cockroaches, which after cephalopods have a claim to be the planet's most neuronally rich invertebrates, have around a million. So the 500 million neurons of the common octopus, *Octopus vulgaris,* put the animals into a completely different league. In terms of their neuron count, they are better endowed than a mouse (80 million) or rat (200 million) and are almost on a par with a cat (around 700 million). Yet although vertebrates keep most of their neurons in their heads, two-thirds of an octopus's are in its arms. What's more, nervous systems take a lot of energy to run and can evolve to be large only when the benefits outweigh the costs. So what's going on?

Peter Godfrey-Smith, a philosopher turned octopus biologist at City University of New York and the University of Sydney in Australia, suggests that several forces may have helped the octopus develop a complex nervous system. The first is its body. Nervous systems, after all, evolve in tandem with bodies, and the octopus body has evolved to be unusually complex. Being boneless, an octopus can extend any arm in any direction at any point;

BONELESS BODIES, COMPLEX ENVIRONMENTS, DIVERSE DIETS, AVOIDING PREDATORS—ALL FACTORS THAT CAN DRIVE THE EVOLUTION OF INTELLIGENCE.

unlike you or me, it's not limited to moving at shoulder, elbow, or wrist. This gives the octopus an enormous range of possible movements; also, each arm can be doing something different.

An octopus on the hunt can thus be an impressive sight. It can have every arm stretched out over the sand, each one exploring, rummaging, probing into holes. If one arm startles a shrimp, two more can reach out to catch it. Octopuses also have all those suckers that can be moved independently, not to mention the structures and mechanisms for controlling skin color and texture. At the same time, the animal has evolved the capacity to receive and process a huge amount of incoming sensory information: taste and touch from the suckers, gravity sensed by structures called statocysts, as well as all the information that its sophisticated eyes collect.

On top of this, many octopuses live in spatially complicated environments; they must navigate on, around, and through reefs. Having no body armor, they need to keep a sharp lookout for predators, and in case camouflage is not enough, they need to know where to hide. Finally, octopuses are fast, agile hunters that catch and eat a wide variety of animals, from oysters to crabs to fish. Boneless bodies, complex environments, diverse diets, avoiding predators—all factors, Godfrey-Smith suggests, that can drive the evolution of intelligence.

Yet, although octopuses clearly have complex nervous systems, are they, in fact, smart? Evaluating the intelligence of other animals is tricky at the best of times, and sometimes tells us more about ourselves than about the animal in question. Markers of intelligence in birds and mammals, such as the ability to use tools, often don't make much sense for an octopus: Its whole body is a tool. It doesn't need a tool to reach into crevices—it can just reach in—or to pull oysters apart.

That being said, experiments starting in the 1950s and 1960s showed that common octopuses are good at tasks involving learning and memory—two attributes that we associate with intelligence. Indeed, a particular part of the octopus brain, the vertical lobe, is dedicated to such tasks. I'm stressing the

common octopus here because it has been studied the most, by far. Octopus species do differ somewhat in the organization of their brains, and as only a few have been studied, no one knows whether all of them are equally gifted. Roy Caldwell, an octopus researcher at the University of California, Berkeley, says, "Some that I've had in the lab seem to be as dull as toast." Name names? "*Octopus bocki,* a tiny little octopus." What makes it dull? "It just doesn't seem to do much."

But perhaps whether they are smart or dull—whether they are pondering philosophy or lunch, or not thinking anything at all—is less important than the fact that they are just all-around astonishing. Enchanting.

Let's go on one final dive. It's dusk in Lembeh. You're kneeling by a rocky slope. In front of you, swimming cheek to cheek, a pair of small fish are spawning. An eel is curled in a hole. A large hermit crab, in its borrowed shell, comes clunking past. And there, sitting on a rock, is a small algae octopus.

As you watch, it starts to move. One moment it seems to float, levitating like an eight-armed yogi. Another moment it appears to glide. Now it starts to crawl over the rocks—but whether it pulls itself with the arms in front or pushes with the arms behind, you cannot say. As it moves down the slope, one arm finds a tiny hole, and one arm after another, the animal streams into it. Gone. No—not quite. The tip of an arm reaches out of the hole, feels around, grabs some small stones, and pulls them over the entrance. There. All secure for the night. •

East Pacific Red Octopus
Octopus rubescens
Specimen #22; shown 1.5 times life size; mantle is 3.25 inches; Pillar Point,
Half Moon Bay, El Granada, California, United States of America

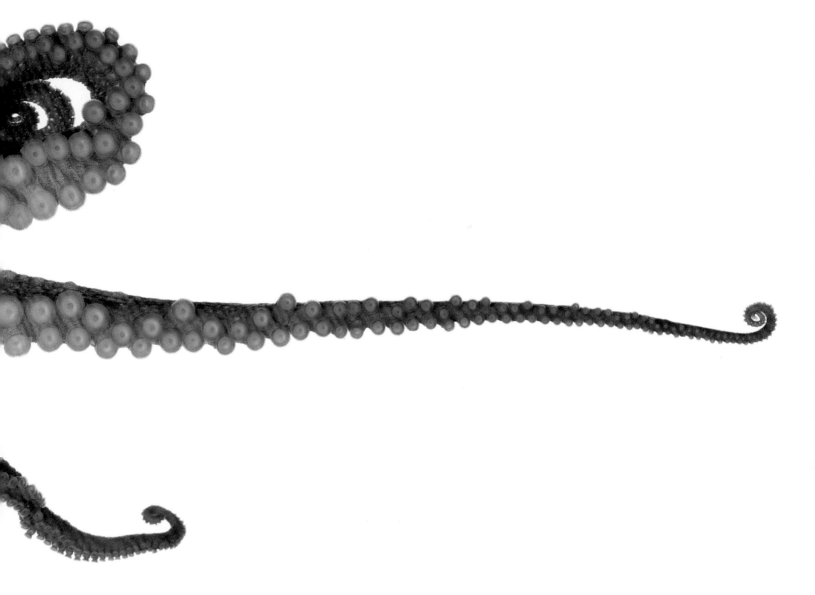

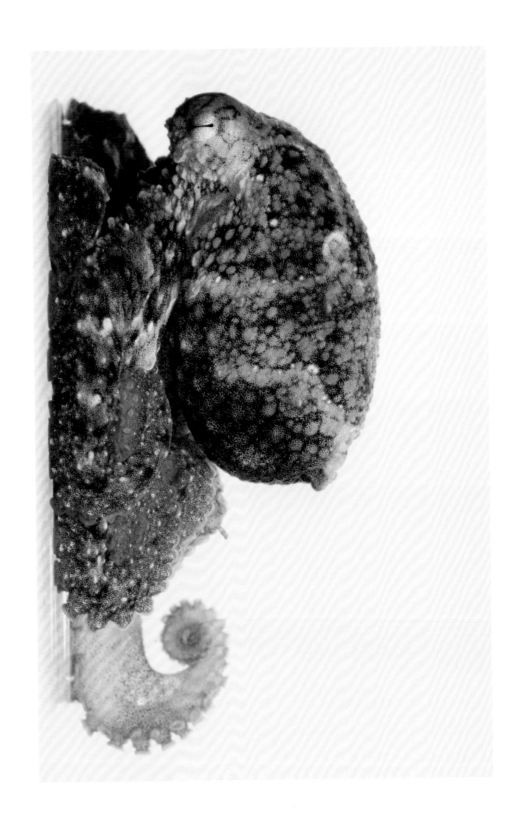

BOTH

East Pacific Red Octopus

Octopus rubescens

Specimen #174; mantle is 1.5 inches long; Bodega Marine Laboratory, University of California,
Davis, Bodega Bay, California, United States of America

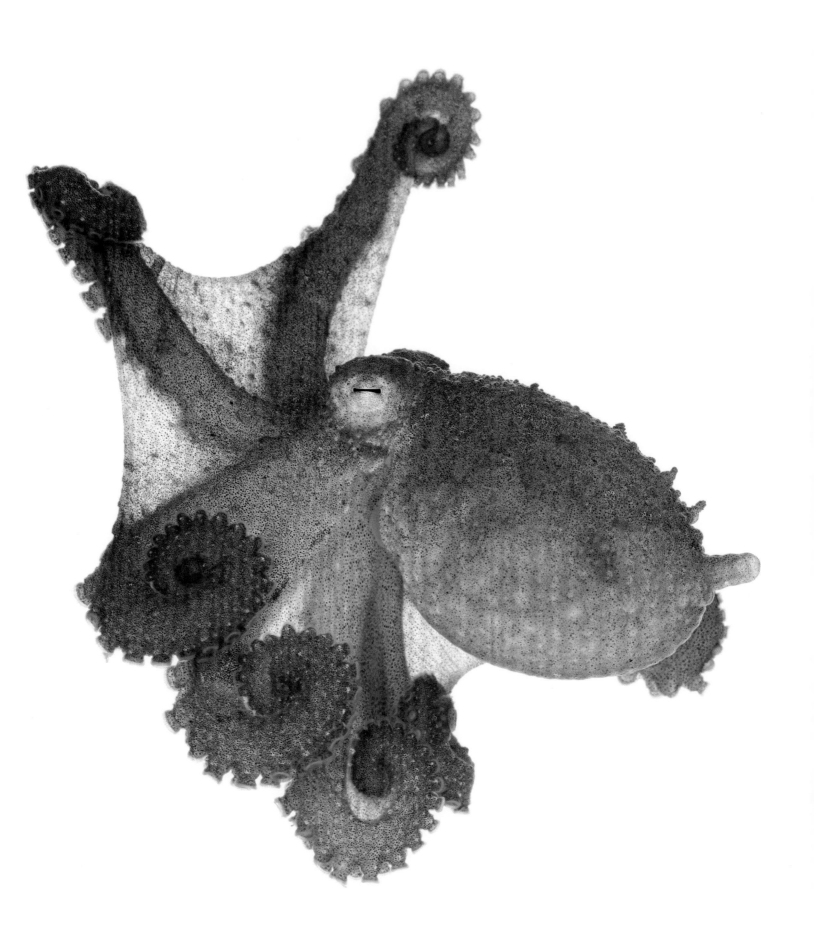

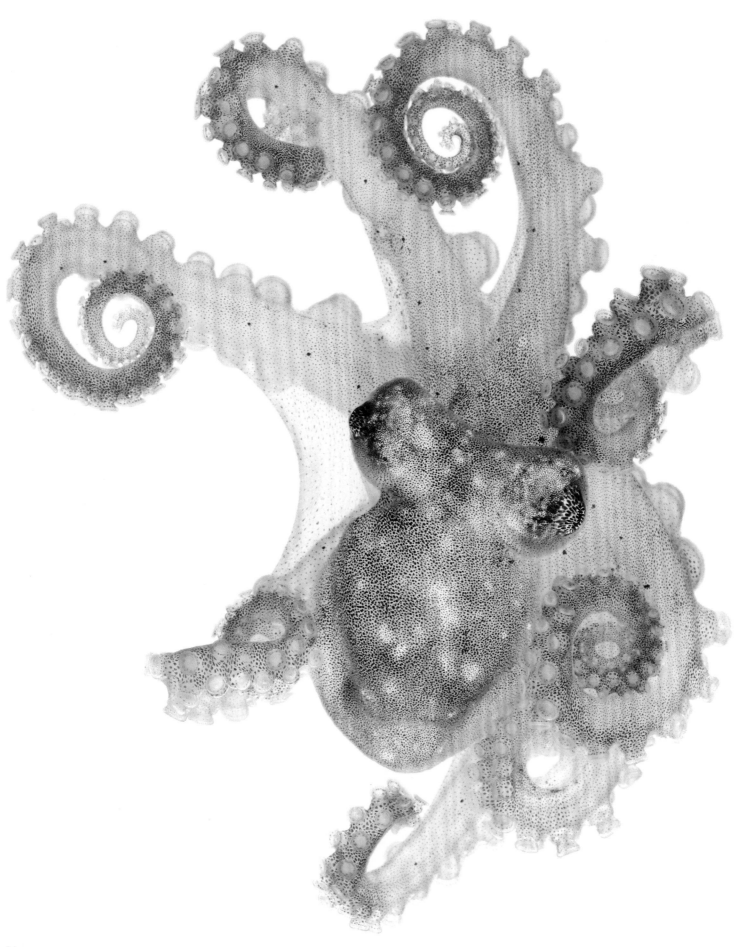

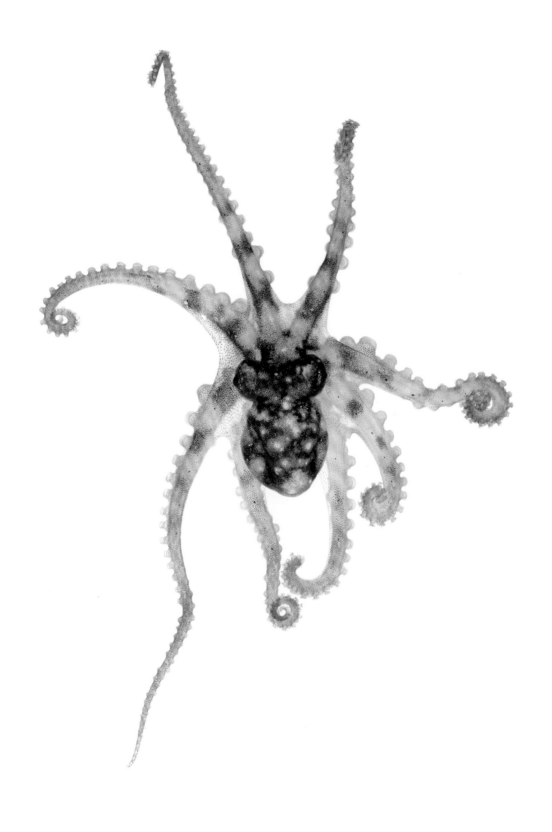

Bock's Pygmy Octopus

Octopus bocki

Specimen #14; mantle is 0.5 inch; Richard B. Gump South Pacific Research Station,
University of California, Berkeley, Moorea, French Polynesia

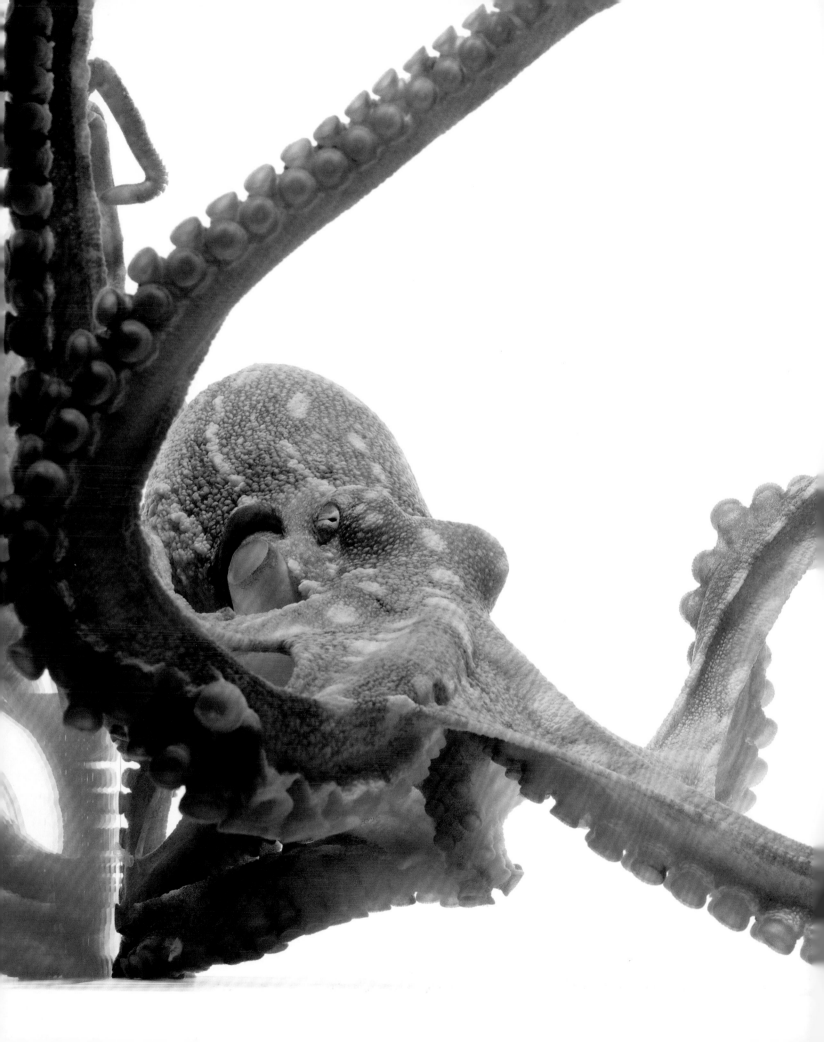

Night Octopus
Callistoctopus ornatus
Specimen #2; mantle is 3 inches long; Kahala Beach, Honolulu, Hawaii, United States of America

Capricorn Night Octopus
Callistoctopus alpheus
Specimen #1; mantle is 1.75 inches long;
Queensland Sustainable Sealife, Slacks Creek,
Queensland, Australia

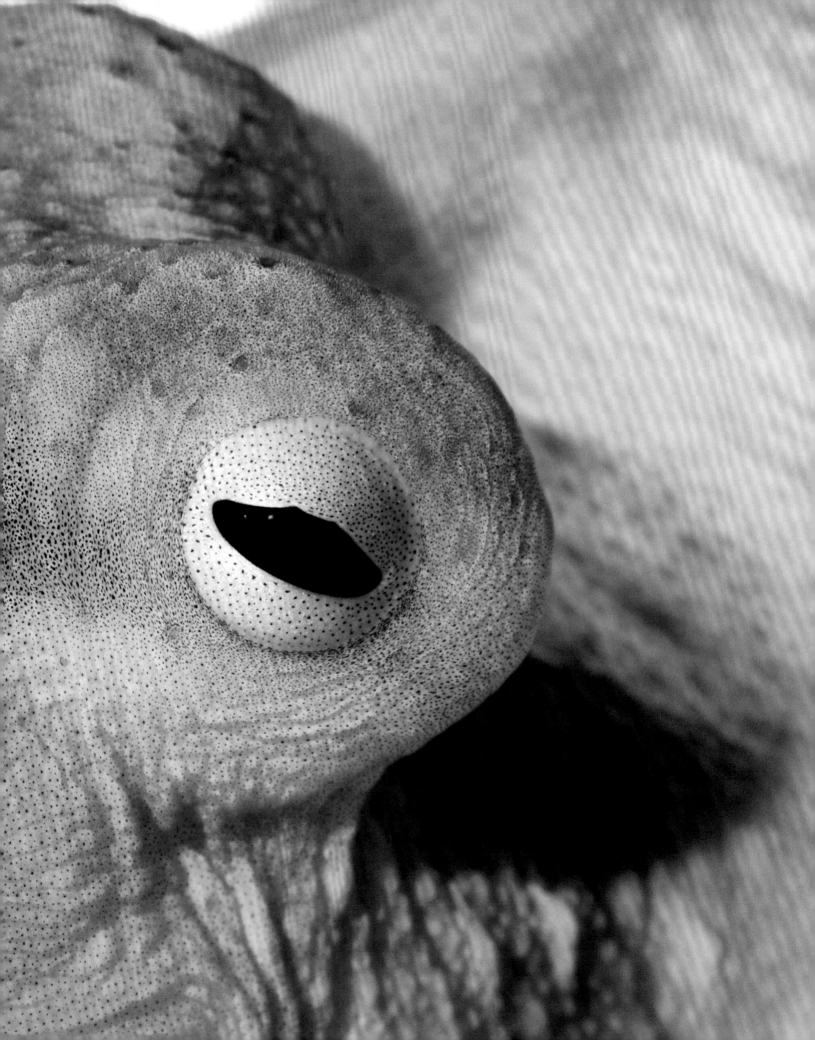

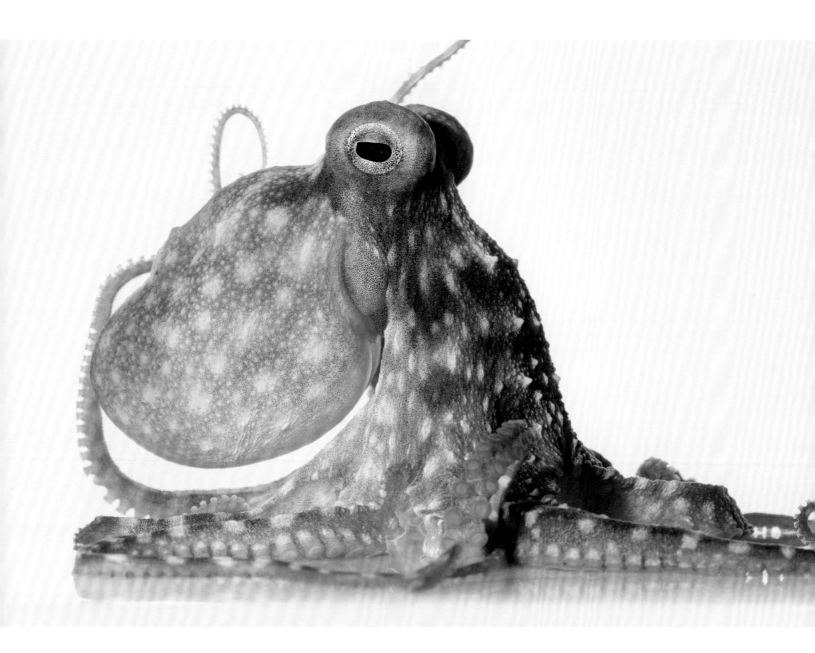

Capricorn Night Octopus
Callistoctopus alpheus
Specimen #1; mantle is 1.75 inches long; Queensland Sustainable Sealife, Slacks Creek, Queensland, Australia

OPPOSITE

Plainbody Night Octopus
Callistoctopus aspilosomatis
Specimen #32; male; mantle is 1.75 inches long; Dive Gizo, Ghizo Island, Solomon Islands

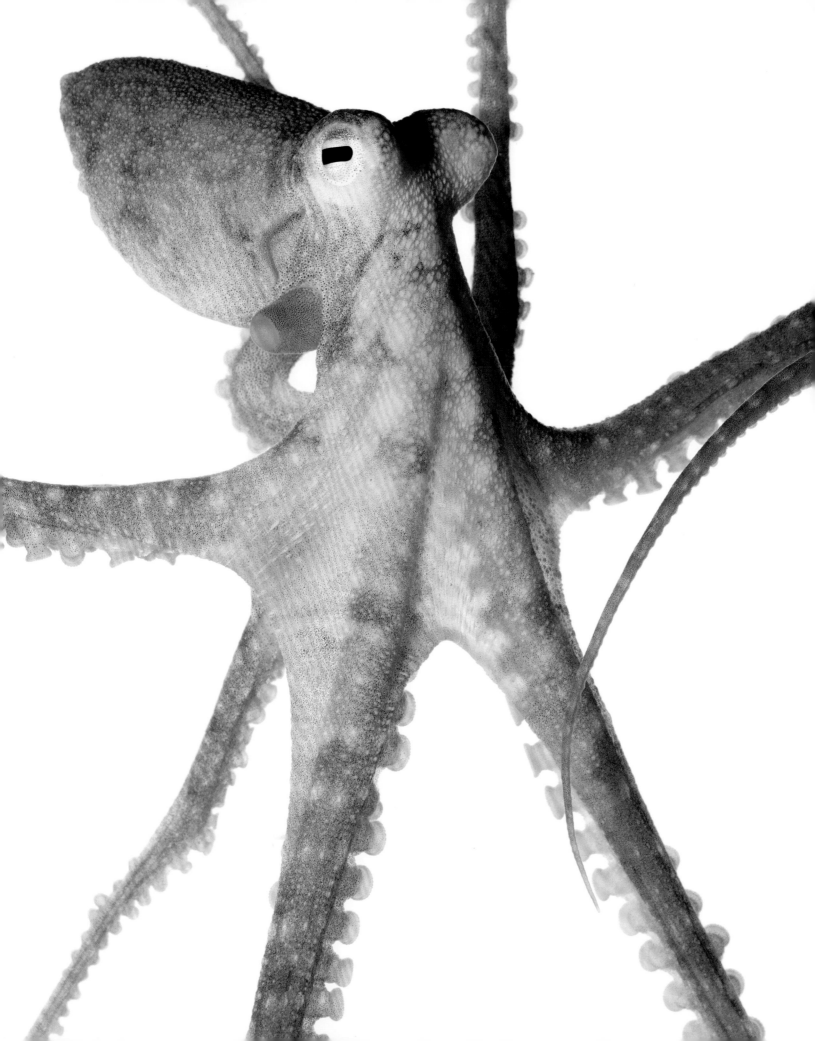

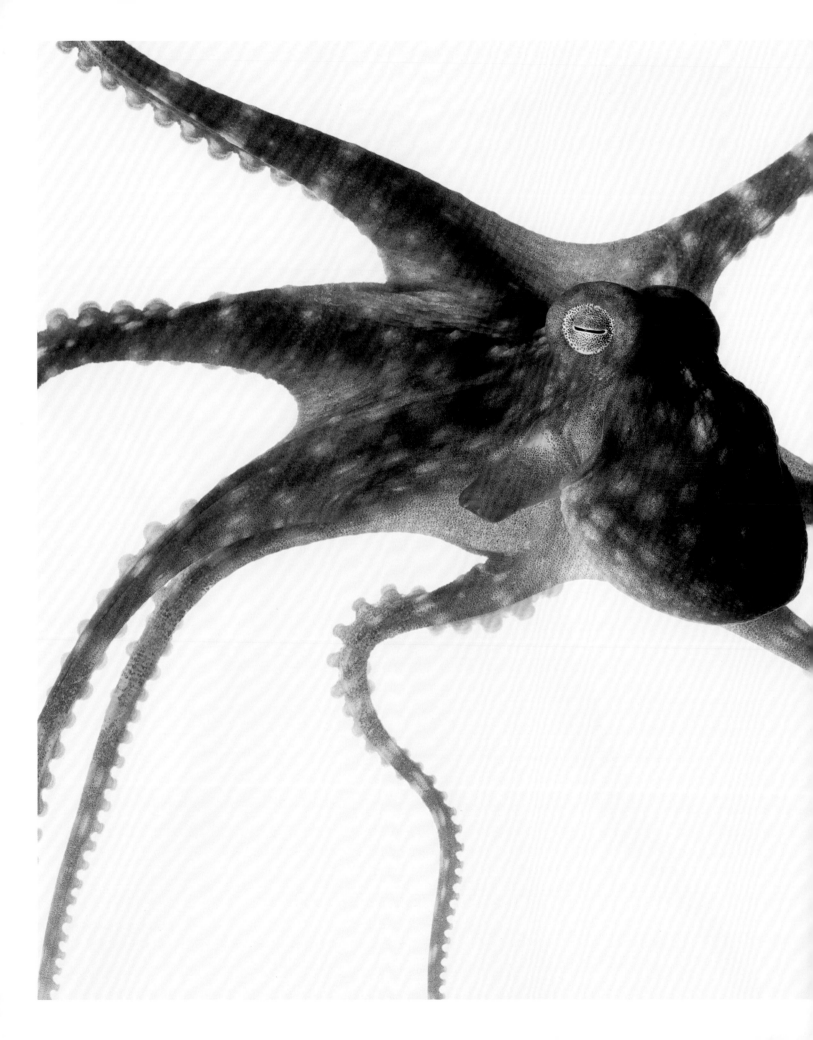

Capricorn Night Octopus

Callistoctopus alpheus

Specimen #1; mantle is 1.75 inches long;
Queensland Sustainable Sealife, Slacks Creek,
Queensland, Australia

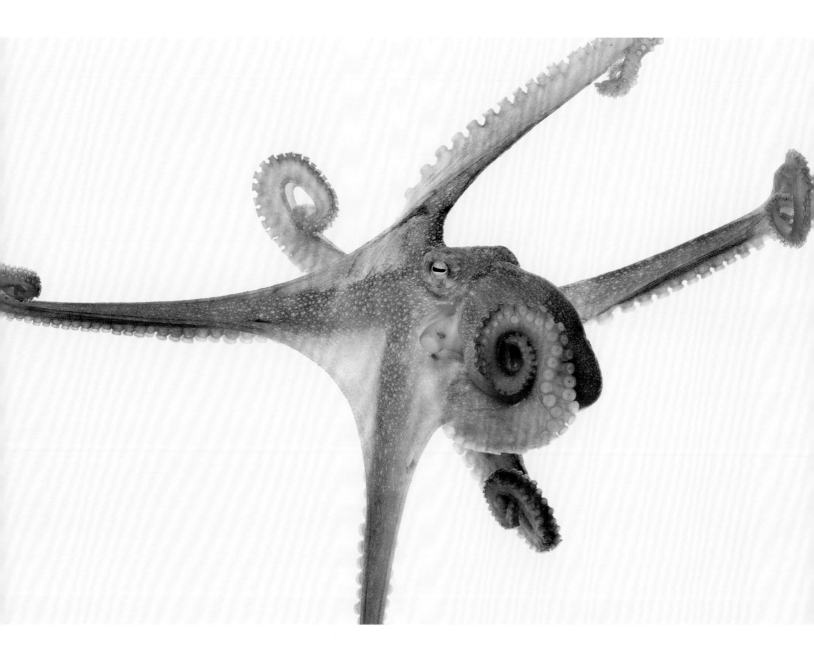

Hawaiian Octopus

Octopus hawiiensis

Specimen #1; mantle is 1.75 inches long; Makapu'u Beach Park, Waimanalo, Hawaii, United States of America

OPPOSITE

Rock Tako

Octopus oliveri

Specimen #3; mantle is 2.25 inches long; Kewalo Basin Harbor, Honolulu, Hawaii, United States of America

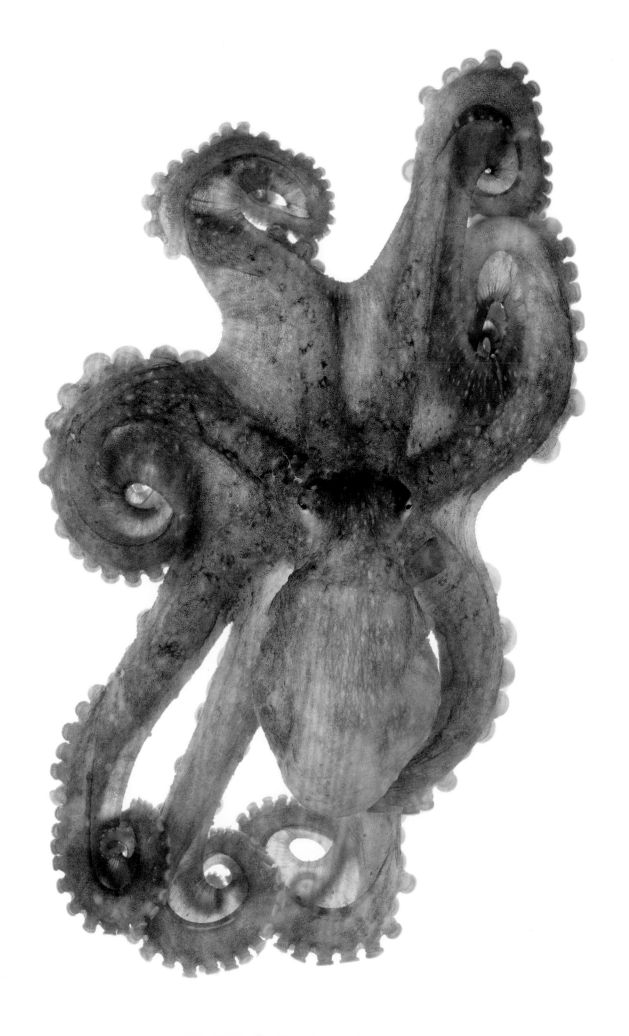

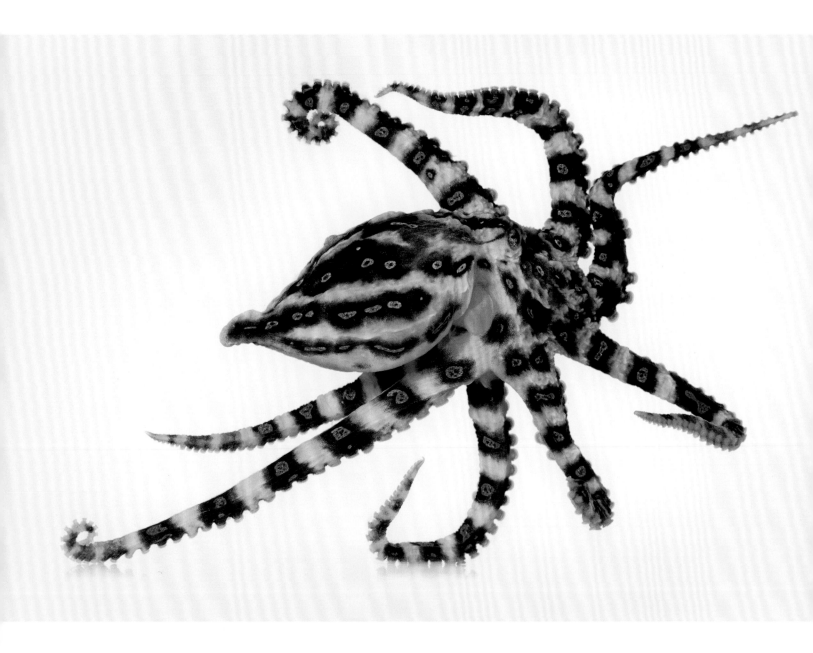

BOTH

Southern Blue-ringed Octopus

Hapalochlaena maculosa

Above: specimen #5; mantle is 1.25 inches long

Opposite: specimen #4; mantle is 1 inch long

Flinders Pier, Victoria, Australia

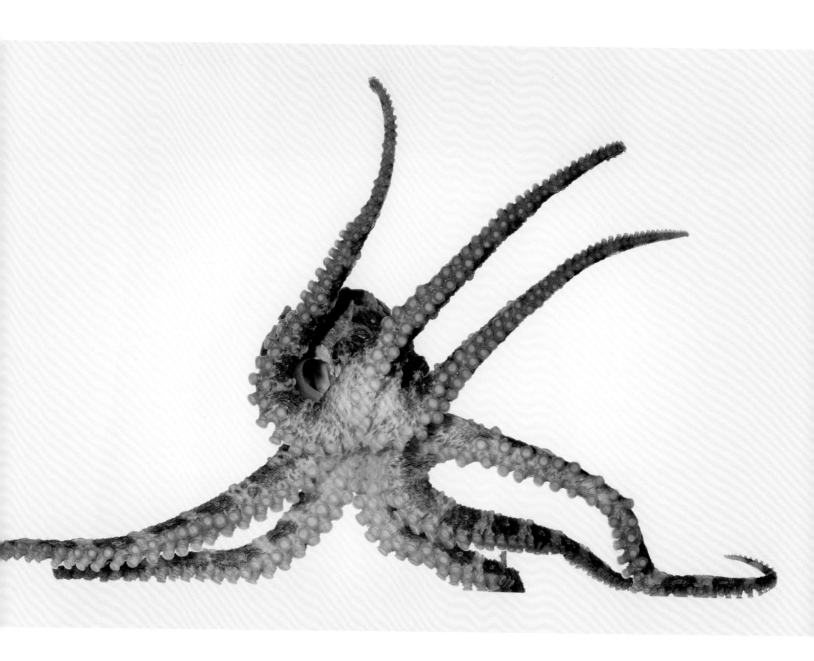

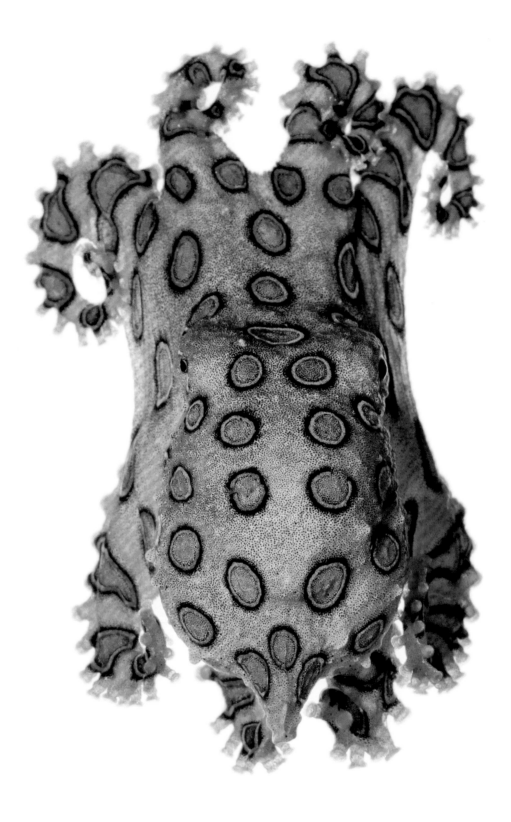

BOTH
Blue-ringed Octopus
Hapalochlaena lunulata
Specimen #28; female; mantle is 0.625 inch long; Dive Gizo, Ghizo Island, Solomon Islands

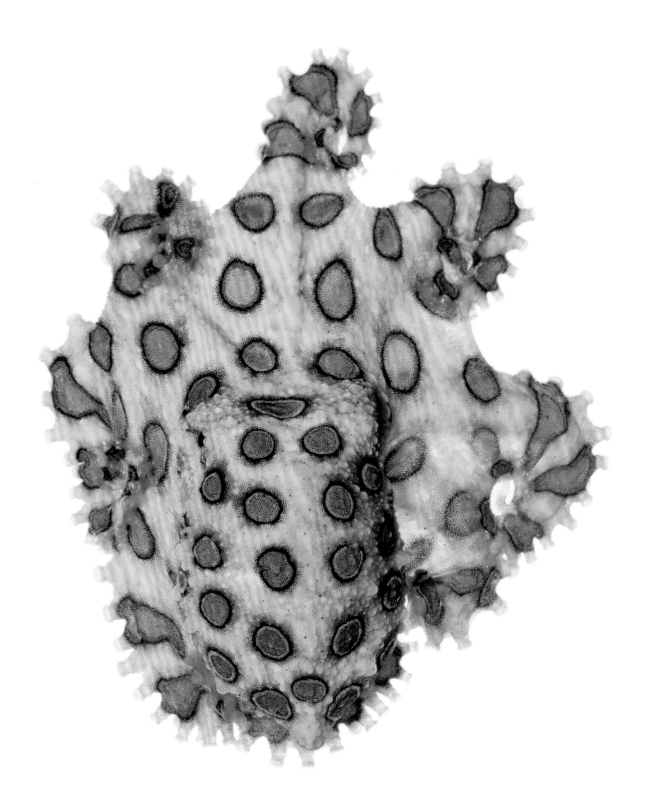

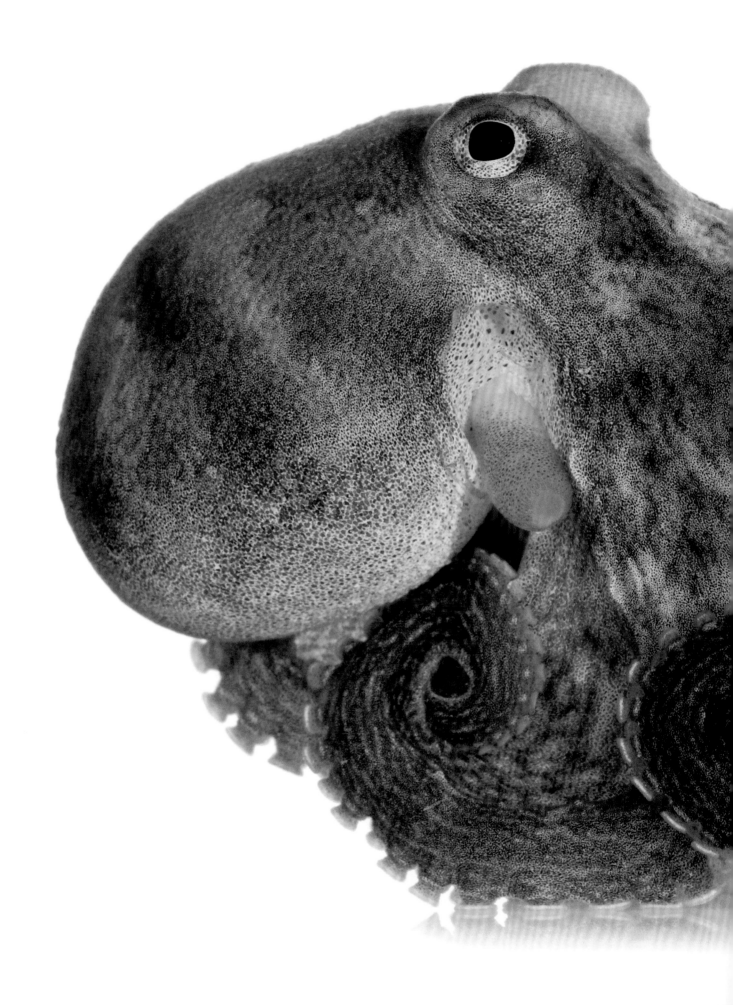

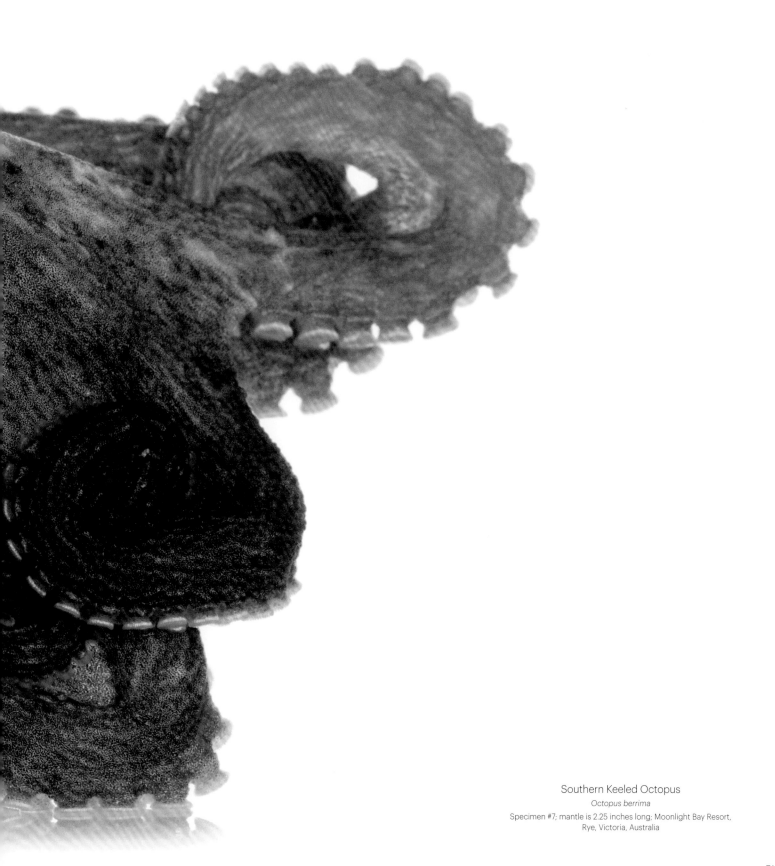

Southern Keeled Octopus
Octopus berrima
Specimen #7; mantle is 2.25 inches long; Moonlight Bay Resort,
Rye, Victoria, Australia

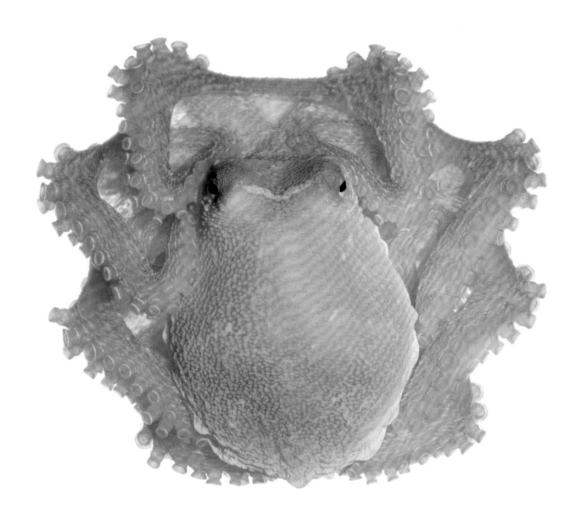

BOTH

Southern Keeled Octopus

Octopus berrima

Specimen #7; mantle is 2.25 inches long; Moonlight Bay Resort, Rye, Victoria, Australia

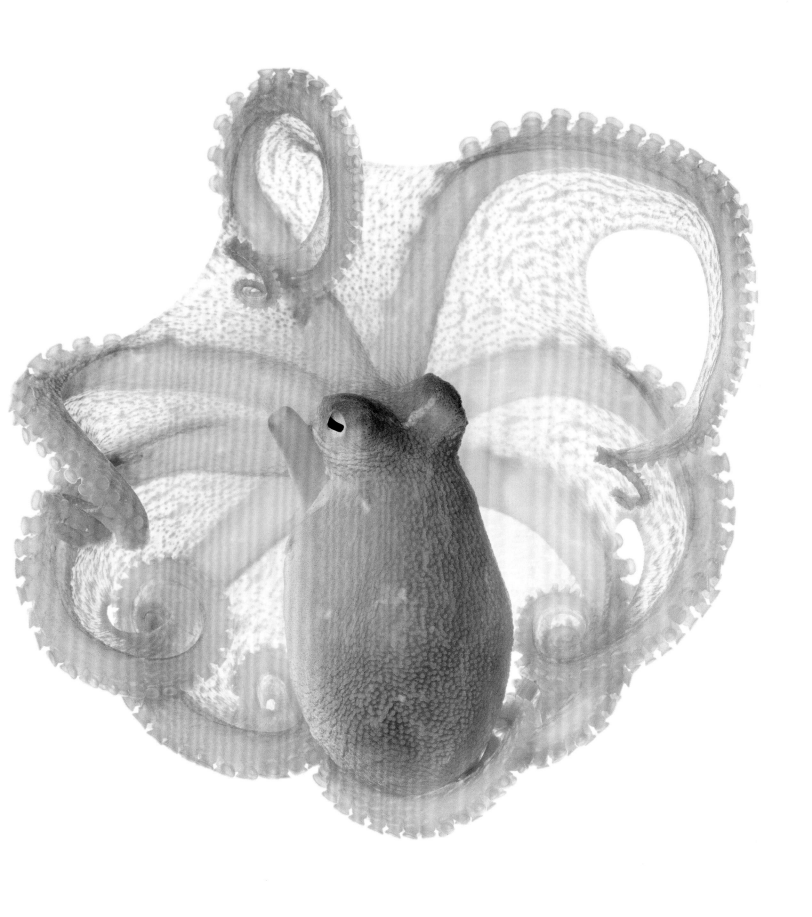

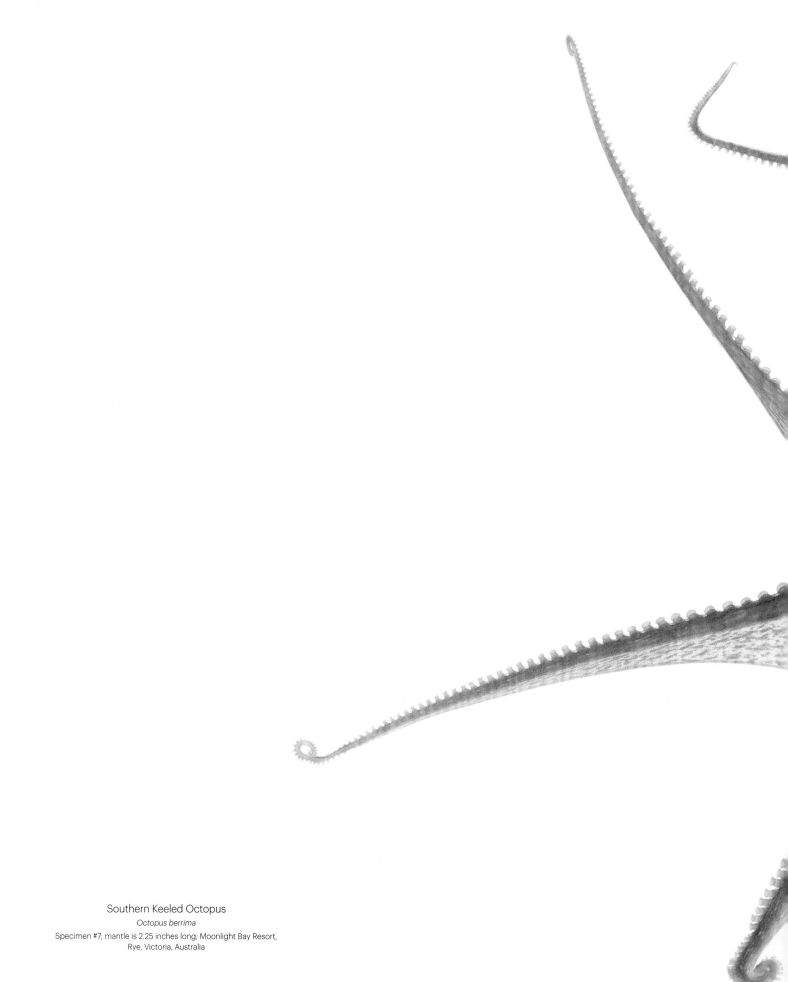

Southern Keeled Octopus
Octopus berrima
Specimen #7; mantle is 2.25 inches long; Moonlight Bay Resort,
Rye, Victoria, Australia

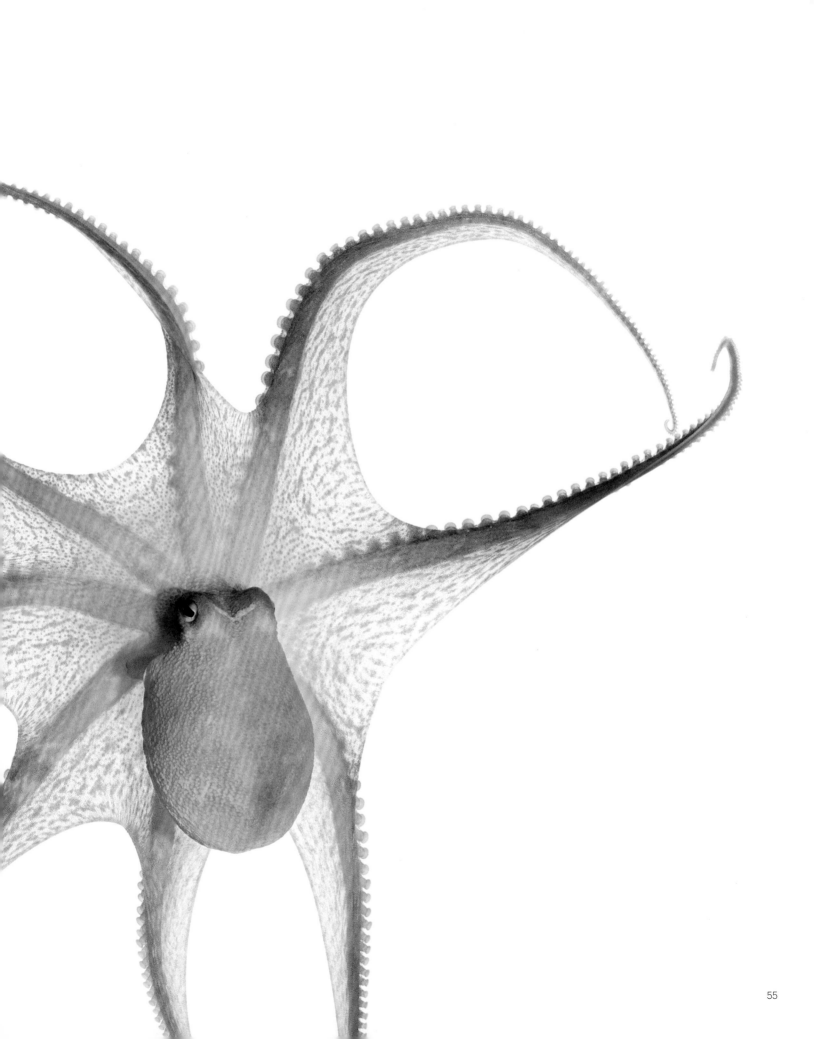

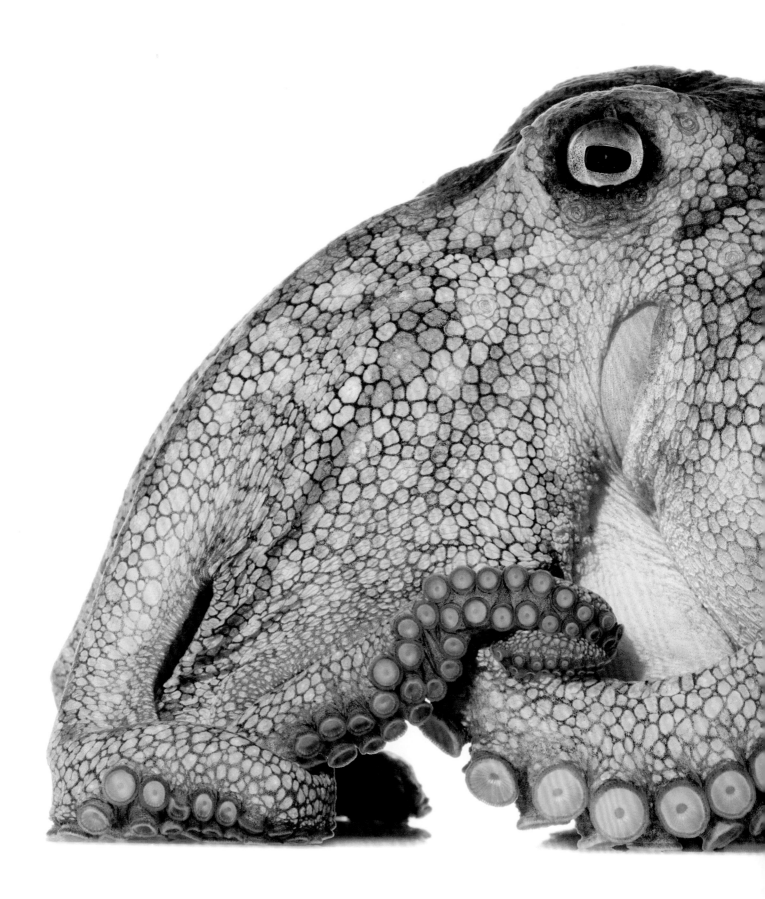

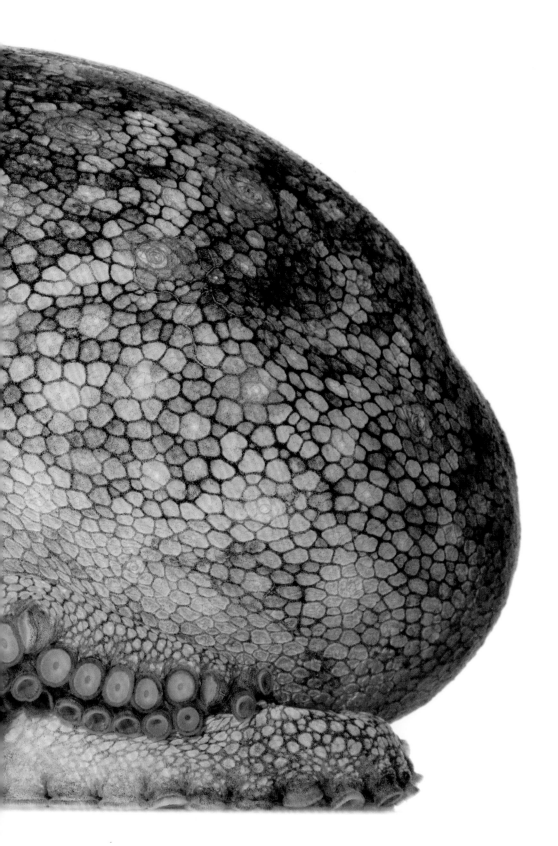

Pale Octopus
Octopus pallidus
Specimen #9; mantle is 4.5 inches long; Moonlight Bay Resort,
Rye, Victoria, Australia

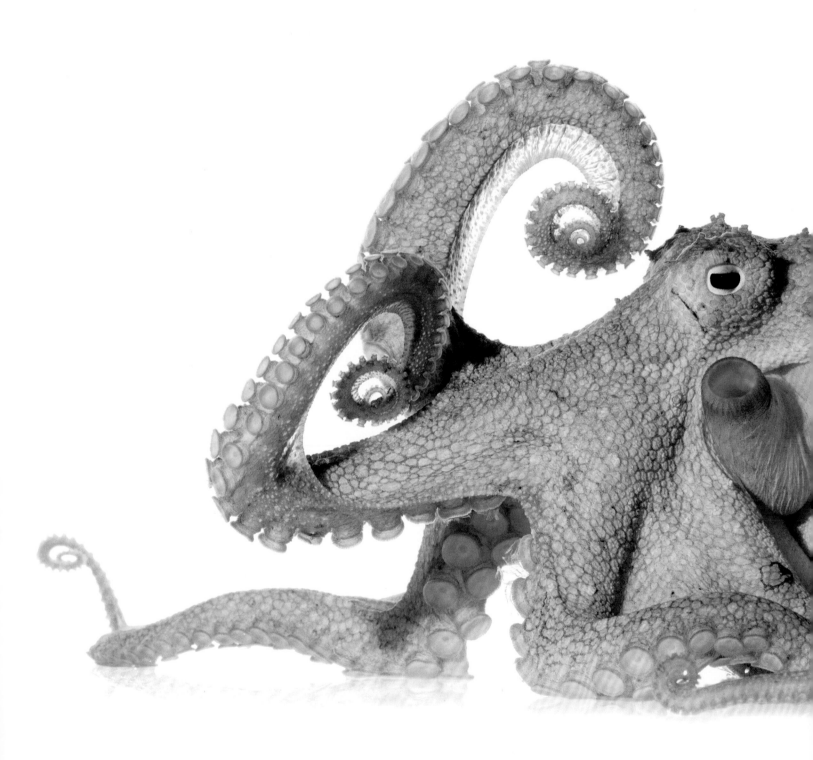

Pale Octopus
Octopus pallidus
Specimen #9; mantle is 4.5 inches long; Moonlight Bay Resort,
Rye, Victoria, Australia

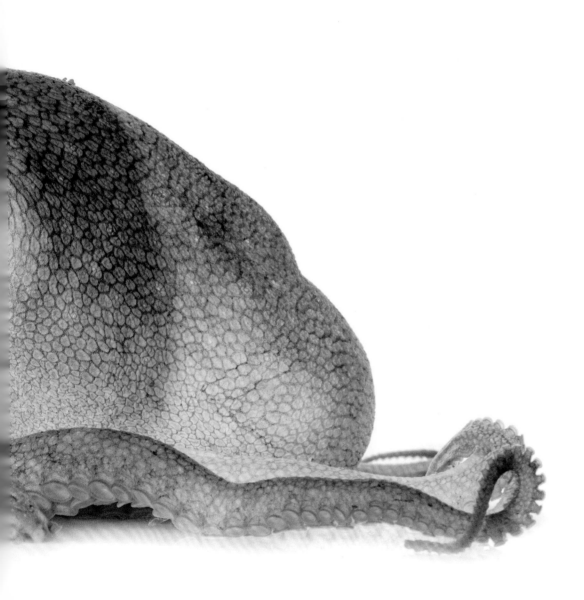

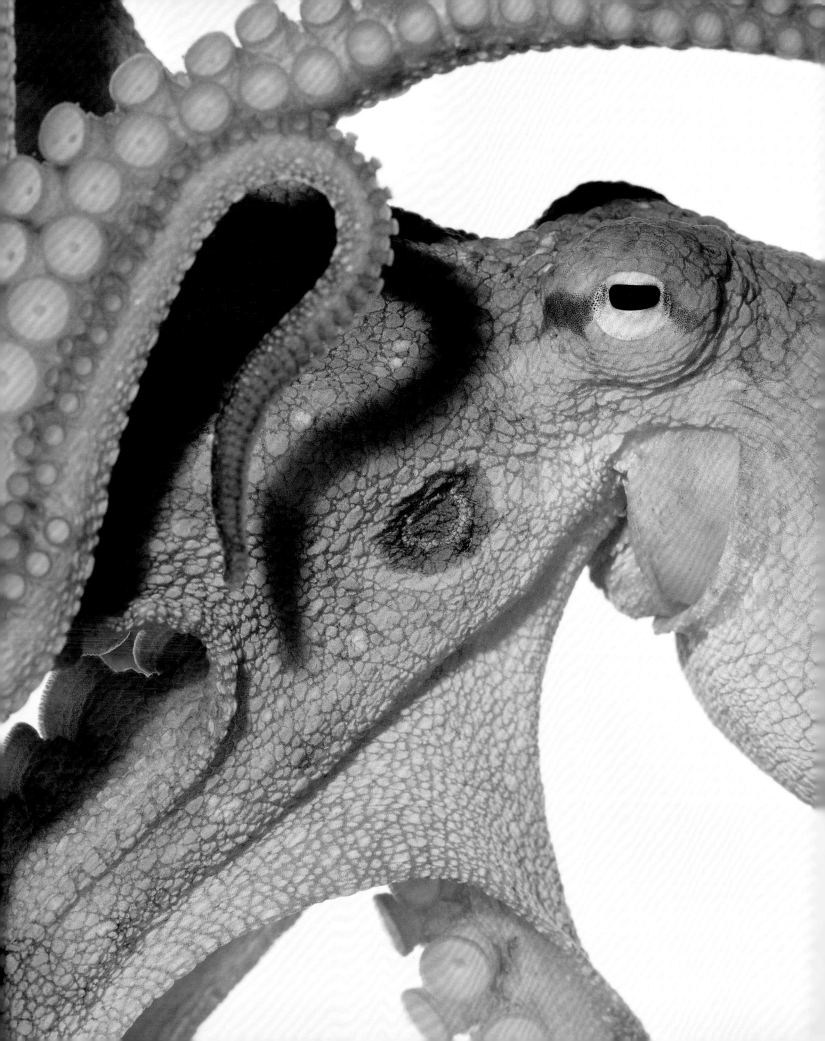

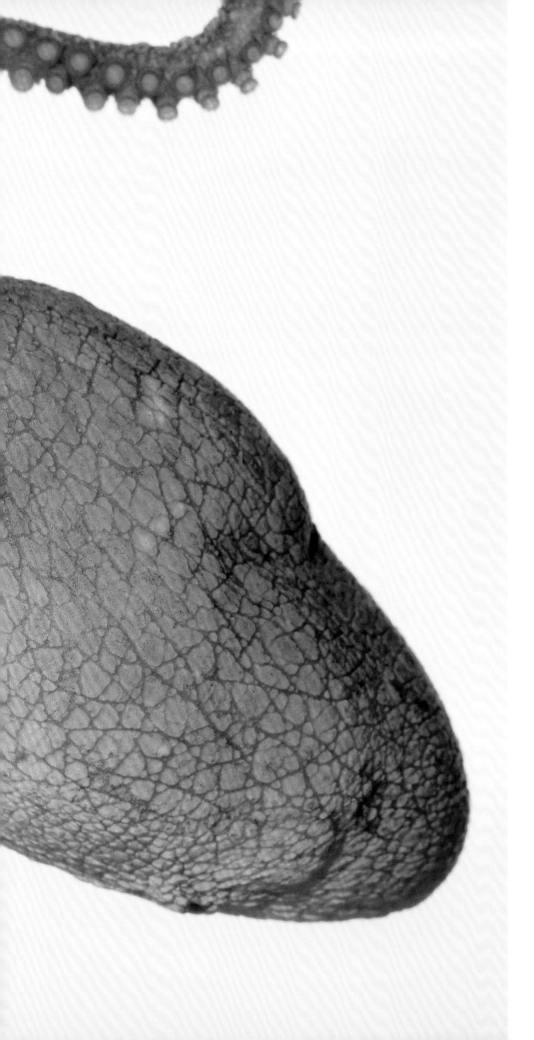

California Two-spot Octopus
Octopus bimaculoides
Specimen #18; mantle is 2.5 inches long; Oakley
Evolution Lab, University of California, Santa
Barbara, United States of America

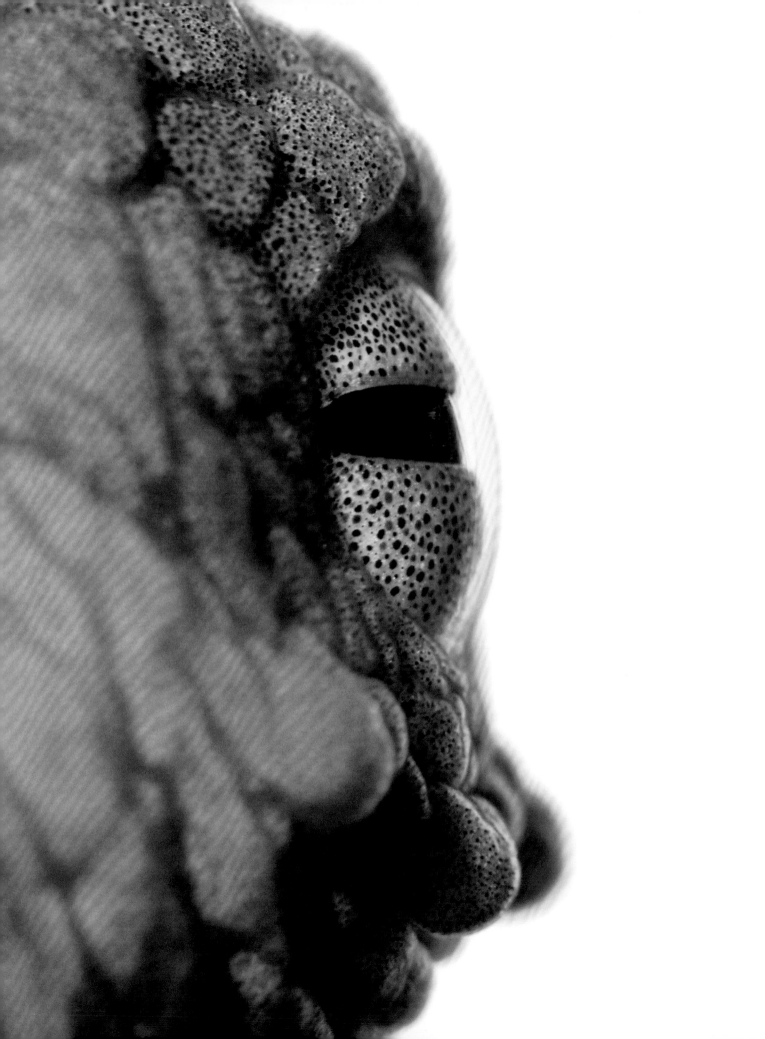

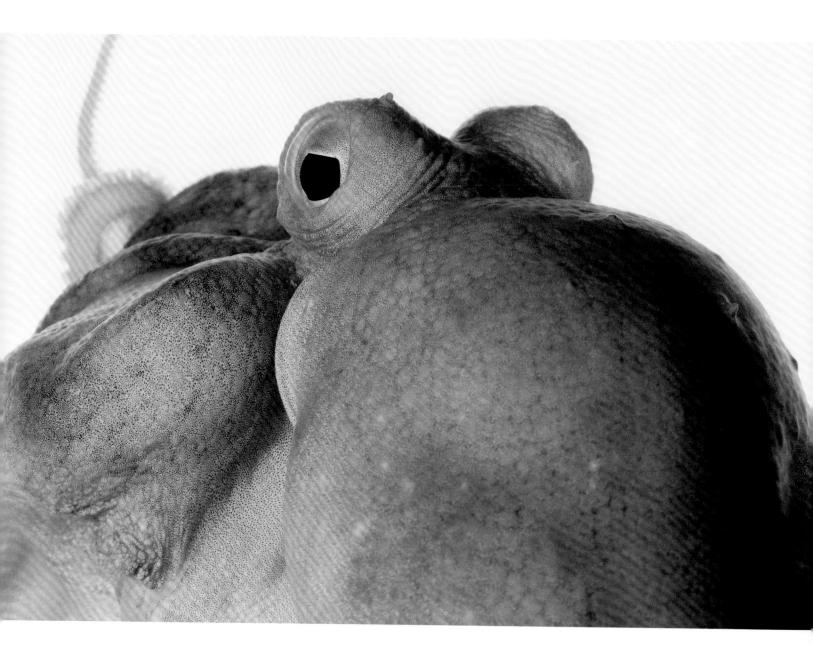

Common Octopus
Octopus vulgaris
Specimen #10; mantle is 3.5 inches long; Florida Keys Marine Life, Big Pine Key, Florida, United States of America

OPPOSITE

California Two-spot Octopus
Octopus bimaculoides
Specimen #18; mantle is 2.5 inches long; Oakley Evolution Lab, University of California, Santa Barbara,
United States of America

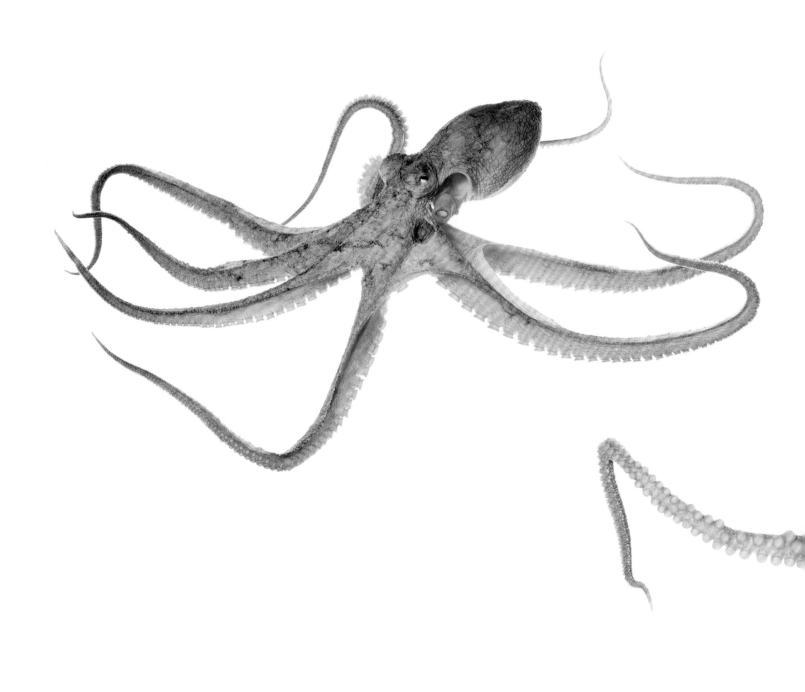

BOTH

California Two-spot Octopus

Octopus bimaculoides

Specimen #25; mantle is 2.5 inches long; Oakley Evolution Lab, University of California,
Santa Barbara, United States of America

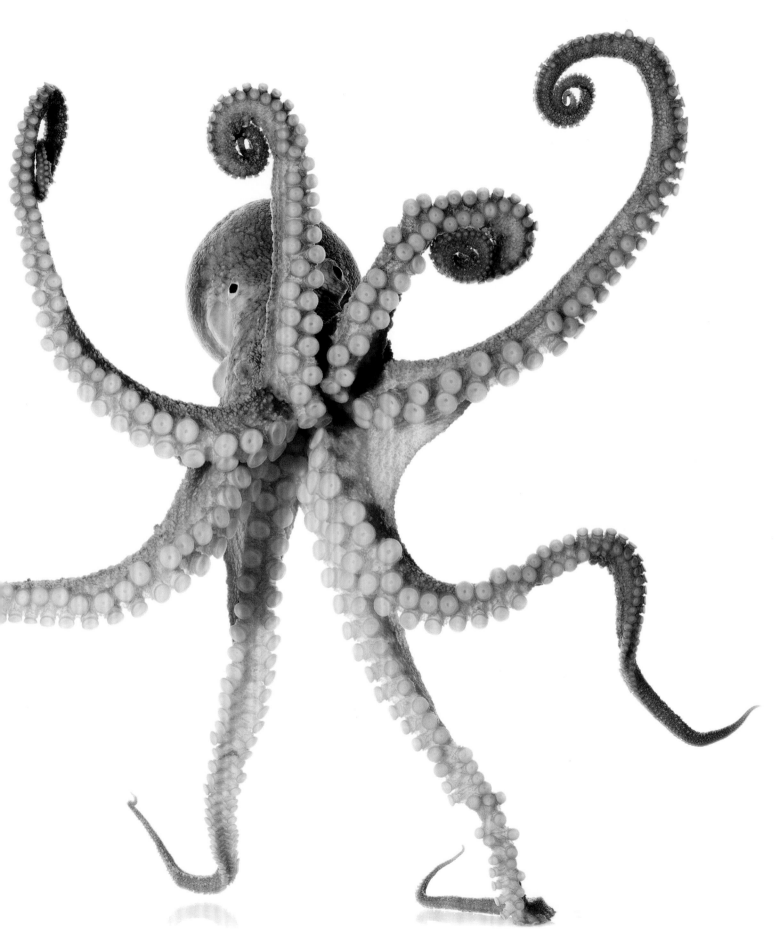

Common Octopus
Octopus vulgaris
Specimen #12; mantle is 3.5 inches long; Florida
Keys Marine Life, Big Pine Key, Florida, United
States of America

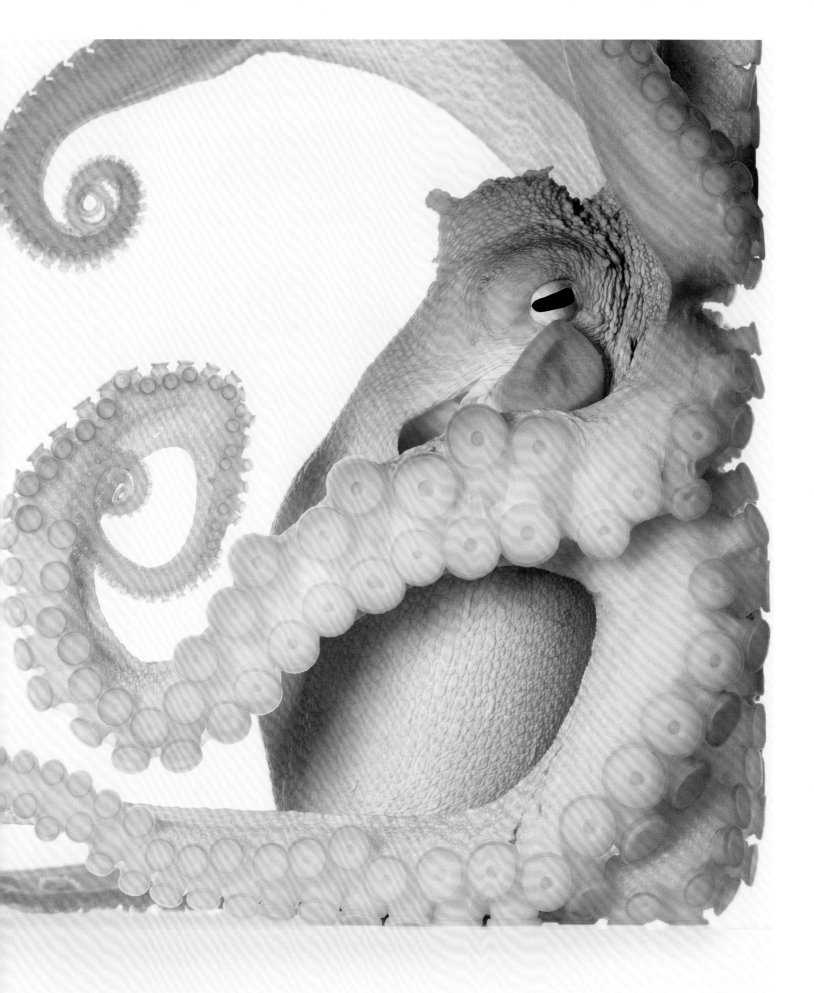

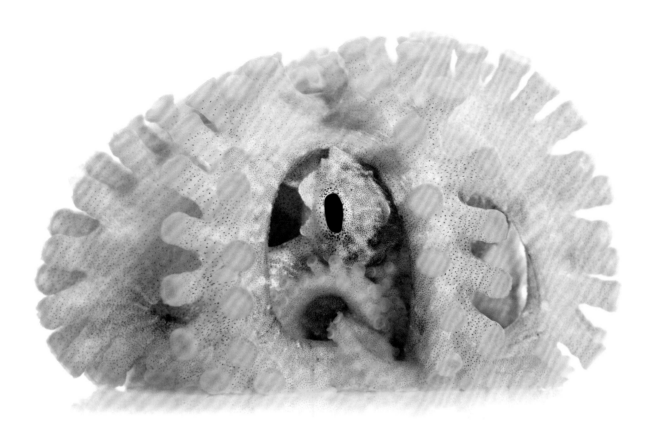

Atlantic Pygmy Octopus
Octopus joubini
Specimen #14; mantle is 1 inch long; Dynasty Marine Associates, Marathon, Florida, United States of America

FOLLOWING PAGES

Octopus with eggs
Undescribed species
Specimen #19; frame is 1.5 inches across; new species from the Pacific side of Nicaragua; Caldwell Lab,
Department of Integrative Biology, University of California, Berkeley, United States of America

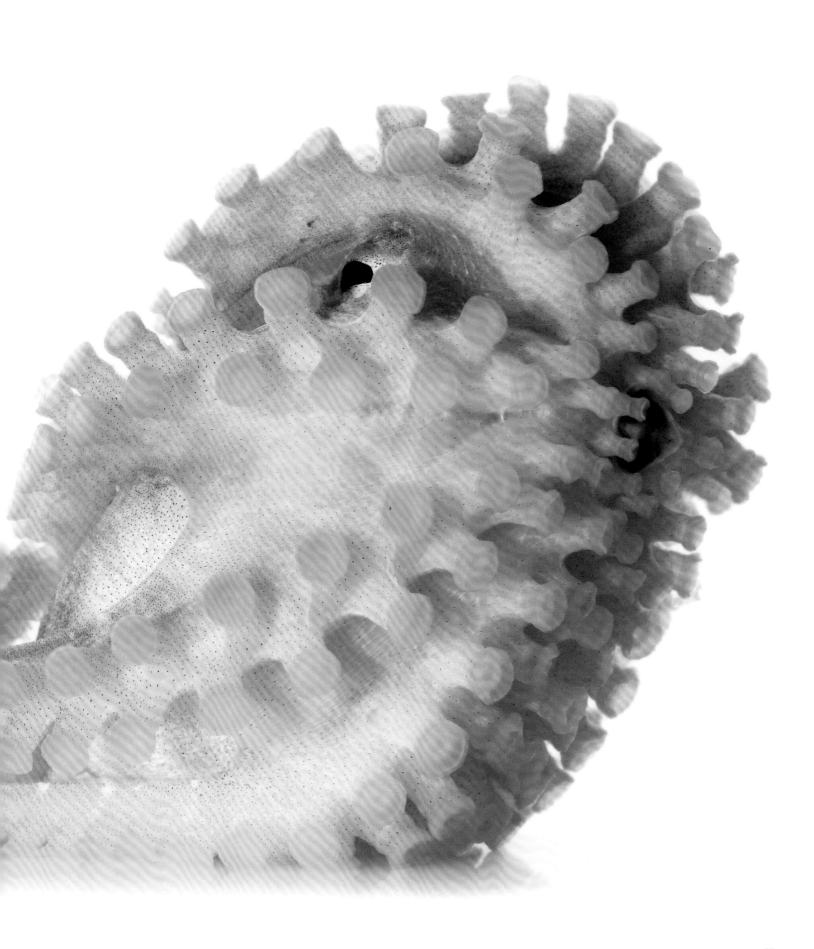

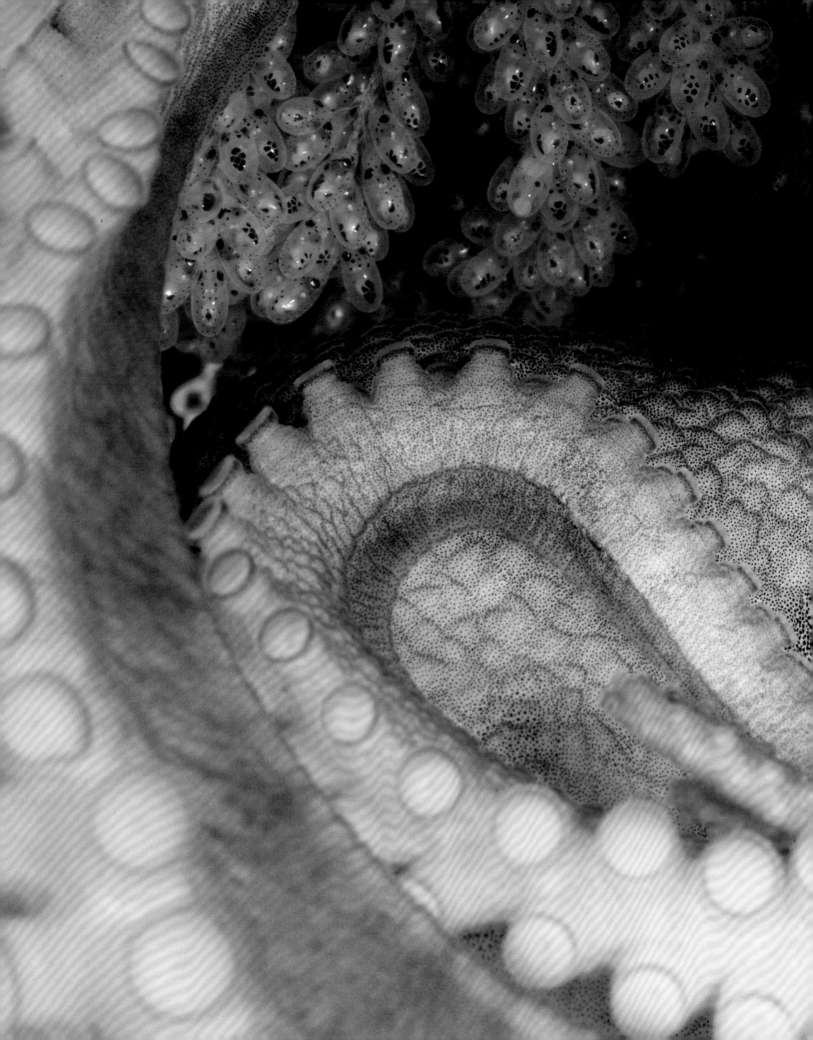

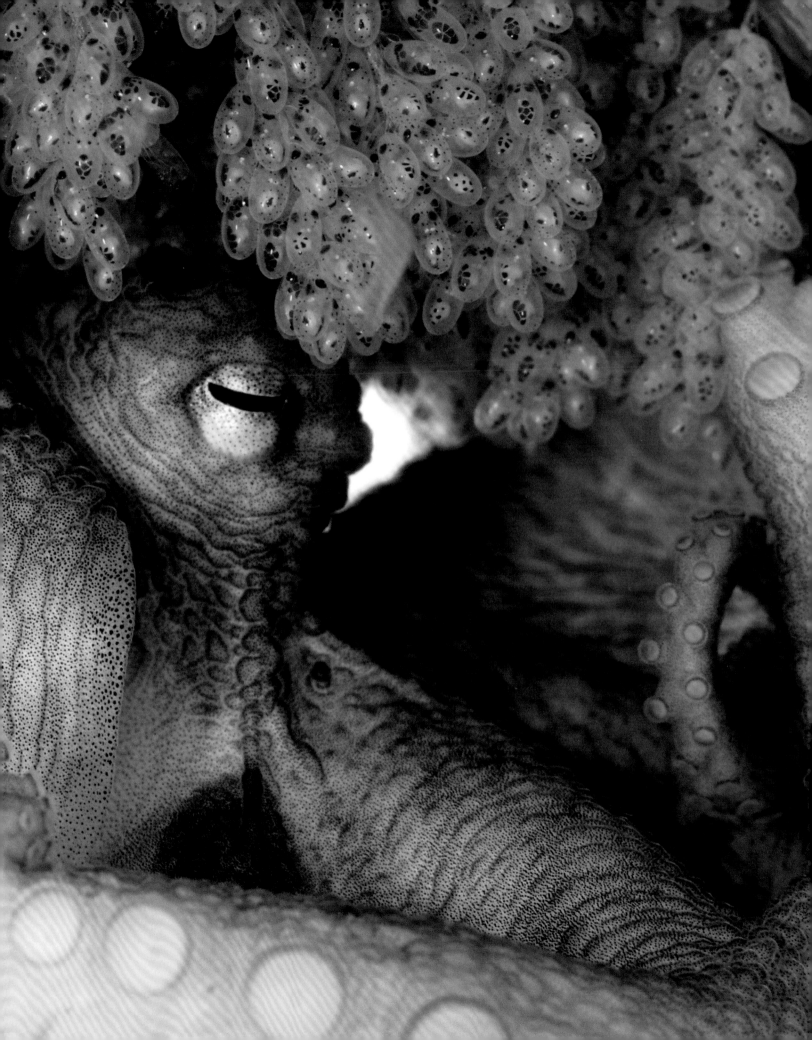

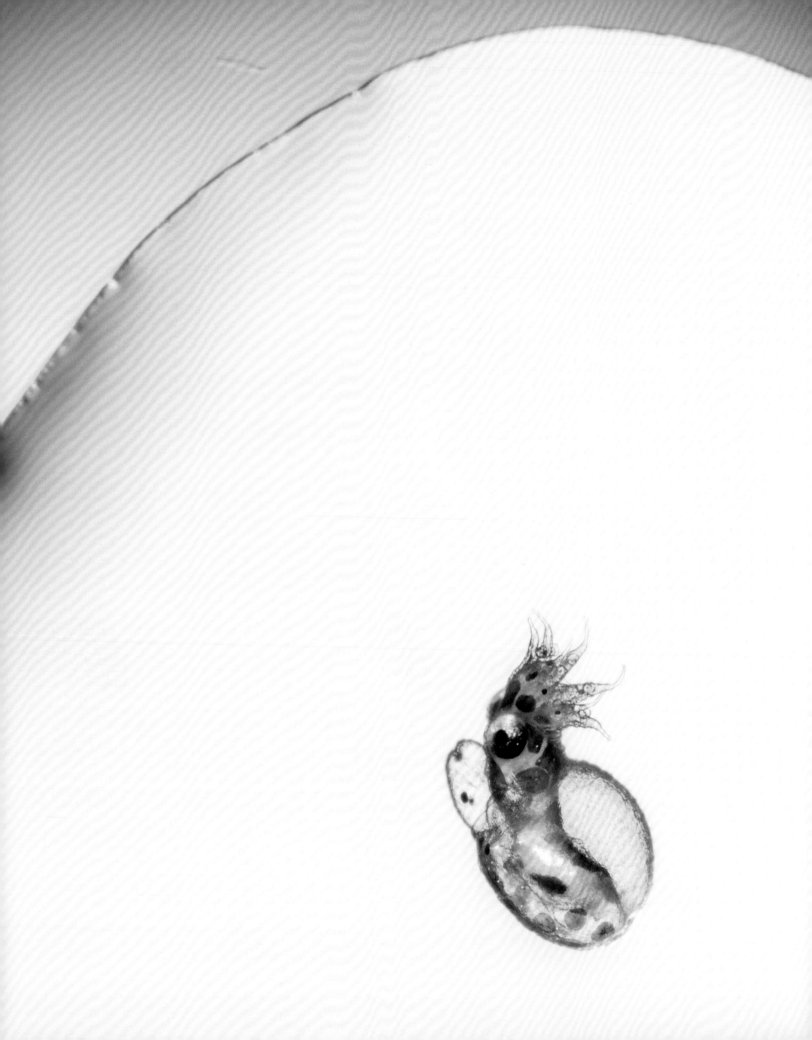

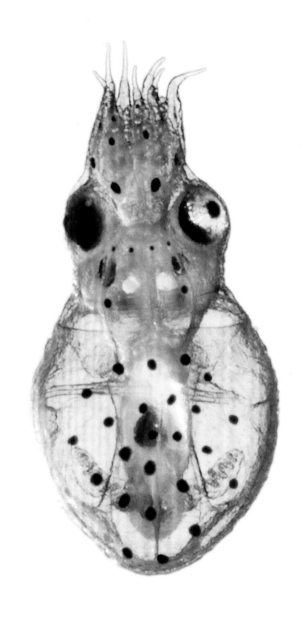

BOTH

Octopus hatchling

Undescribed species

Hatched from Specimen #19; less than 0.125 inch long; less than a day old; Caldwell Lab,
Department of Integrative Biology, University of California, Berkeley, United States of America

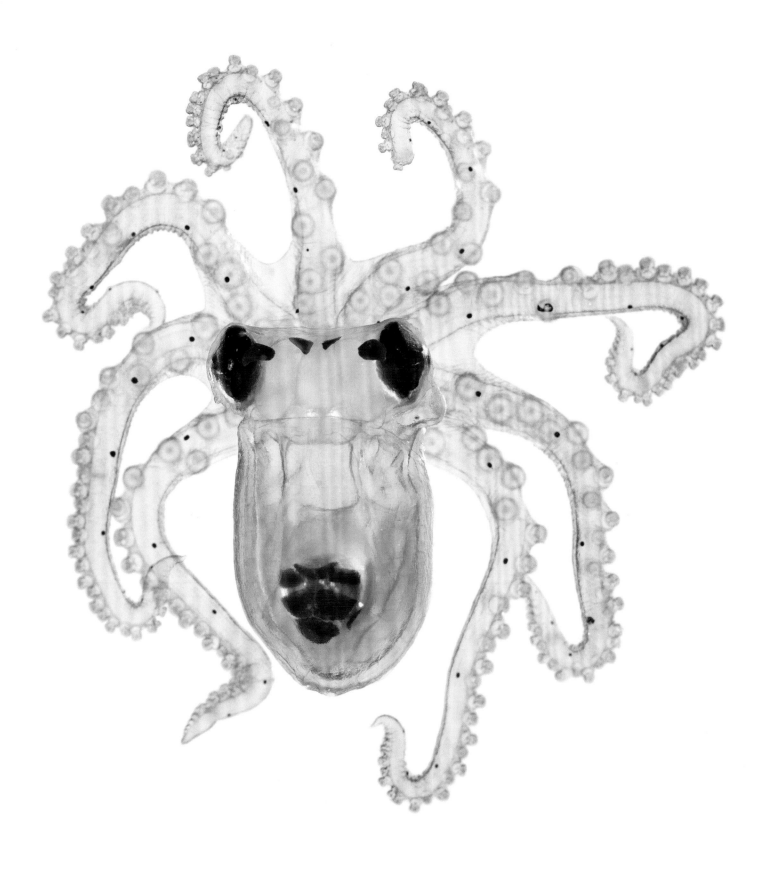

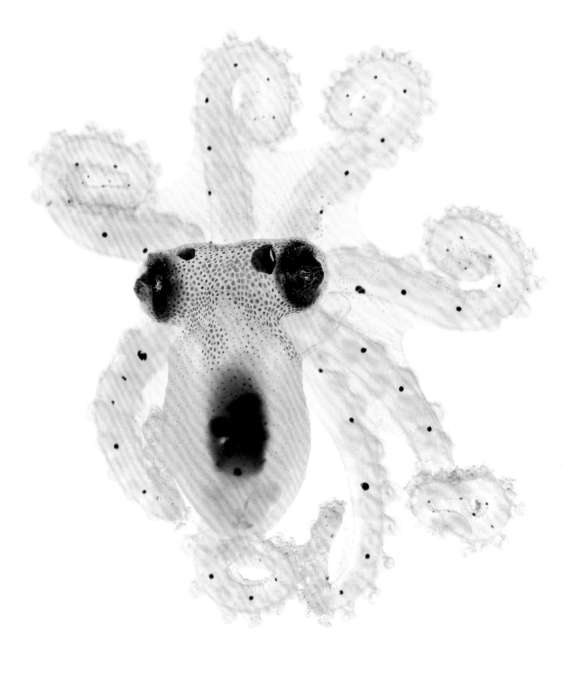

Bock's Pygmy Octopus
Octopus bocki
Specimen #52; 0.5 inch across; Dive Gizo, Ghizo Island, Solomon Islands

OPPOSITE

Post-larval octopus
Octopus sp.
Specimen #29; 0.5 inch across; Richard B. Gump South Pacific Research Station,
University of California, Berkeley, Moorea, French Polynesia

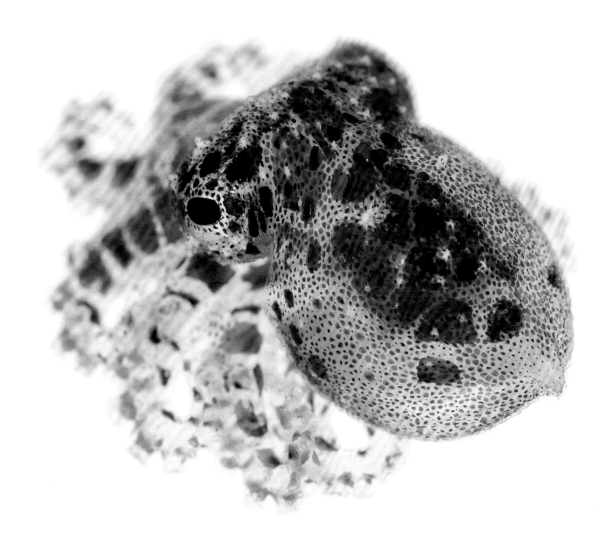

BOTH

Star-sucker Pygmy Octopus

Octopus wolfi

Specimen #46; mantle is 0.25 inch long; Dive Gizo, Ghizo Island, Solomon Islands

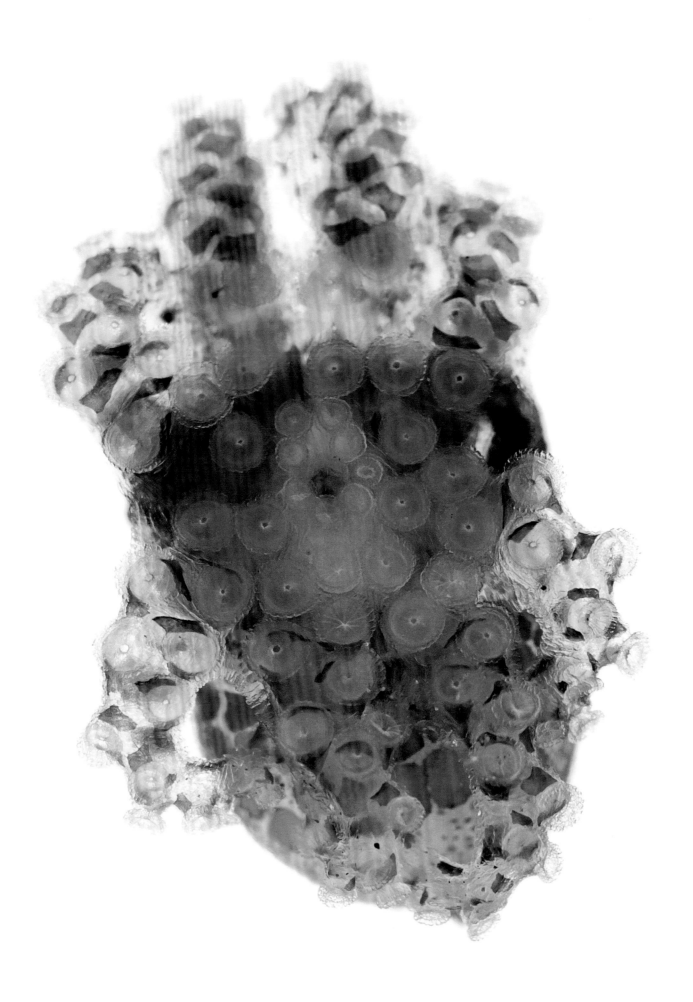

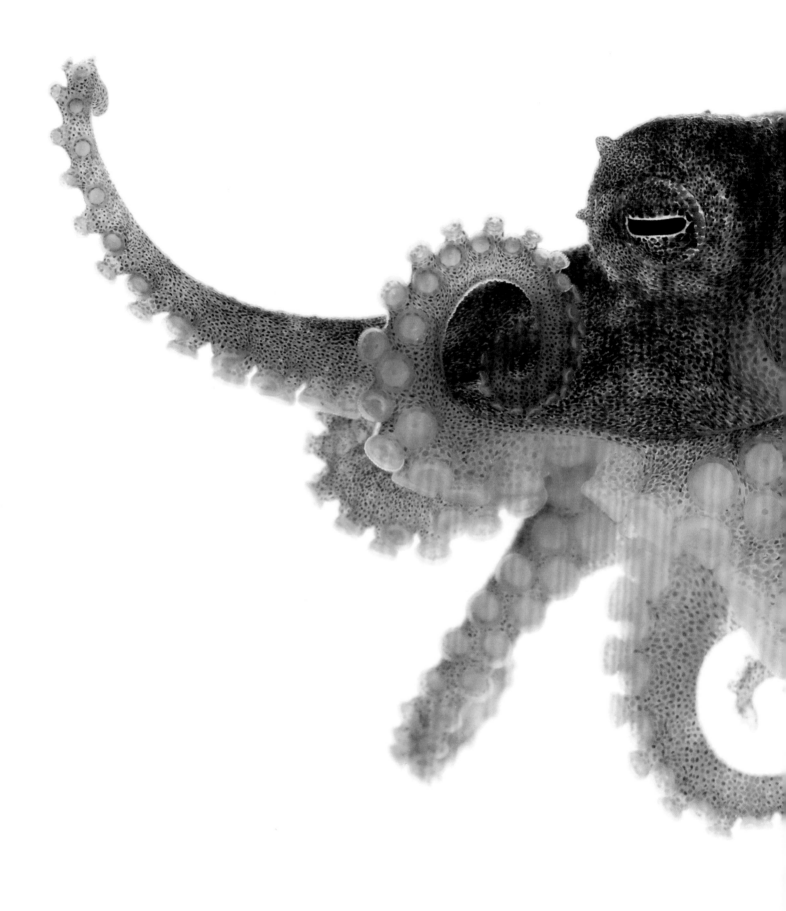

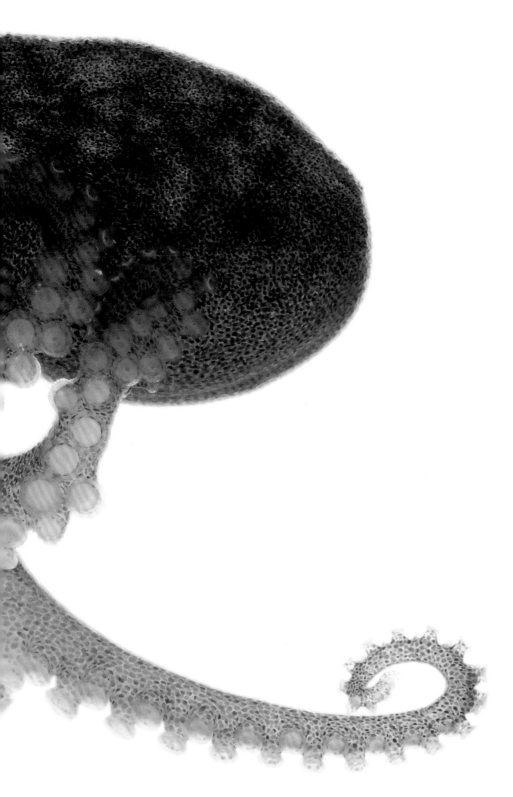

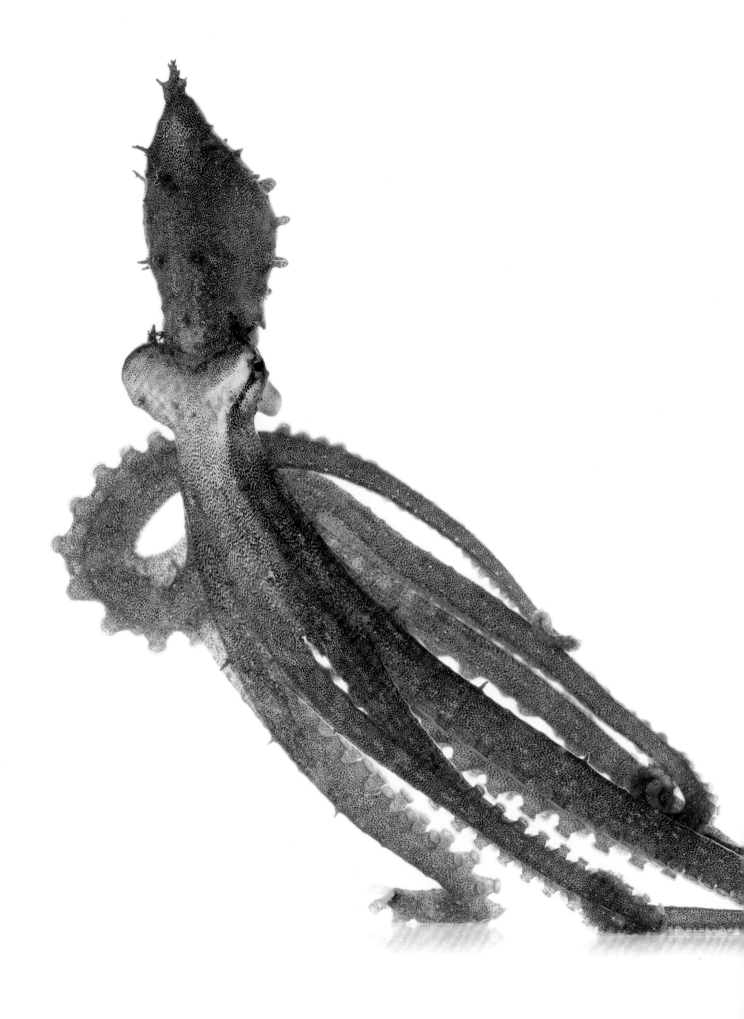

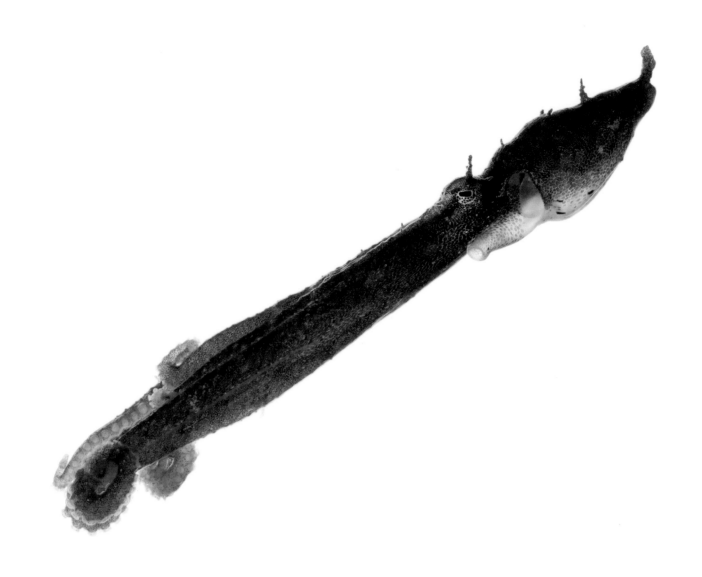

Mosaic Drop-arm Octopus
Abdopus abaculus
Specimen #37; female; mantle is 0.625 inch long; Dive Gizo,
Ghizo Island, Solomon Islands

LEFT

Algae Octopus
Abdopus aculeatus
Specimen #39; female; mantle is 0.625 inch long; Dive Gizo,
Ghizo Island, Solomon Islands

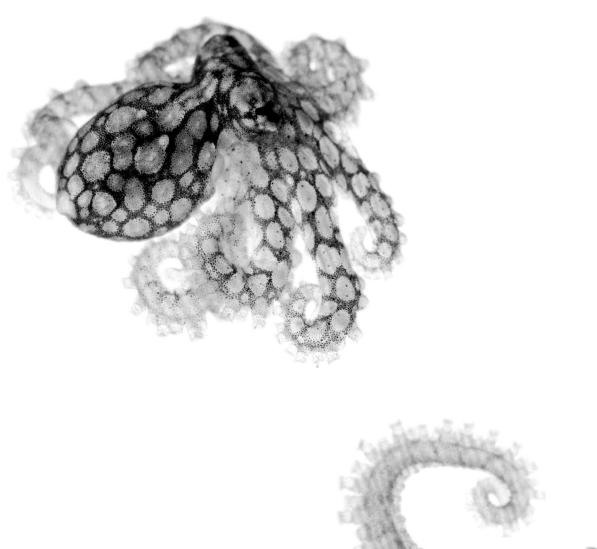

BOTH
Octopus gorgonus
Above: specimen #53; mantle is 0.25 inch long
Right: specimen #56; mantle is 0.375 inch long
Dive Gizo, Ghizo Island, Solomon Islands

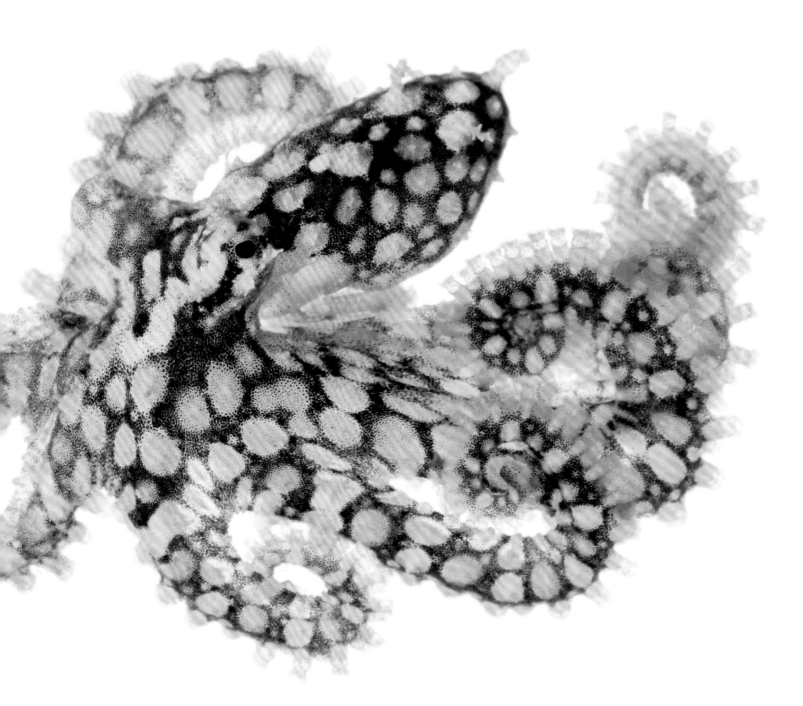

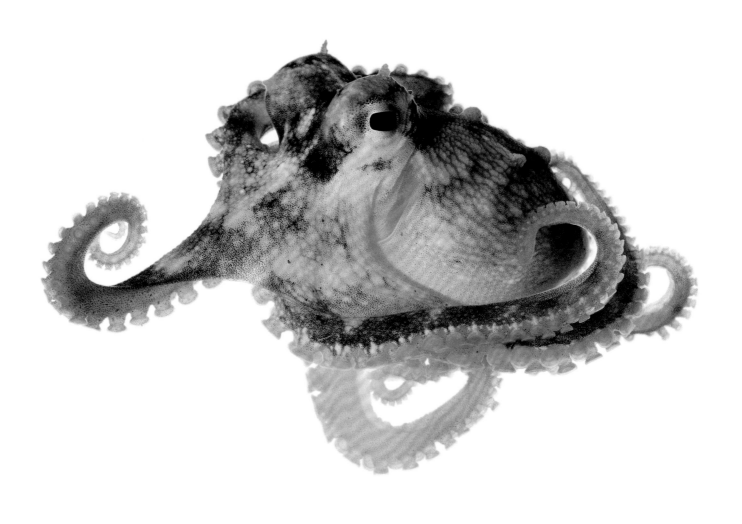

BOTH

Sand Bird Octopus

Amphioctopus aegina

Specimen #44; female; mantle is 1 inch long; Dive Gizo, Ghizo Island, Solomon Islands

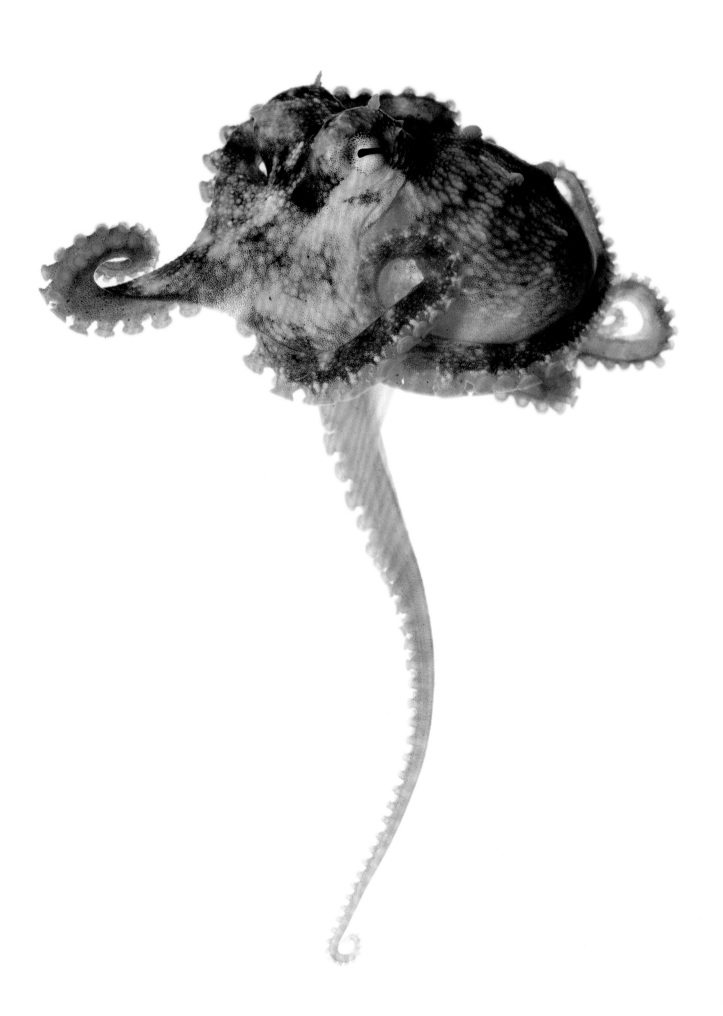

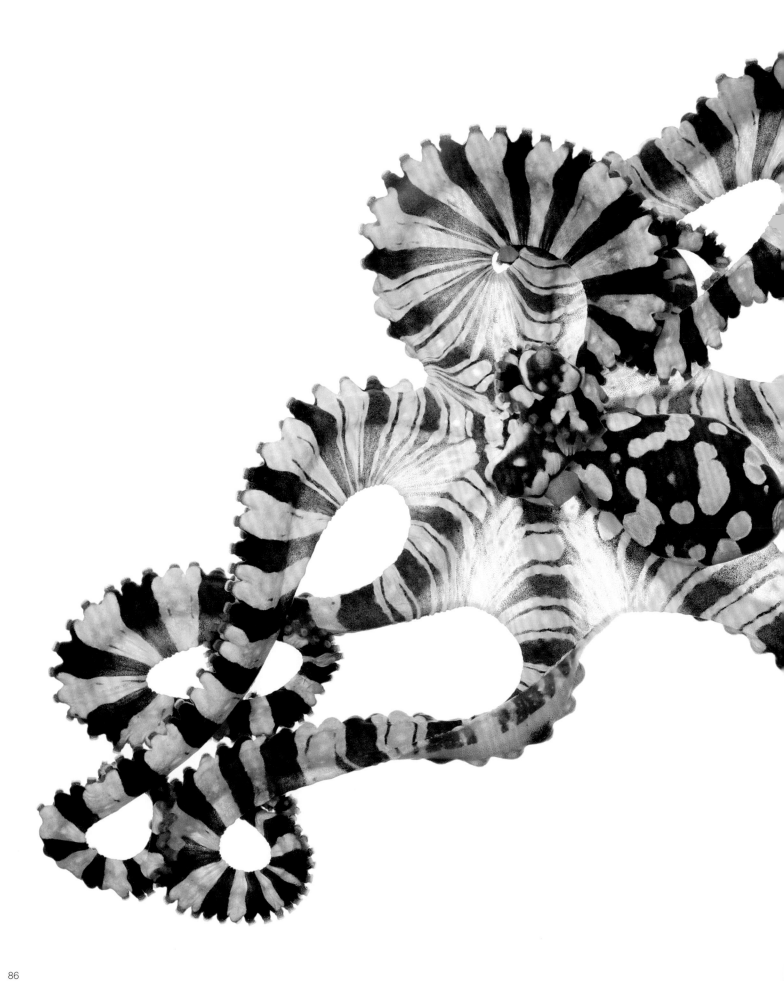

Wonderpus Octopus
Wunderpus photogenicus
Specimen #21; male; mantle is 0.625 inch long; Caldwell Lab, Department of
Integrative Biology, University of California, Berkeley, United States of America

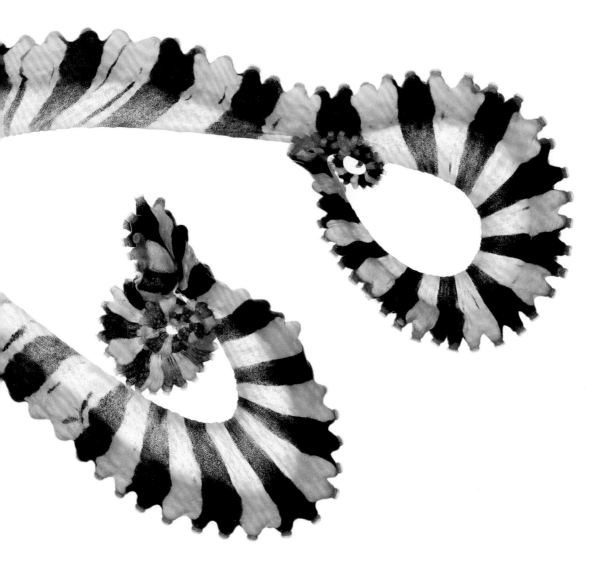

Algae Octopus

Abdopus aculeatus

Specimen #41; gravid female; mantle is 2 inches long; Dive Gizo,
Ghizo Island, Solomon Islands

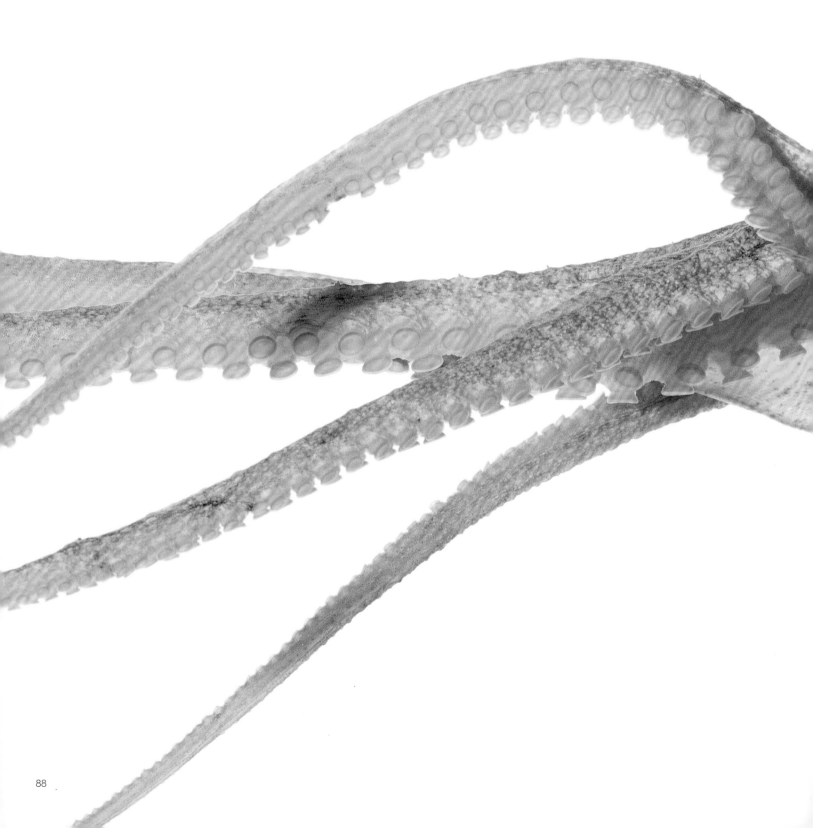

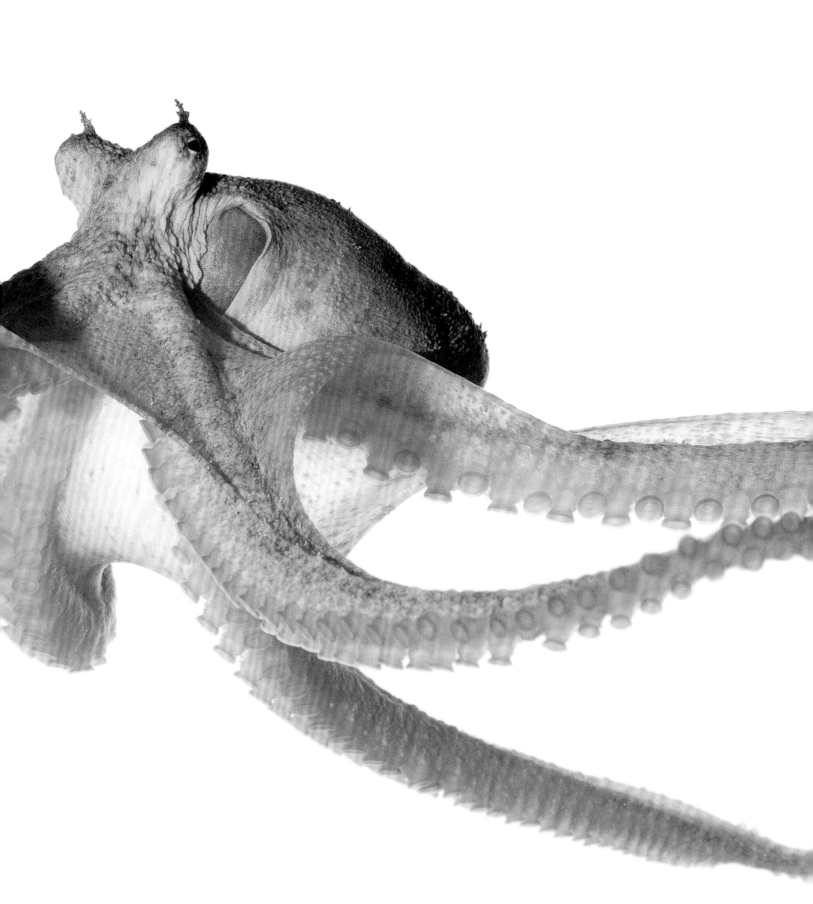

Algae Octopus

Abdopus aculeatus

Specimen #41; gravid female; mantle is 2 inches long; Dive Gizo,
Ghizo Island, Solomon Islands

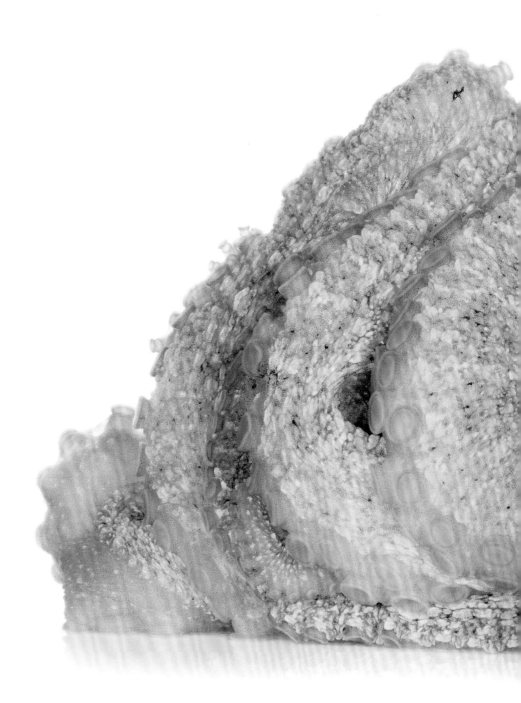

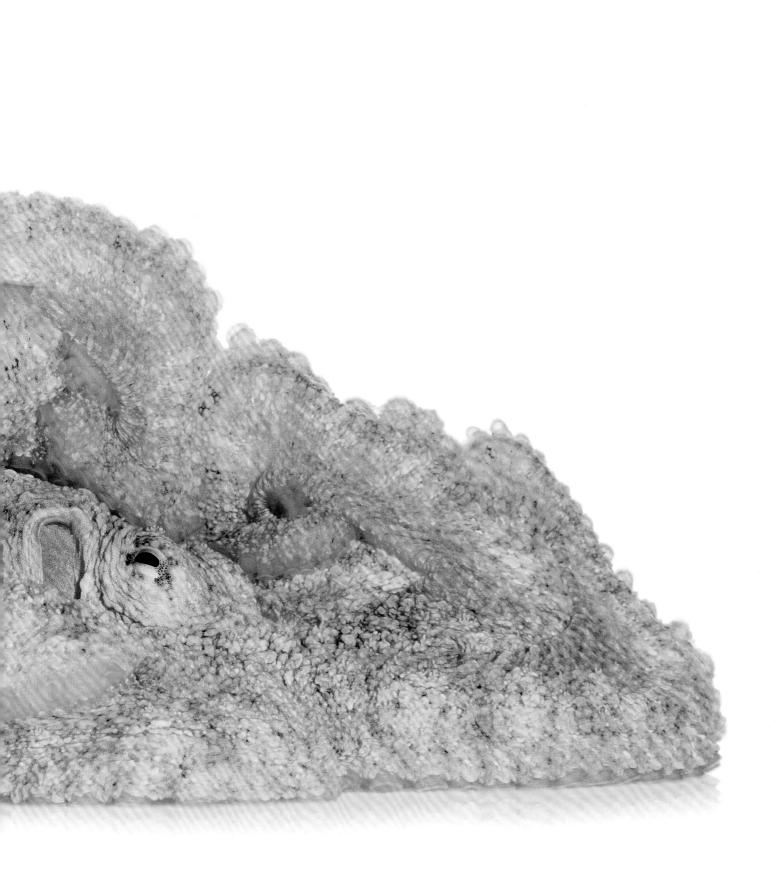

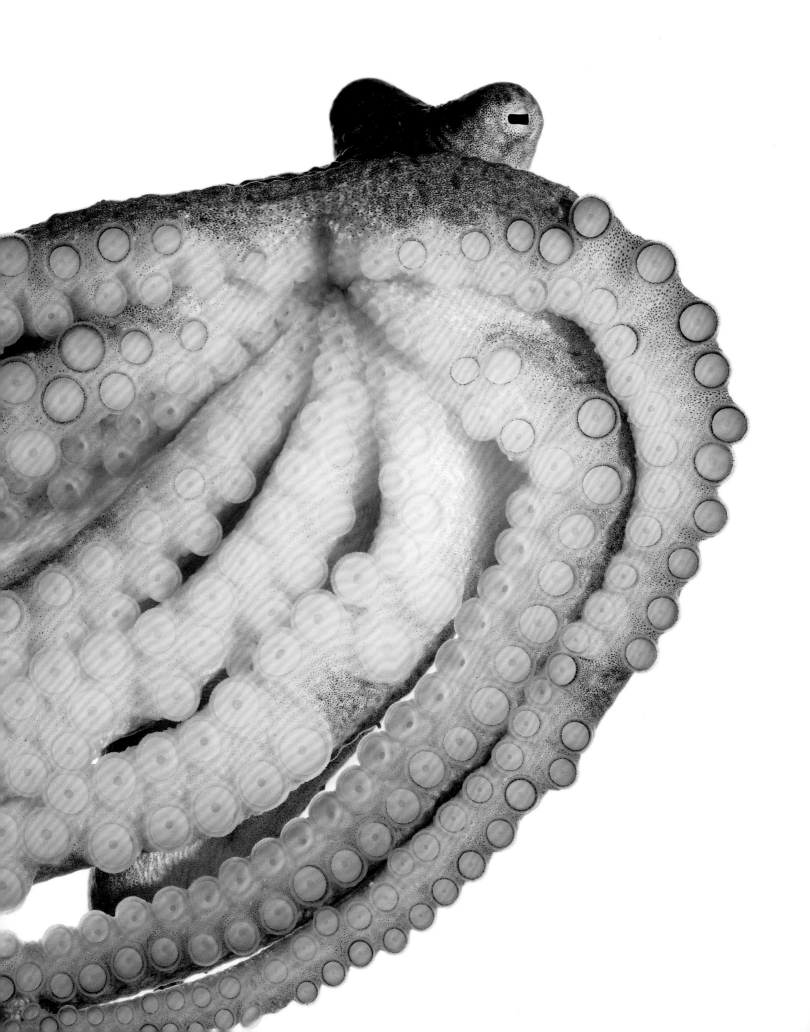

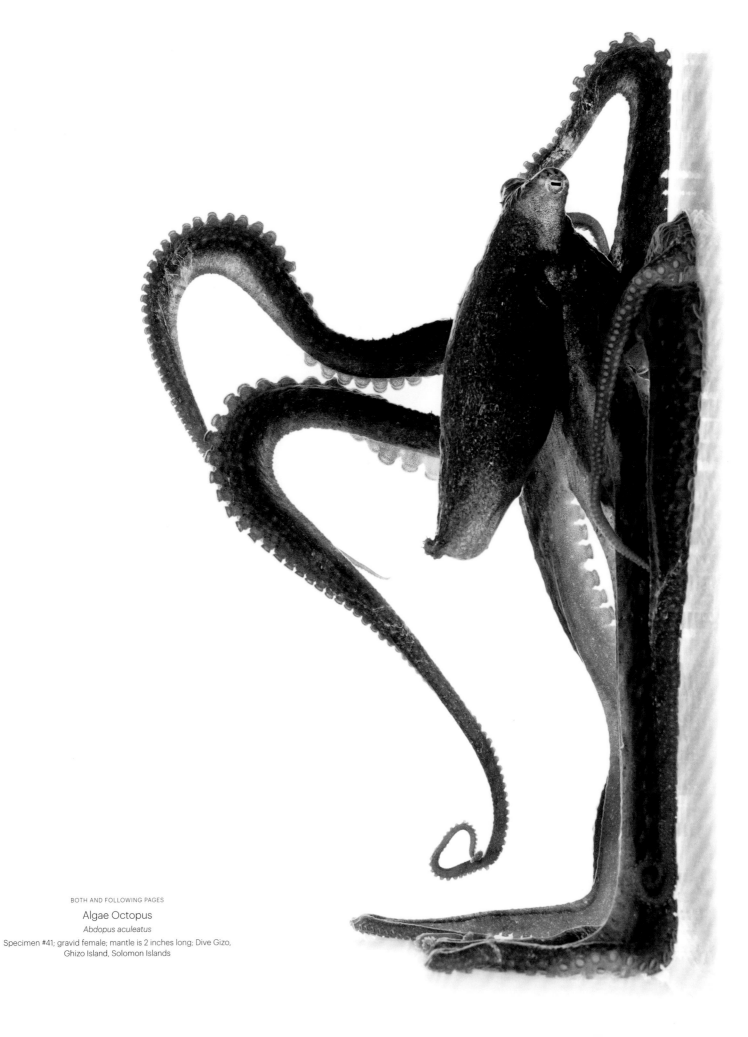

BOTH AND FOLLOWING PAGES

Algae Octopus

Abdopus aculeatus

Specimen #41; gravid female; mantle is 2 inches long; Dive Gizo,
Ghizo Island, Solomon Islands

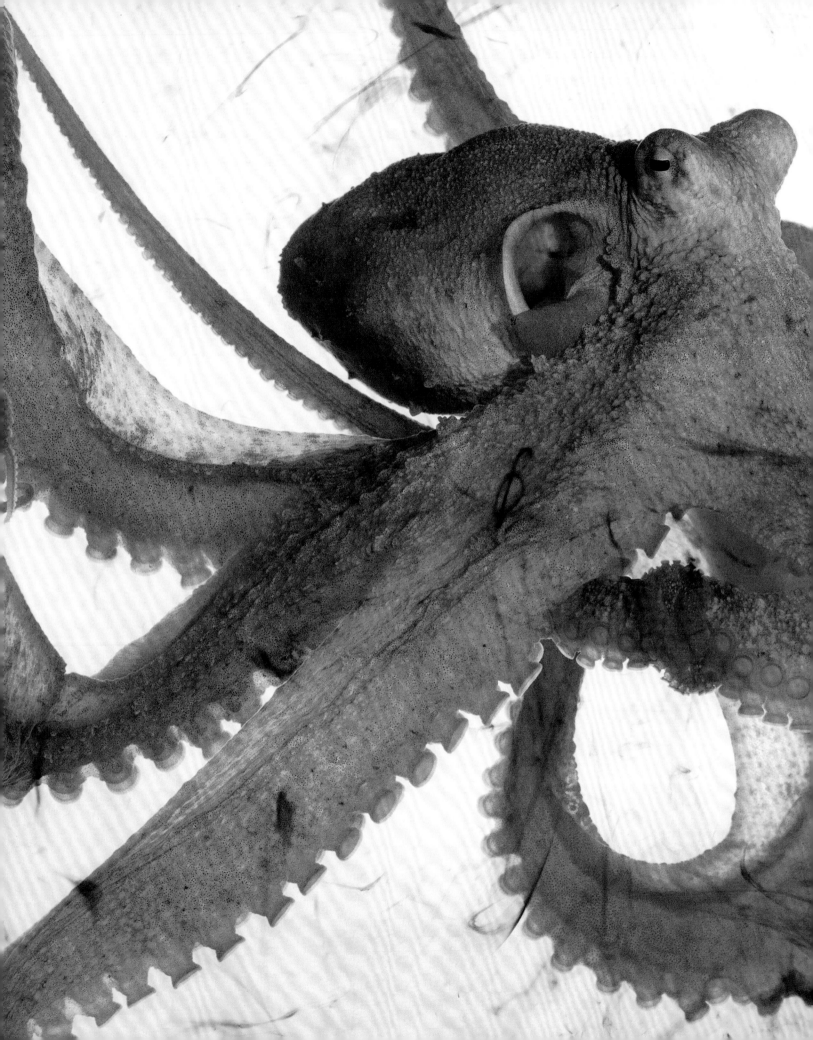

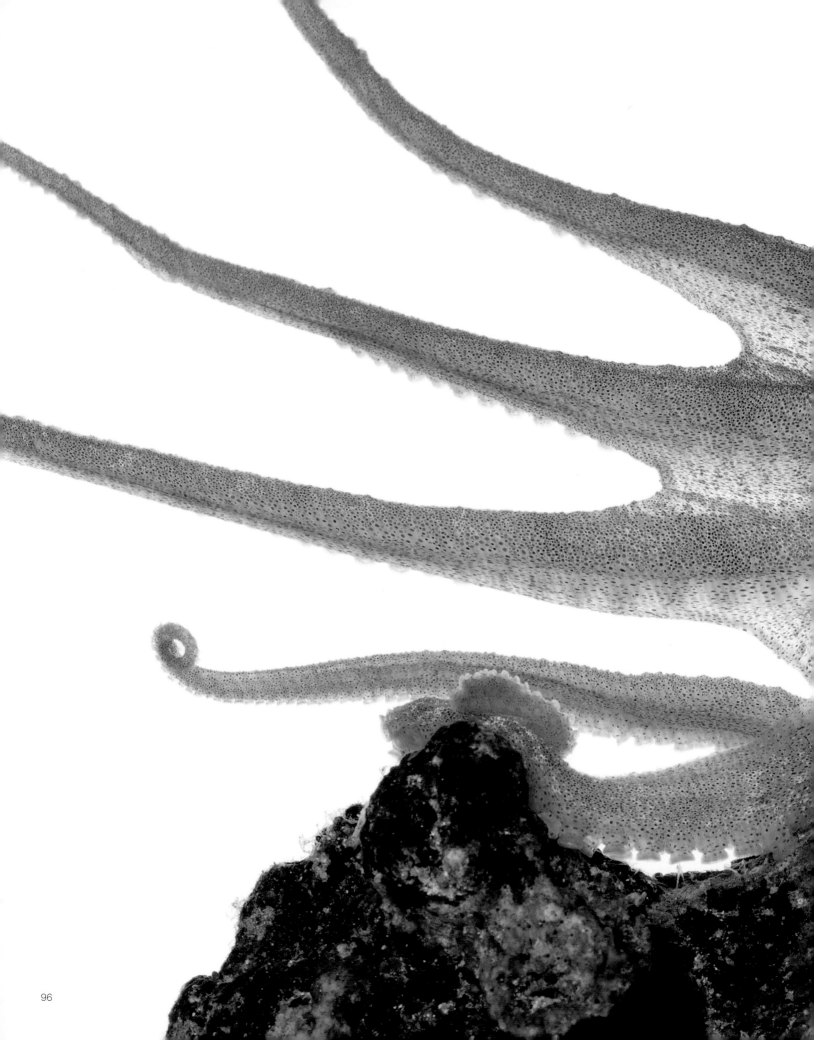

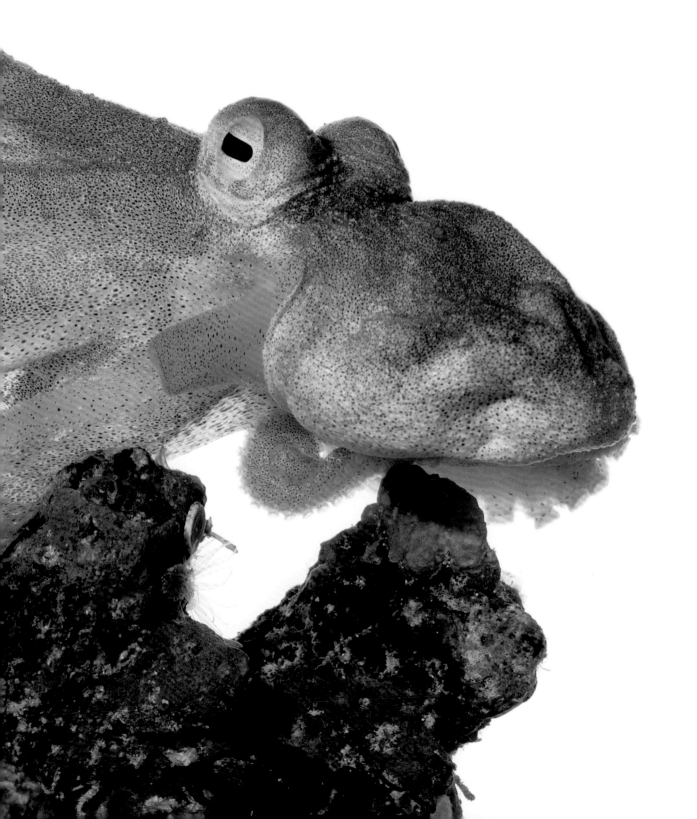

97

Long-armed Sand Octopus
Thaumoctopus sp.
Specimen #49; mantle is about 1 inch long; Dive Gizo,
Ghizo Island, Solomon Islands

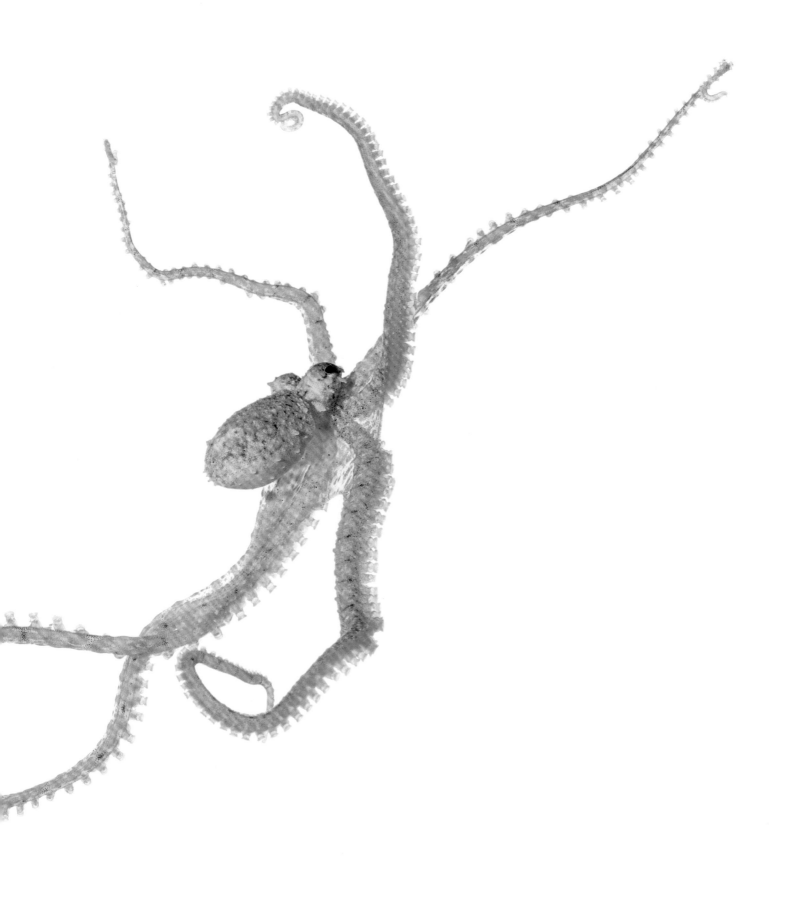

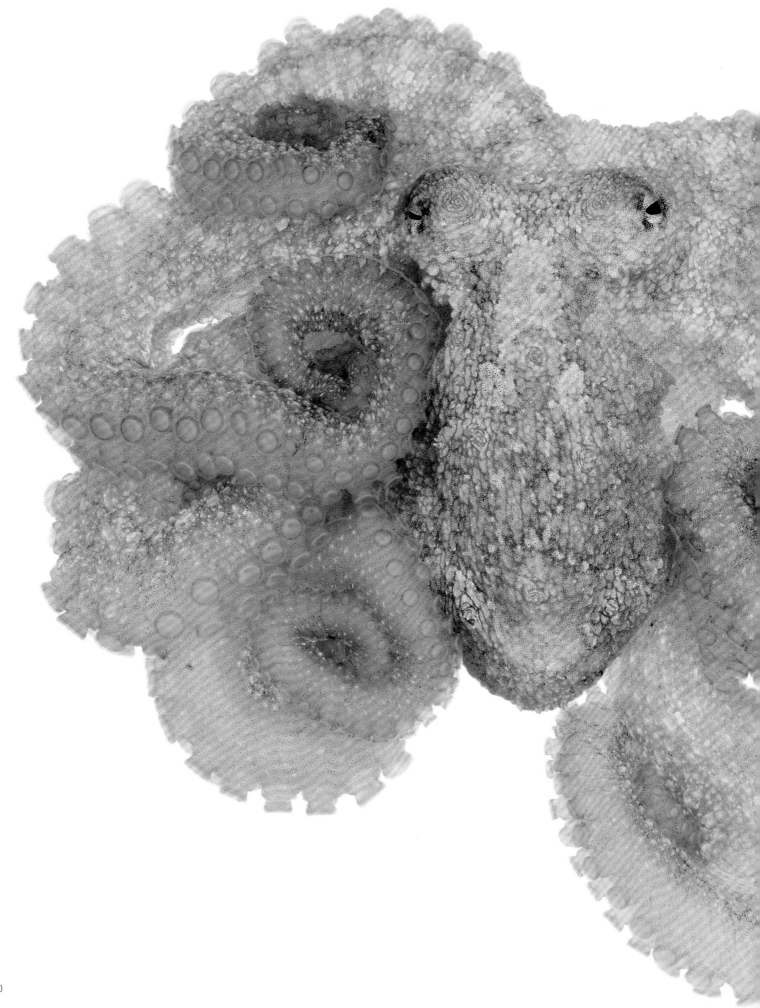

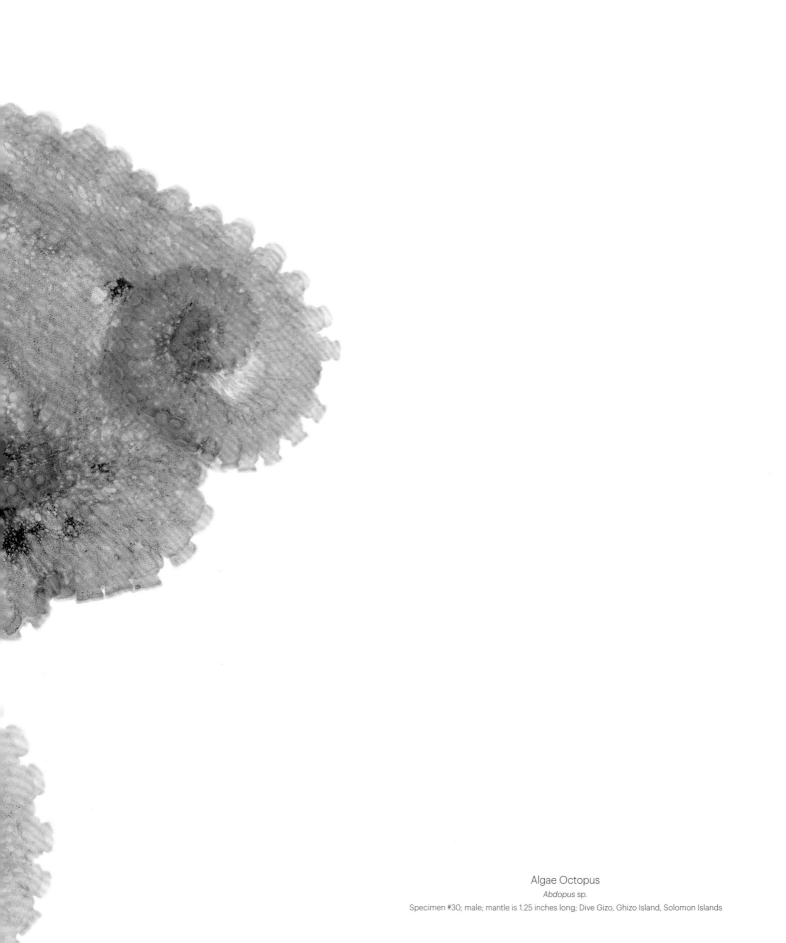

Algae Octopus
Abdopus sp.
Specimen #30; male; mantle is 1.25 inches long; Dive Gizo, Ghizo Island, Solomon Islands

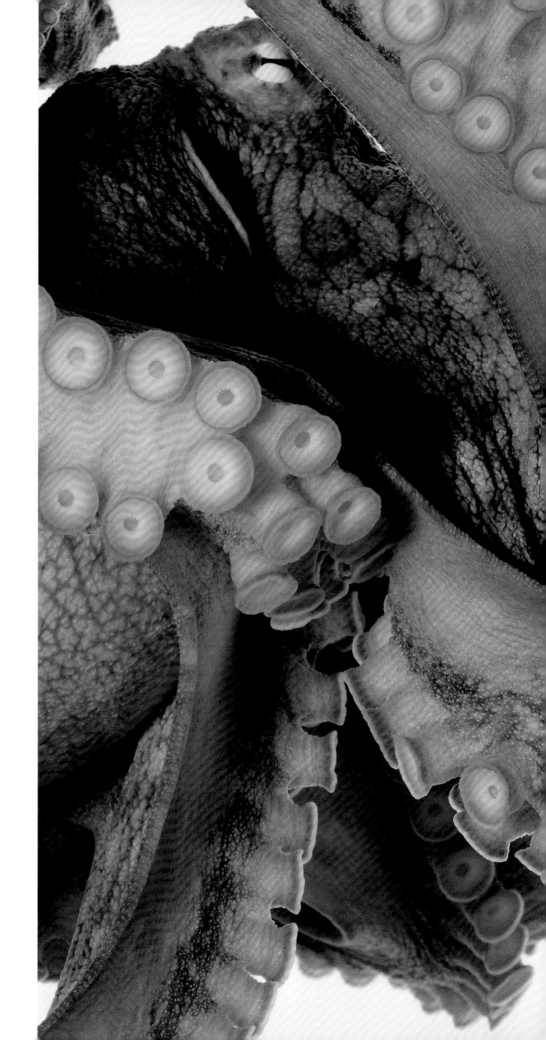

Day Octopus

Octopus cyanea

Specimen #6; mantle is 5 inches long;
Honokohau Harbor, Kailua-Kona, Hawaii,
United States of America

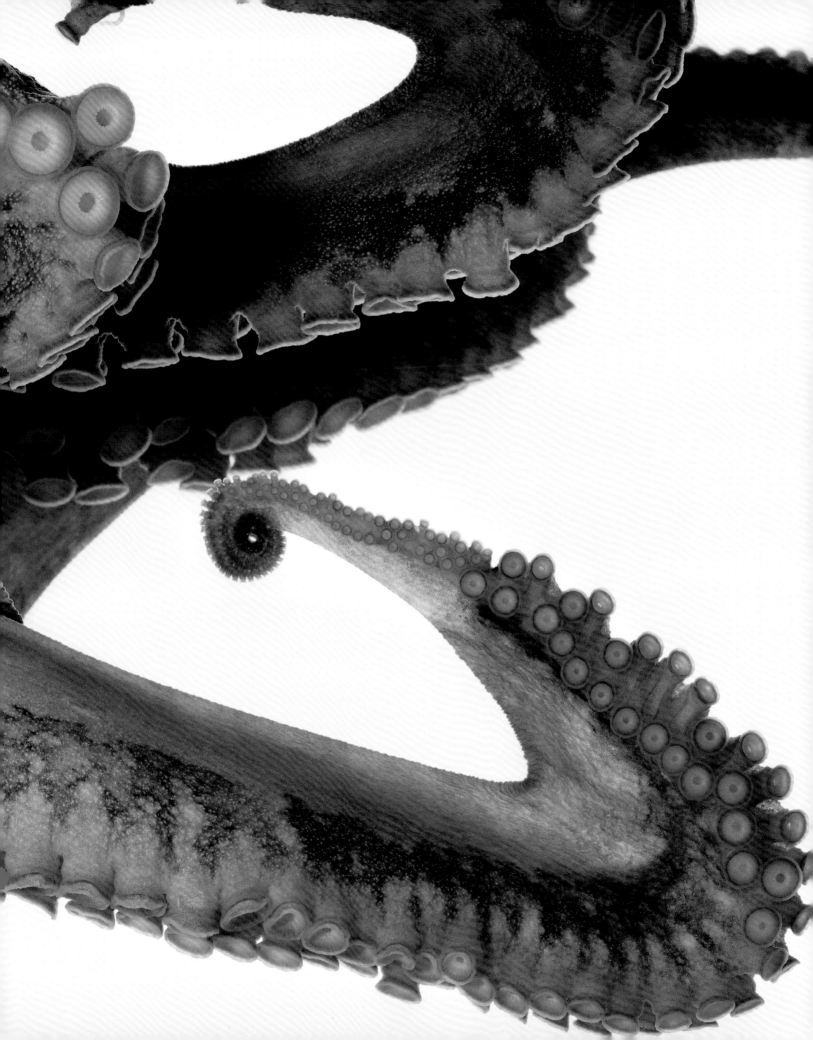

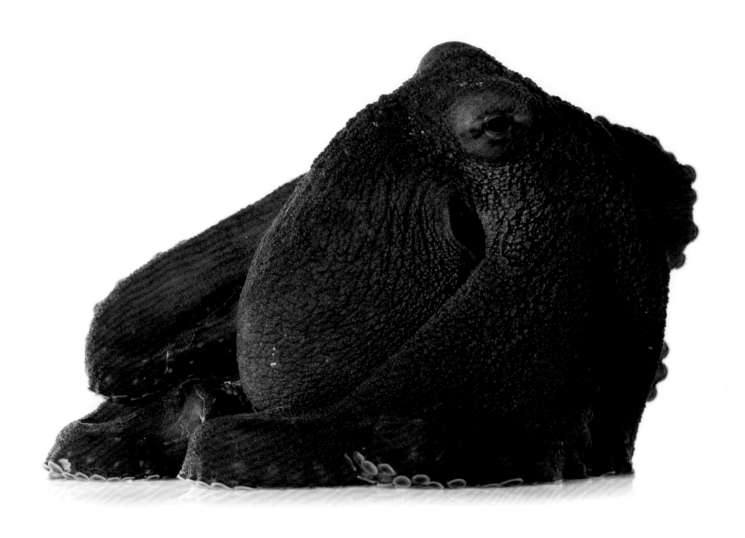

Day Octopus
Octopus cyanea
Specimen #29; female; mantle is 2 inches long; Dive Gizo, Ghizo Island, Solomon Islands

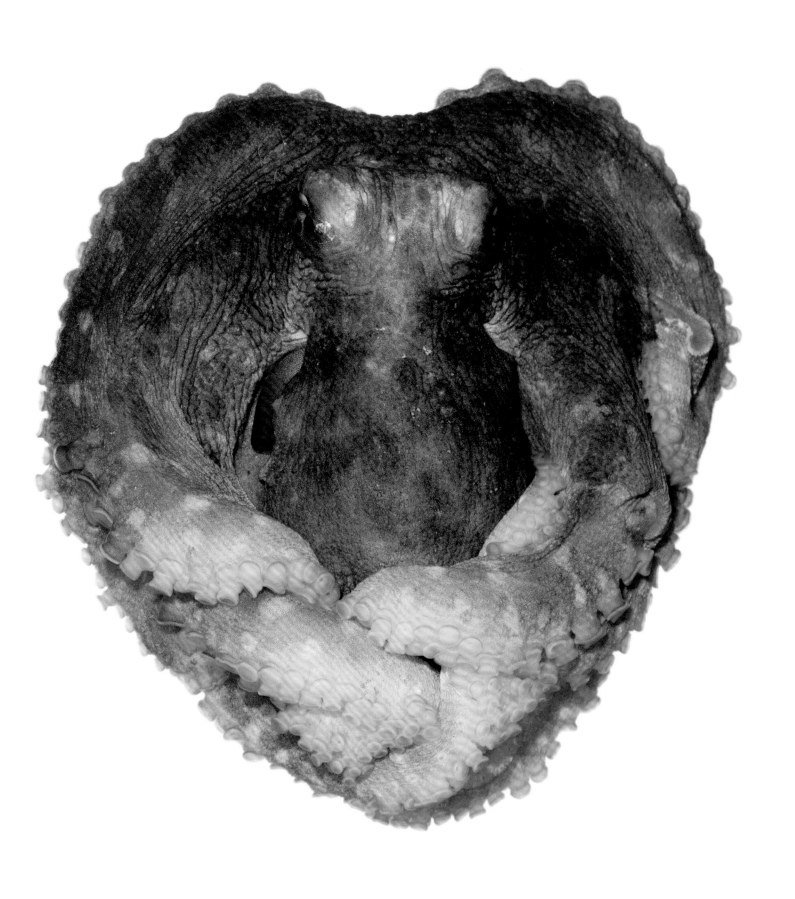

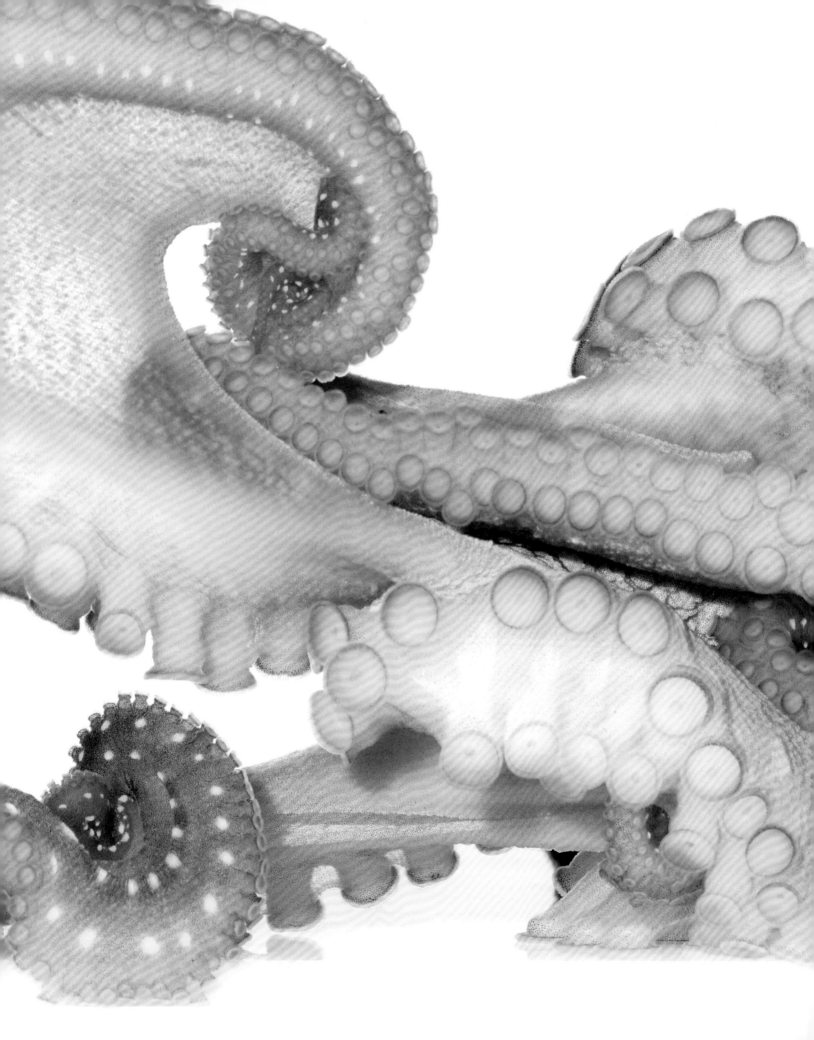

Day Octopus
Octopus cyanea
Specimen #29; female; mantle is 2 inches long; Dive Gizo, Ghizo Island, Solomon Islands

FOLLOWING PAGES
Day Octopus
Octopus cyanea

Specimen #61; mantle is 0.625 inch long; Dive Gizo, Ghizo Island, Solomon Islands

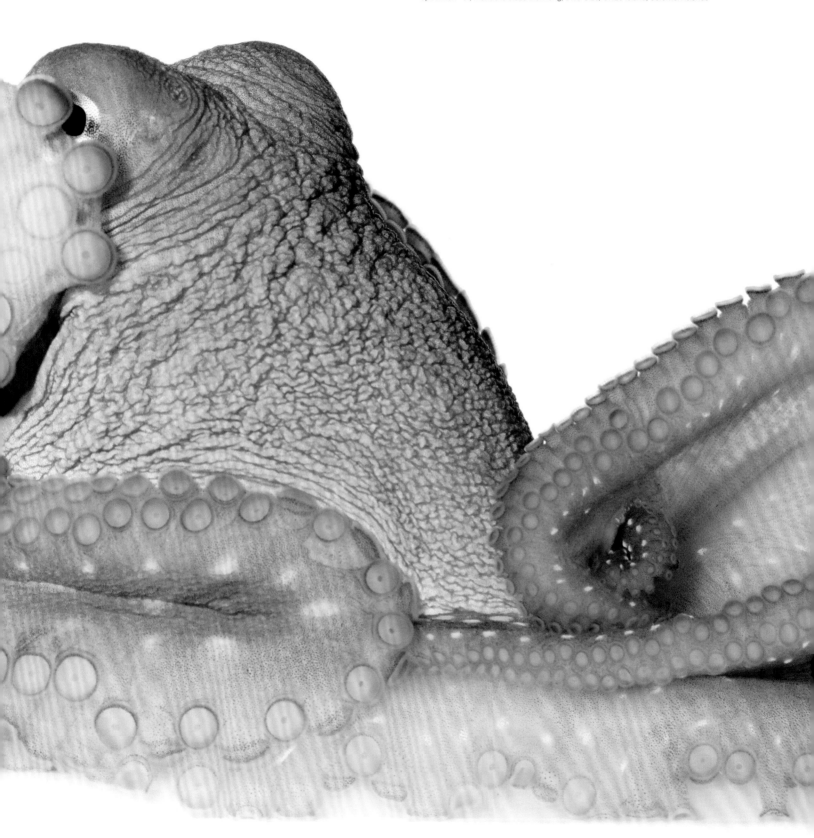

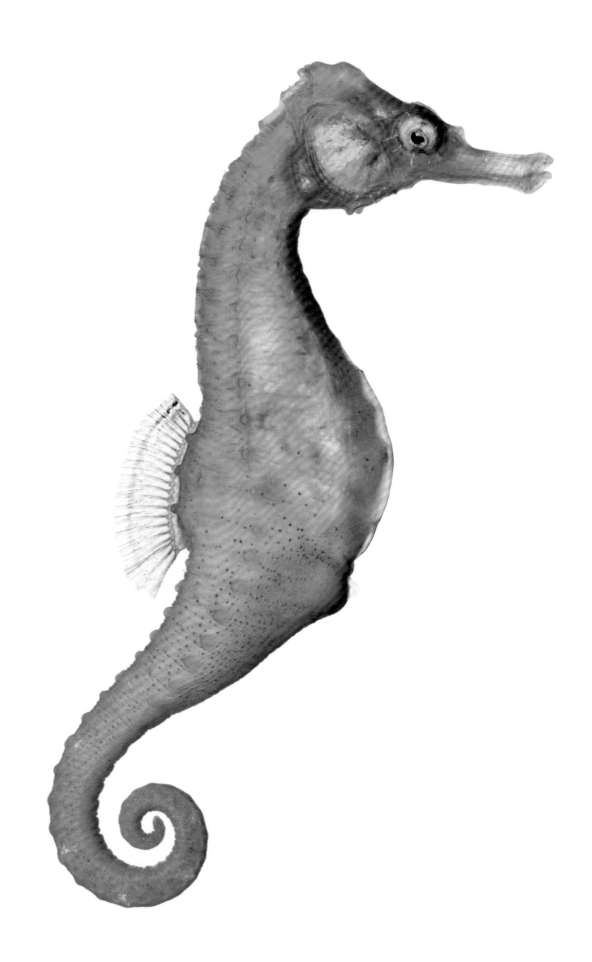

CHAPTER TWO

SEAHORSE

Pot-bellied Seahorse

Hippocampus abdominalis

Specimen #16; female; 8 inches overall length; Birch Aquarium, Scripps
Institution of Oceanography, La Jolla, California, United States of America

PAGE 110

Lined Seahorse

Hippocampus erectus

Specimen #12; male; 4.3 inches overall length; Birch Aquarium, Scripps
Institution of Oceanography, La Jolla, California, United States of America

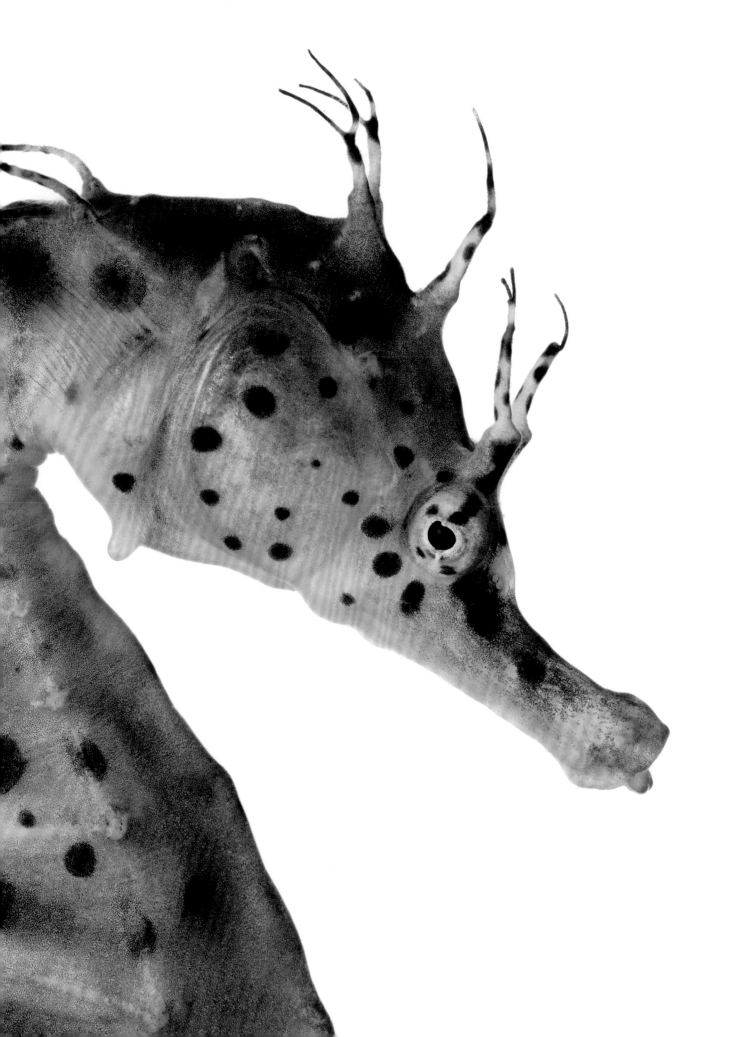

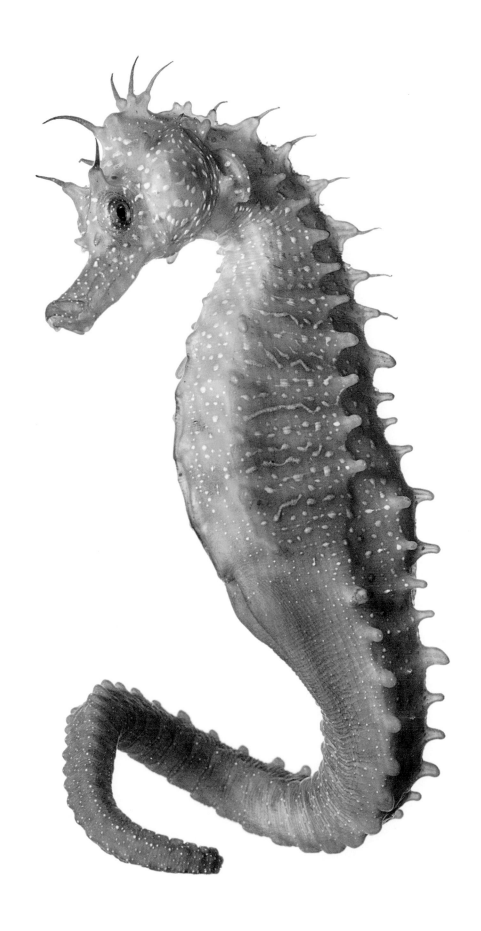

SEAHORSE
THE STRANGEST FISH IN THE SEA
JENNIFER HOLLAND

MIGUEL CORREIA POINTED AT THE SEAFLOOR. I stared and shook my head. He jabbed a gloved finger at the spot. I swam closer and stared harder. Sand. Algae. Rocks. A spiral of sea cucumber poop. I exhaled a swarm of bubbles in frustration.

And then, suddenly, there it was, tucked into the seaweed right where I'd been looking: a three-inch-tall long-snouted seahorse *(Hippocampus guttulatus),* muddied yellow with a smattering of dark freckles and a mane of skin filaments. Later that dive, I spotted (also with help) its short-snouted cousin, *Hippocampus hippocampus,* the other seahorse native to this coastal lagoon called Ria Formosa.

Every continent but Antarctica has varieties of these fabled fish in their coastal waters. Worldwide, scientists currently recognize 47 seahorse species, the smallest no bigger than a lentil, the largest the size of a baseball glove. Blink and that number may rise: Fourteen new species were named in just the past eight years.

It wasn't long ago that Ria Formosa, in the Algarve region of southern Portugal, was home to as many as two million seahorses, says Correia, a biologist at the University of Algarve's Center for Ocean Sciences. He and colleagues breed and study the animals in a small waterfront facility, and

Long-snouted Seahorse
Hippocampus guttulatus
Specimen #42; male; 6.75 inches overall length;
Ramalhete Marine Station, Faro, Portugal

WORLDWIDE, SCIENTISTS CURRENTLY RECOGNIZE 47 SEAHORSE SPECIES, THE SMALLEST NO BIGGER THAN A LENTIL, THE LARGEST THE SIZE OF A BASEBALL GLOVE.

they've seen populations of both species decline dramatically. "We've lost up to 90 percent in less than 20 years," he says.

Such falloff appears widespread, in part because seahorses live in the most hammered marine habitats in the world, including estuaries, mangroves, sea grass beds, and coral reefs. In the Algarve, for example, human activity in the lagoon—from farming clams to dropping boat anchors—buries or rips up the sea grass beds that seahorses prefer.

But the hardest hitter globally is unregulated fishing, which fuels a wide-reaching trade in dried seahorses. Stripped from the seabed as bycatch, the fish are sold around the world for traditional Asian medicine and trinkets. A much smaller number are sold live for the aquarium trade, mostly to U.S. consumers.

It's easy to see the seahorse's allure, with its fanciful blend of borrowed traits—a horse's head, a chameleon's independent eyes and camo skills, a kangaroo's pouch, a monkey's prehensile tail. *Hippocampus* comes in colors rivaling Crayola's Big Box, and just as many combinations of bumps and blotches, stripes and speckles, spikes and lacy skin extensions. A seahorse has bony plates instead of scales and, with no stomach to store food, it almost constantly sucks up copepods, shrimp, fish larvae, and other tiny edibles that happen by.

The sit-and-wait predators are also dancers of a sort. During courtship, a pair rises and falls face-to-face in the water column, communicating with color changes and tail embraces. The couple may tango for days and remain seasonally monogamous.

And then the surprise: The female impregnates the male rather than the reverse, an evolutionary quirk unique to seahorses and their close relatives. She deposits her yoke-rich eggs into his belly pouch through a port on her trunk called an ovipositor. Several weeks later the distended male goes into body-spasming labor, ejecting dozens to hundreds of young into the current. (The largest species may spew 2,000 of them.) Offspring drift a while before settling down, and only a scant few survive predation in those early days.

When a seahorse needs to move from here to there, it swims upright with the frantic flutter of a dorsal fin at up to 70 beats a second and steers with a pair of pectoral fins. To stay put, the fish's flexible tail grabs onto sea grass, coral, or other fixed items on the seafloor. The animal's excellent camouflage then makes it all but invisible.

For all their notoriety—who wouldn't recognize a seahorse?—the fish remain little known in their distribution and population trends. The IUCN Red List of Threatened Species includes all *Hippocampus* species, and most are listed as *Data Deficient*. "For the vast majority of species," says marine biologist Amanda Vincent of the University of British Columbia (UBC), "beyond taxonomy and a basic description, we know almost nothing." (Vincent is the director of Project Seahorse, a conservation alliance between UBC and the Zoological Society of London.)

Such a knowledge gap, blamed in part on the dearth of seahorse-focused scientists, is especially problematic for an animal that's so exploited. Project Seahorse estimates that the bycatch figure has surpassed 37 million seahorses a year, with more than 70 countries involved in their trade. "Fishermen used to throw them back," notes conservation biologist Healy Hamilton of NatureServe, "but now in many places you'll see a [buyer] on the dock just waiting to take them."

Some fishers do target these animals. Correia says an illegal fishery in Ria Formosa, for example, quietly employs both trawling and scuba divers to collect the animals, which can fetch five to 10 euros apiece. "You'll hear fishermen in the coffee shop brag about bringing in 500 in a night," he says. But it's the incidental capture, using bottom trawlers and other catchall gear, that's devastating seahorse populations, says Project Seahorse's Sarah Foster.

Legal trade in seahorses was squeezed dramatically in 2004, when concern about no-rules fishing prompted new regulations under CITES (the Convention on International Trade in Endangered Species of Wild Fauna and Flora). But the rules have made little difference. "You can regulate all

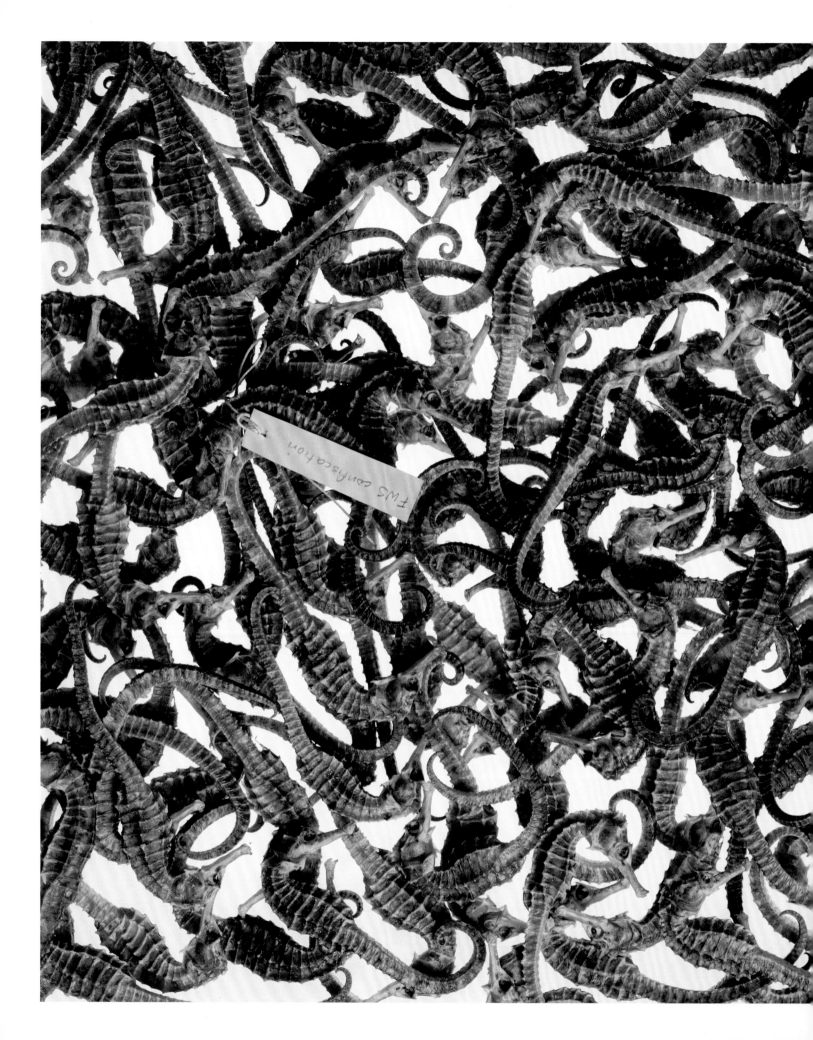

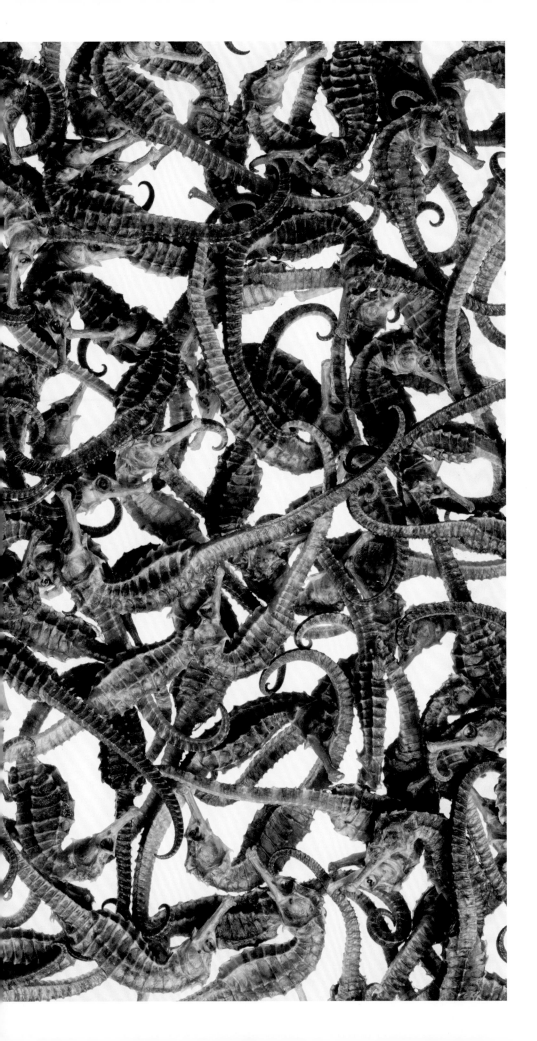

The nearly 200 female seahorses pictured are confiscated evidence from the San Francisco Airport. Property of the U.S. Fish and Wildlife Service

Specimen #4; life size; California Academy of Sciences, San Francisco, California, United States of America

IT'S EASY TO SEE THE SEAHORSE'S ALLURE, WITH ITS FANCIFUL BLEND OF BORROWED TRAITS—A HORSE'S HEAD, A CHAMELEON'S INDEPENDENT EYES AND CAMO SKILLS, A KANGAROO'S POUCH, A MONKEY'S PREHENSILE TAIL.

you like, but it won't matter as long as blind capture rages and rules aren't enforced," Vincent says. "I don't think trade is in any way diminished. It has simply gone underground."

Field surveys and CITES records have exposed Southeast Asia, especially Thailand, as the main supplier, with numerous West African countries recently upping their exports. Hong Kong is by far the top importer, with heavy shipments also to Taiwan and mainland China. Most of the demand is for medicine, as vendors promise that dried seahorse boosts virility, has anti-inflammatory properties, and can treat everything from asthma to incontinence.

To get a sense of the loss, I visited a windowless storage room at the California Academy of Sciences (CAS), where Healy Hamilton, up on a ladder, rifled through one of many boxes of plastic bags bulging with brittle skeletons. There were hundreds, maybe thousands of animals "representing just a year's worth of what was stopped at a single port," she told me. Confiscated at the San Francisco International Airport, the animals were part of an effort by Hamilton and the U.S. Fish and Wildlife Service to determine the top-traded species.

Occasionally, officials seize a supersize haul: In 2019 in Lima, Peru, more than 12 million dried seahorses were confiscated from a single Asia-bound ship—a load worth some $6 million on the black market. But more often, animals in transit escape detection, Hamilton says, with incalculable losses to each exploited species.

How will seahorses manage as habitat disappears and ocean temperatures and acidity continue to rise? It's all a bit of a guess right now. Few studies exist on seahorses' ability to adapt to the various changes in progress, though scientists expect them, like many species, to struggle.

On a positive note, in 2019 Correia penned a scientific report that encouraged officials to establish no-take zones in Ria Formosa, to bump up surveillance of seahorse-heavy areas, and to restrict access to the sea grass beds within the national park. In response, last year the Portuguese

government, with input from relevant stakeholders, created two small marine protected areas within the lagoon to act as seahorse sanctuaries.

It's good news, but experts say the key to maintaining seahorse numbers in most locales is through better global fisheries management, with severe limits and even bans on trawling. Market demand, whether for tinctures, souvenirs, or pets, doesn't have to be a death sentence for *Hippocampus,* says Foster—*"if* we can get CITES rules to work as intended to support sustainable legal trade" rather than encouraging illegal activity.

Meanwhile, Asia's consumption of seahorse products could shrink on its own "as younger, more progressive-minded people move away from using wildlife in traditional ways," Foster says. Plus, the traditional medicine community ultimately shares a goal with conservationists. Traders and users are often vilified, she says, "but in the end we all have incentives to keep seahorses from disappearing."

Acting on those incentives matters, because "there is absolutely no way seahorses can sustain today's level of exploitation," Hamilton said to me from her perch overlooking the warehouse shelves at CAS. "And people need to know: We are headed towards a world nearly bereft of these most extraordinary of fishes." •

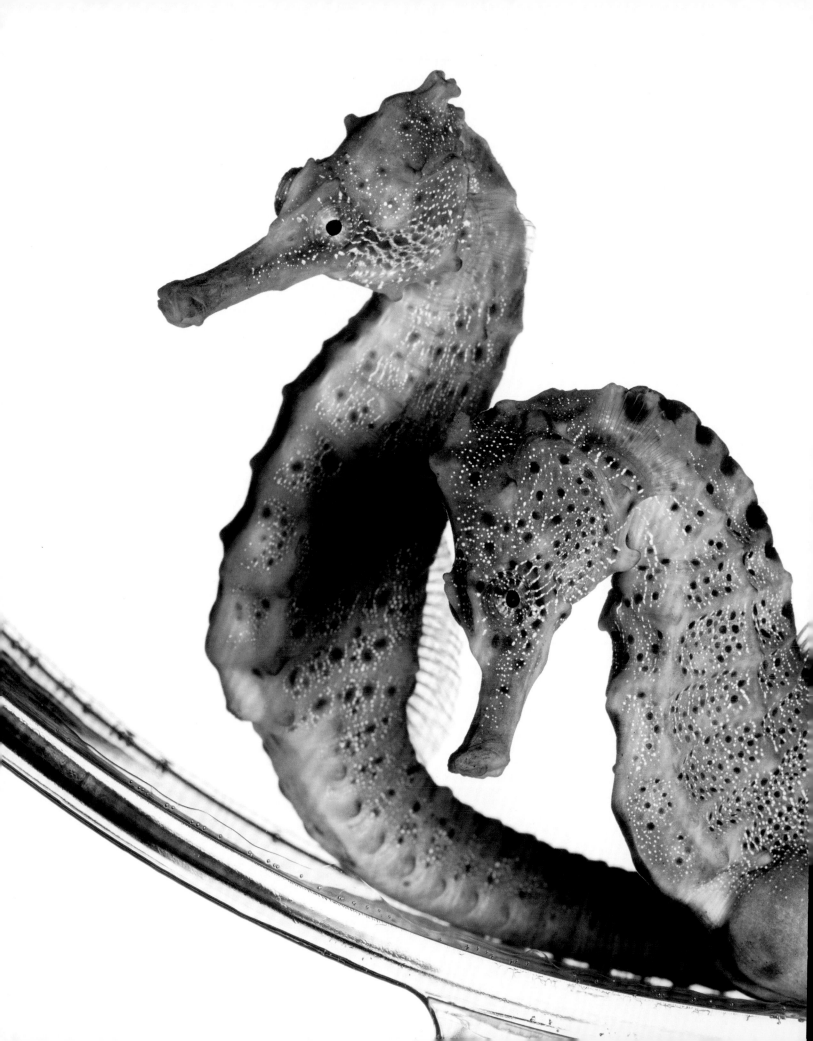

Pacific Seahorse
Hippocampus ingens
Specimens #50 and #51; female and male; individuals are 6.5 inches overall length;
Aquarium of the Pacific, Long Beach, California, United States of America

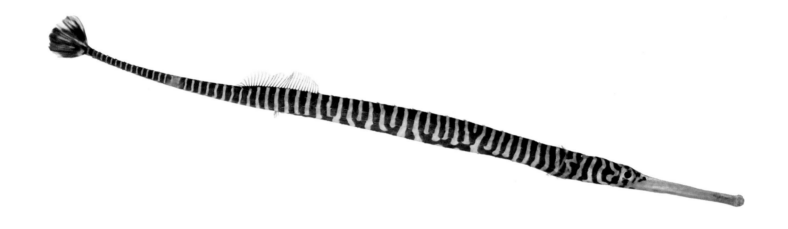

Yellowbanded Pipefish
Doryrhamphus pessuliferus
Specimen #46; 5 inches long; Aquarium of the Pacific, Long Beach, California, United States of America

OPPOSITE

Ribboned Pipefish
Haliichthys taeniophorus
Specimen #32; 11 inches overall length; Birch Aquarium, Scripps Institution of Oceanography,
La Jolla, California, United States of America

Seahorses are part of the family Syngnathidae, which includes pipefishes (above
and opposite) and sea dragons (following pages).

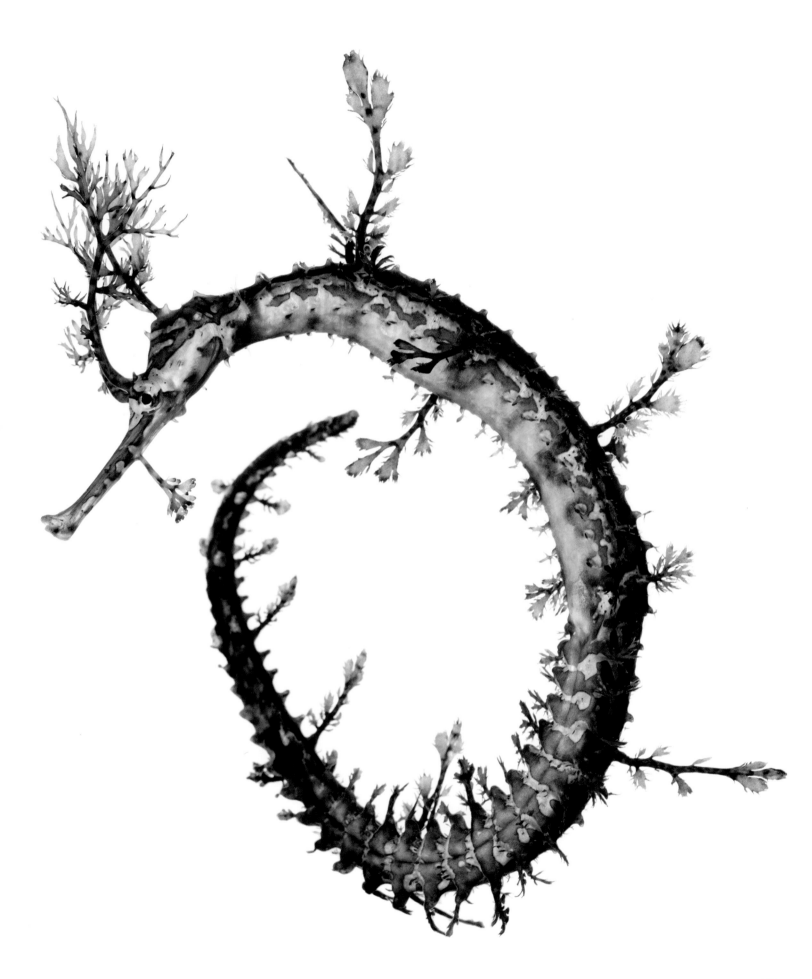

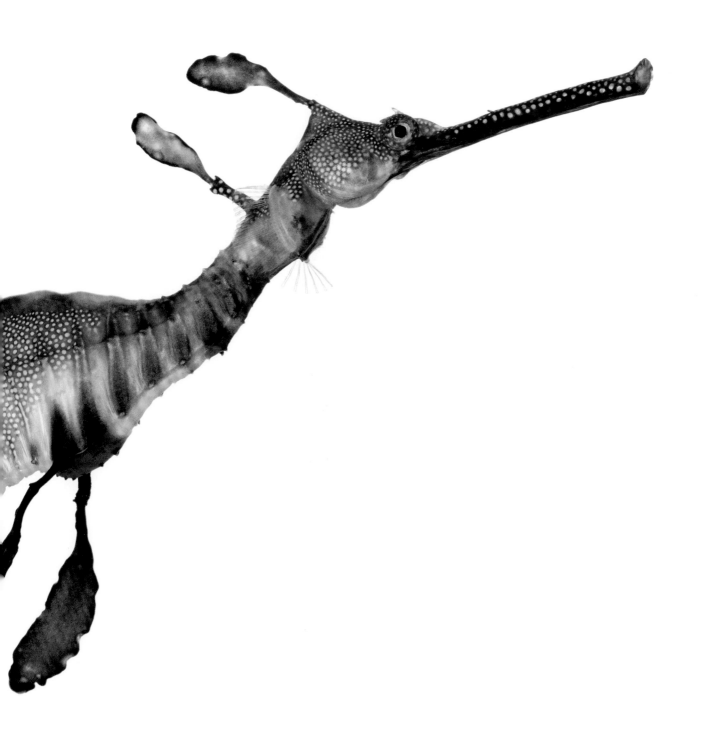

Weedy Seadragon
Phyllopteryx taeniolatus
Specimen #55; 10 inches long; Aquarium of the Pacific, Long Beach, California,
United States of America

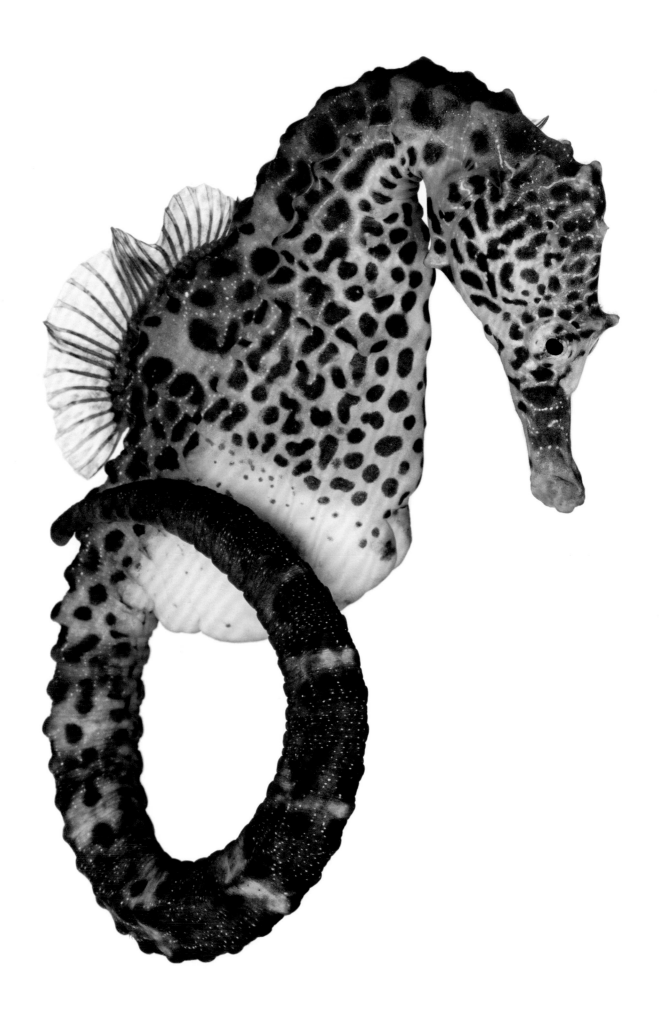

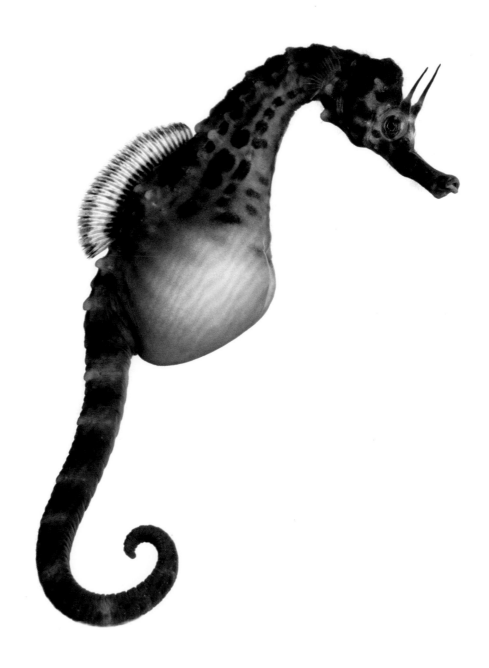

Pot-bellied Seahorse
Hippocampus abdominalis
Above: specimen #70; pregnant male; 5.5 inches tall; Seahorse World, Beauty Point, Tasmania, Australia
Opposite: specimen #54; male; 4 inches high; Aquarium of the Pacific, Long Beach, California, United States of America

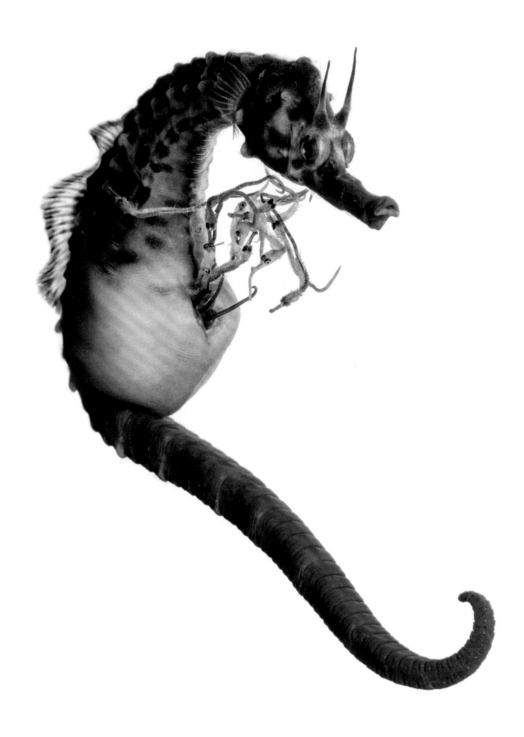

BOTH

Pot-bellied Seahorse

Hippocampus abdominalis

Above: specimen #70; male giving birth; 5.5 inches tall

Opposite: specimen #72; male; hatchlings are 0.75 inch overall length

Seahorse World, Beauty Point, Tasmania, Australia

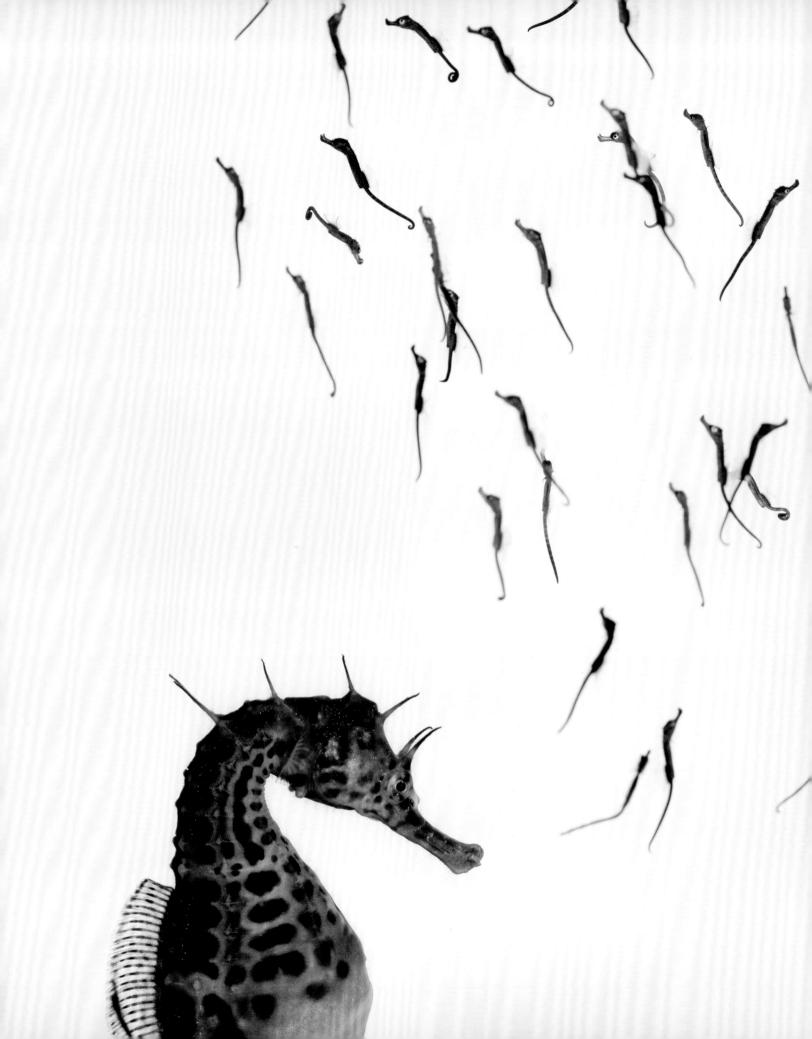

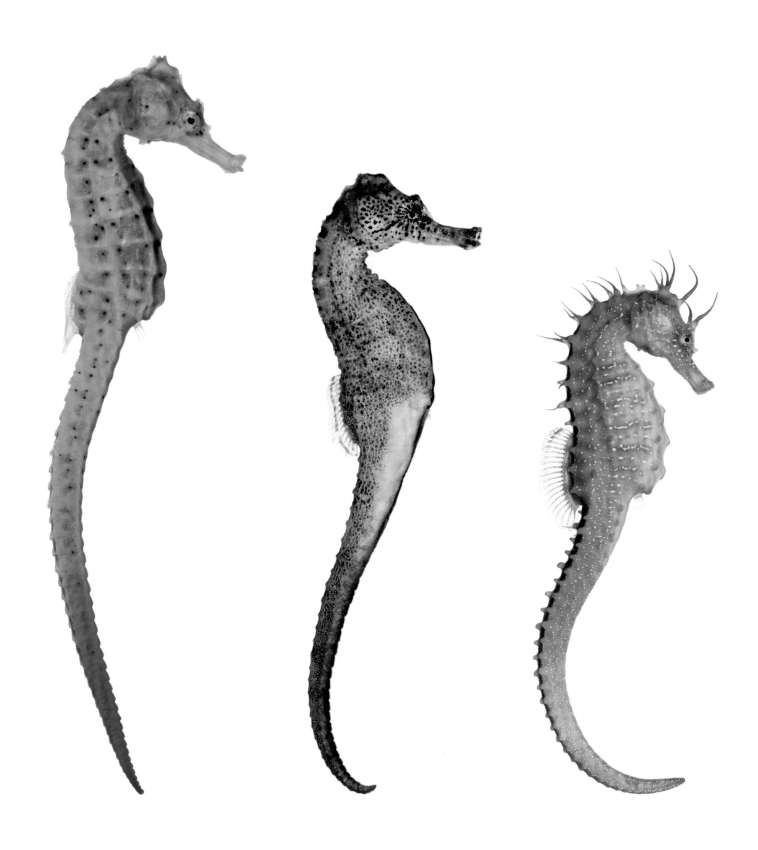

SHOWN ACTUAL SIZE FROM LEFT TO RIGHT

Pacific Seahorse, *Hippocampus ingens,* Specimen #36, female
Longsnout Seahorse, *Hippocampus reidi,* Specimen #20, male
Long-snouted Seahorse, *Hippocampus guttulatus,* Specimen #40, female
Pot-bellied Seahorse, *Hippocampus abdominalis,* Specimen #18, subadult
Barbour's Seahorse, *Hippocampus barbouri,* Specimen #24, male
White's Seahorse, *Hippocampus whitei,* Specimen #25, male
Knobby Seahorse, *Hippocampus tuberculatus,* Specimen #75, female
Dwarf Seahorse, *Hippocampus zosterae,* Specimen #29, male

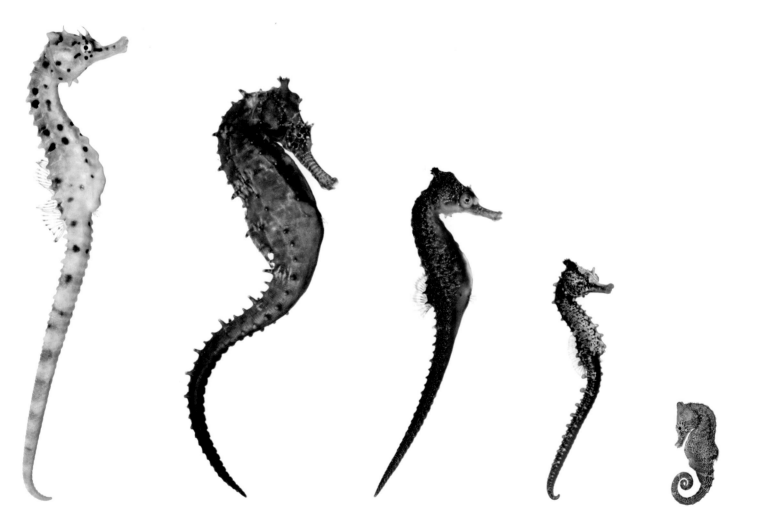

Short-snouted Seahorse
Hippocampus hippocampus
Below: specimen #44; newborn; 0.3125 inch tall
Right: specimen #37 group; male; 3 inches long
Ramalhete Marine Station, Faro, Portugal

Short-snouted seahorses were originally named *Hippocampus hippocampus* by Carl Linnaeus. The small individual is a newborn; the larger is a near sexually mature male, as evidenced by his developing brood pouch. Both are shown five times life size.

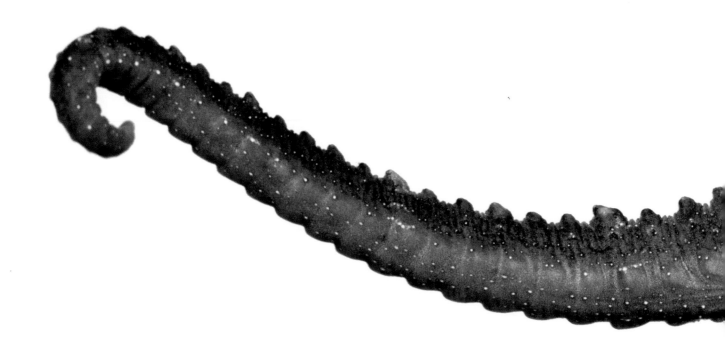

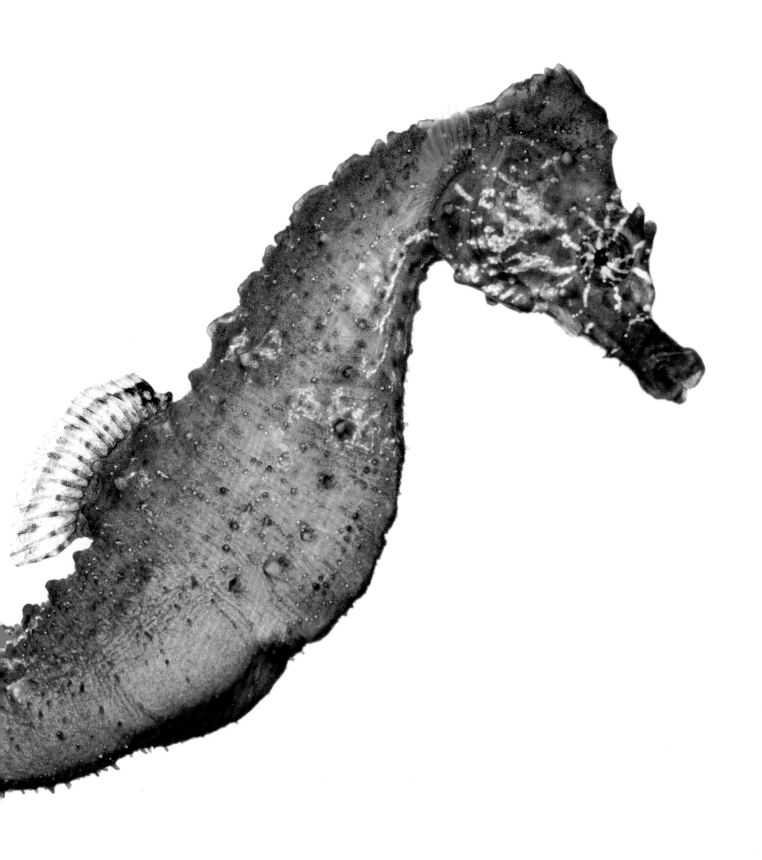

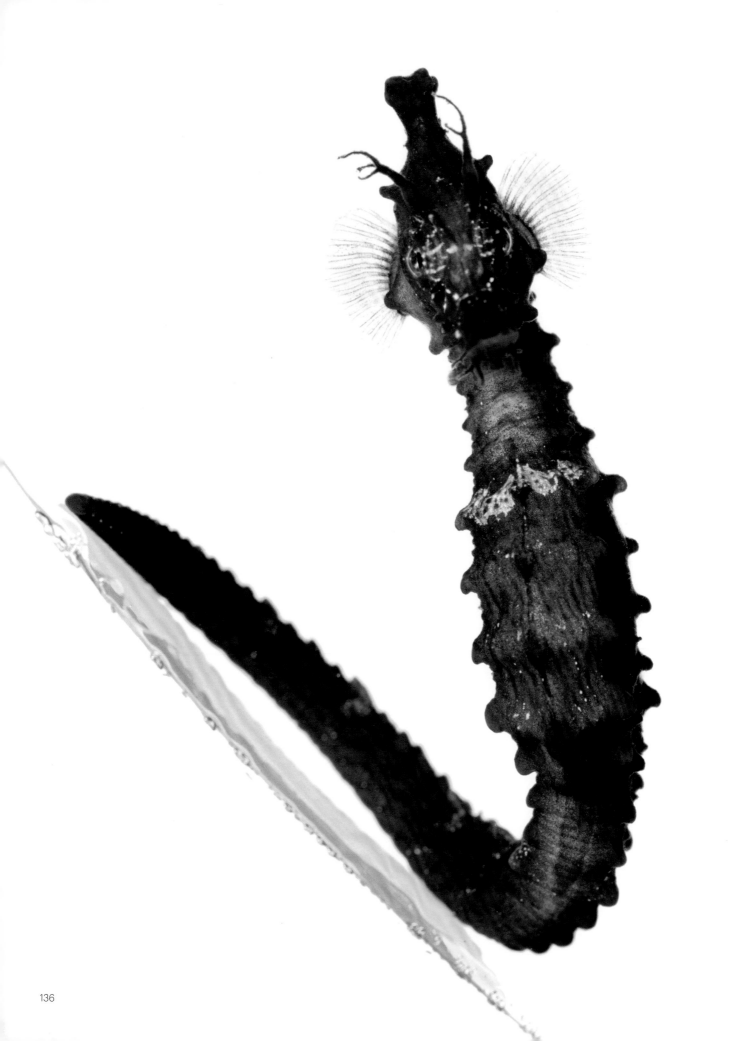

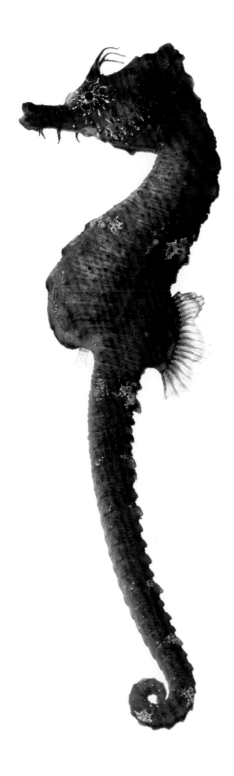

BOTH

Short-snouted Seahorse
Hippocampus hippocampus
Specimen #37 group; female; 3.5 inches overall length; Ramalhete Marine Station, Faro, Portugal

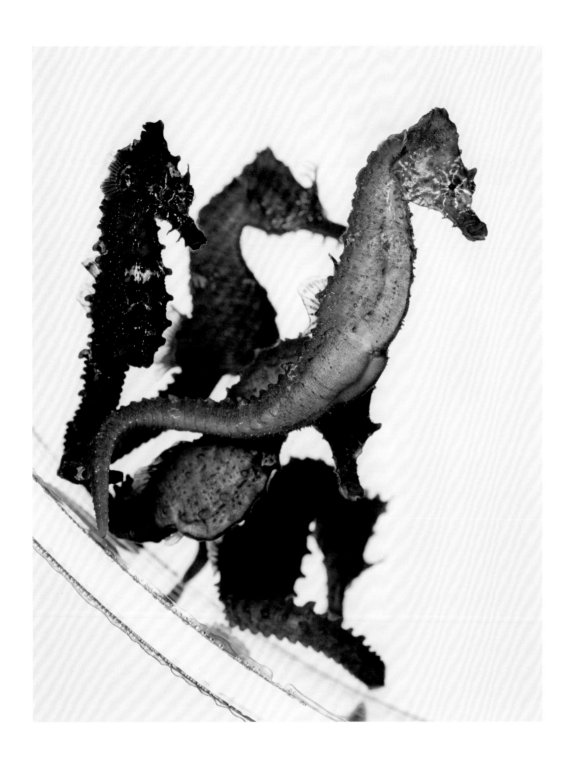

BOTH

Short-snouted Seahorses

Hippocampus hippocampus

Specimen #37 group; females and males; individuals are 3.5 inches overall length; Ramalhete Marine Station, Faro, Portugal

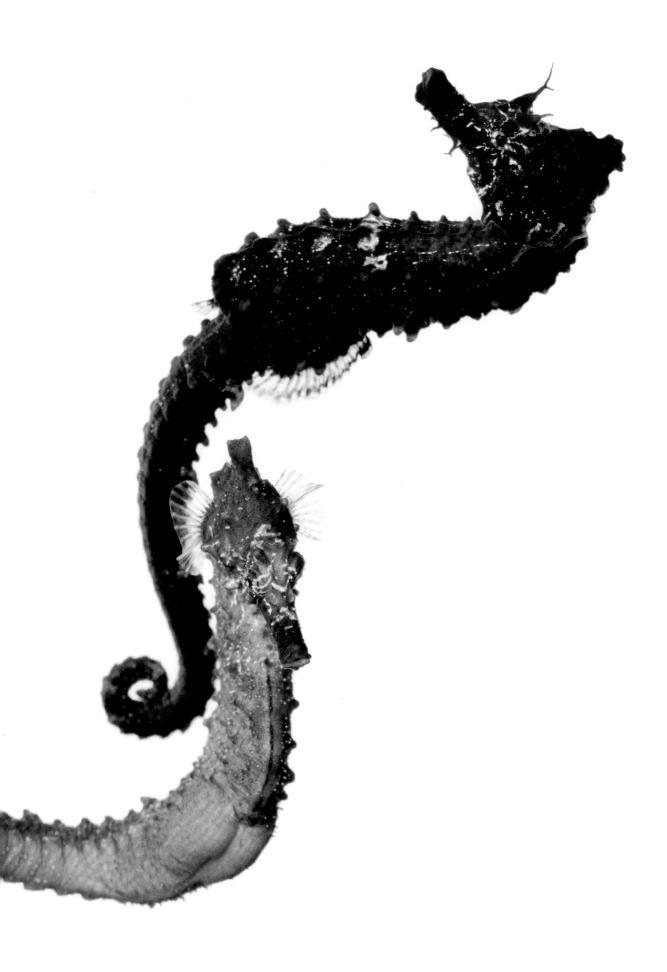

BOTH

Lined Seahorse

Hippocampus erectus

Above: specimen #14; 0.75 inch tall; juvenile, about one month old, too young to sex, offspring of specimens #10 and #11, born August 28, 2018

Opposite: specimen #12; male; 4.3 inches overall length; subadult, offspring of specimens #10 and #11, born October 17, 2017

Birch Aquarium, Scripps Institution of Oceanography, La Jolla, California, United States of America

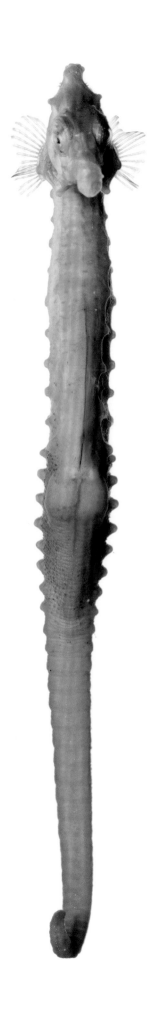

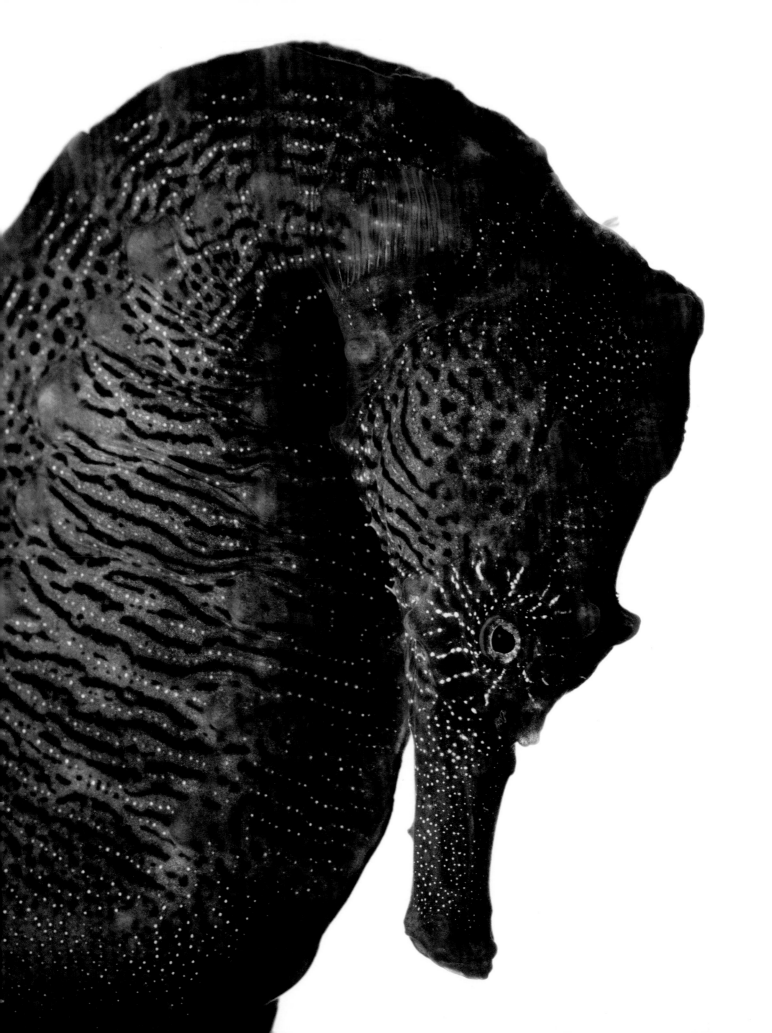

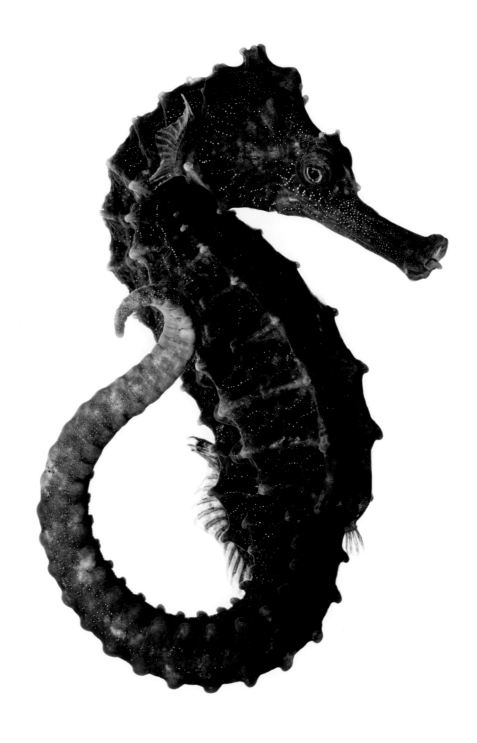

BOTH

Lined Seahorse
Hippocampus erectus
Above: specimen #11; female; 6 inches overall length; wild-caught four to five years old
Opposite: specimen #10; male; 7 inches overall length; wild-caught four to five years old
Birch Aquarium, Scripps Institution of Oceanography, La Jolla, California, United States of America

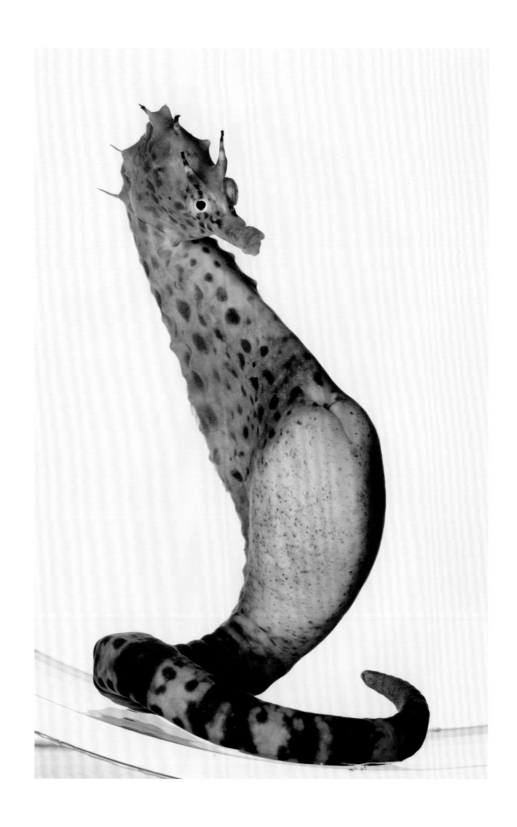

BOTH

Pot-bellied Seahorse

Hippocampus abdominalis

Specimen #17; male; 8.25 inches overall length; about seven years old; born and raised at Birch
Aquarium, Scripps Institution of Oceanography, La Jolla, California, United States of America

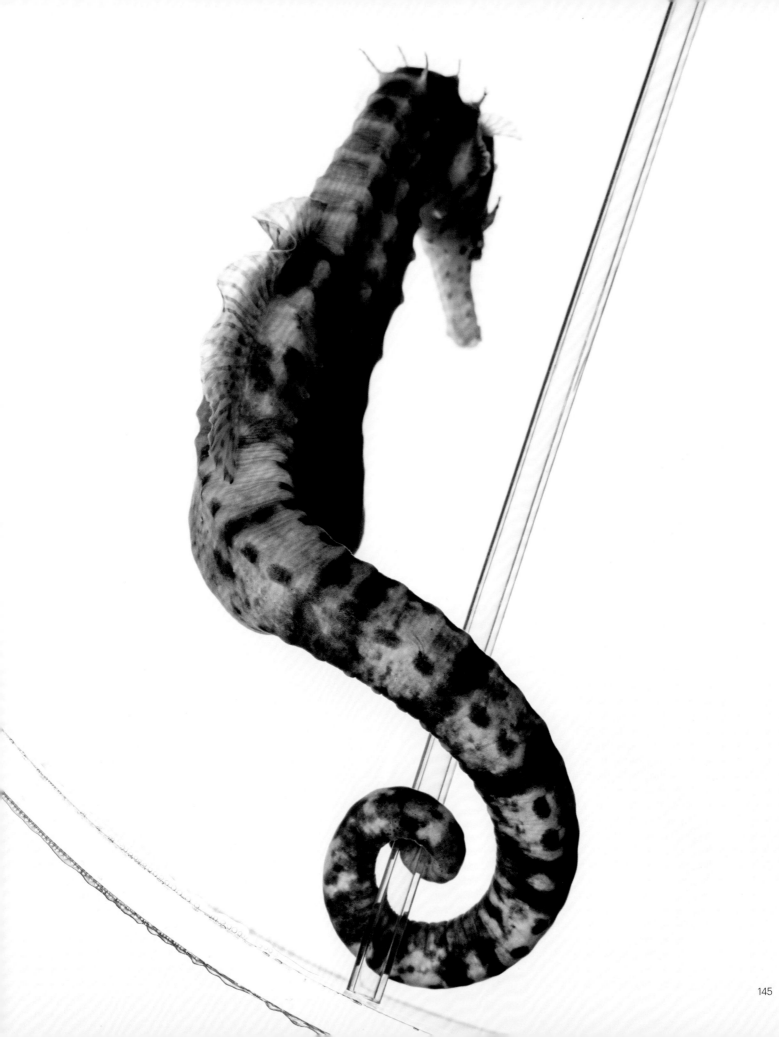

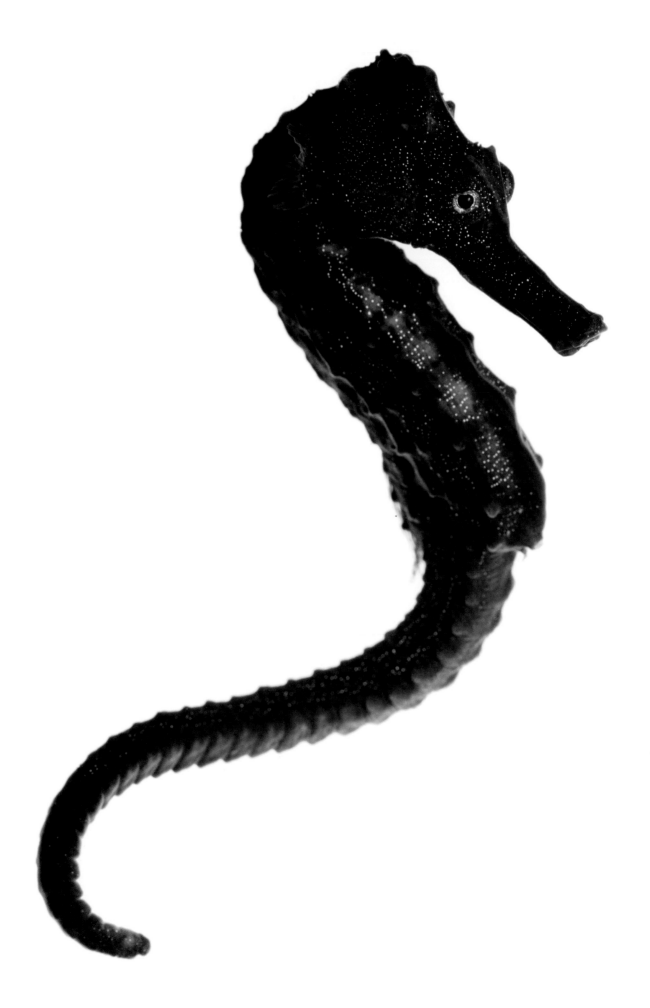

Longsnout Seahorse
Hippocampus reidi
Opposite: specimen #19; female; 7.5 inches overall length
Below: specimen #20; male; 6.5 inches overall length
Birch Aquarium, Scripps Institution of Oceanography, La Jolla, California, United States of America

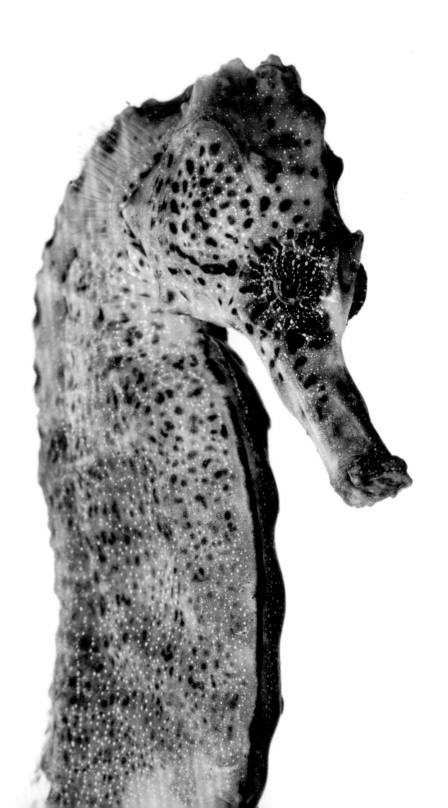

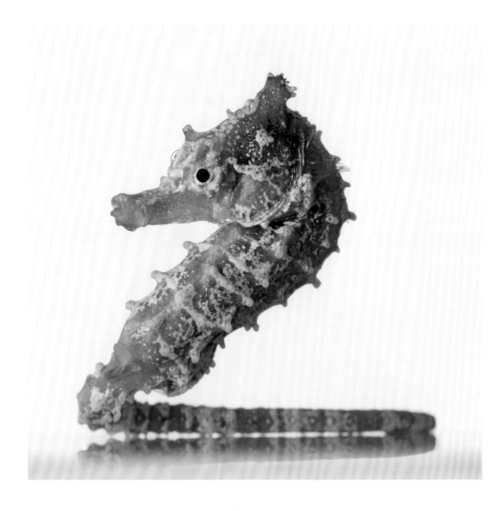

BOTH

Dwarf Seahorse

Hippocampus zosterae

Above: specimen #47b; female; 0.5 inch high

Right: specimen #47a; male; 1.25 inches overall length

Aquarium of the Pacific, Long Beach, California, United States of America

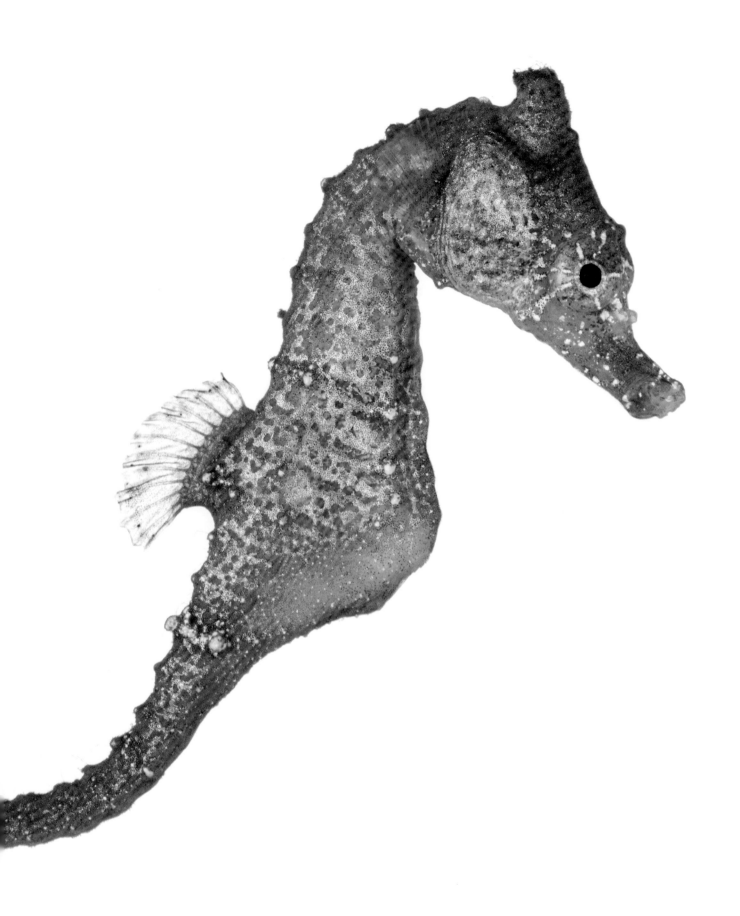

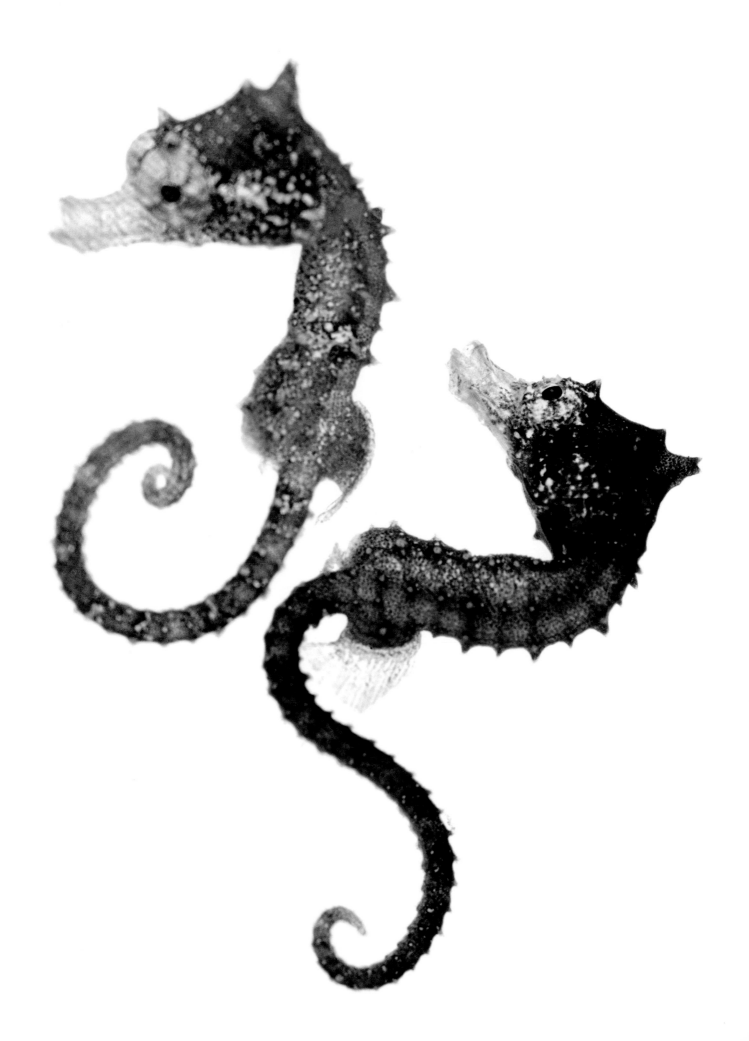

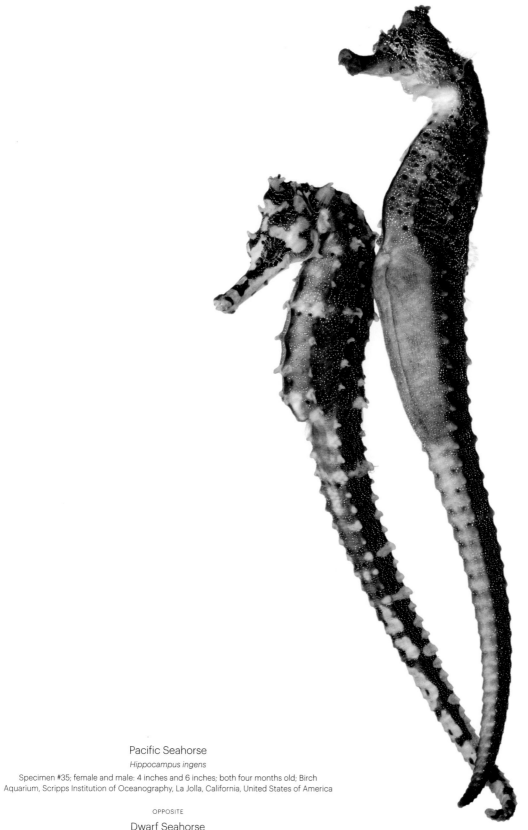

Pacific Seahorse

Hippocampus ingens

Specimen #35; female and male: 4 inches and 6 inches; both four months old; Birch
Aquarium, Scripps Institution of Oceanography, La Jolla, California, United States of America

OPPOSITE

Dwarf Seahorse

Hippocampus zosterae

Specimen #28b; 0.5 inch overall length; Birch Aquarium, Scripps Institution of Oceanography,
La Jolla, California, United States of America

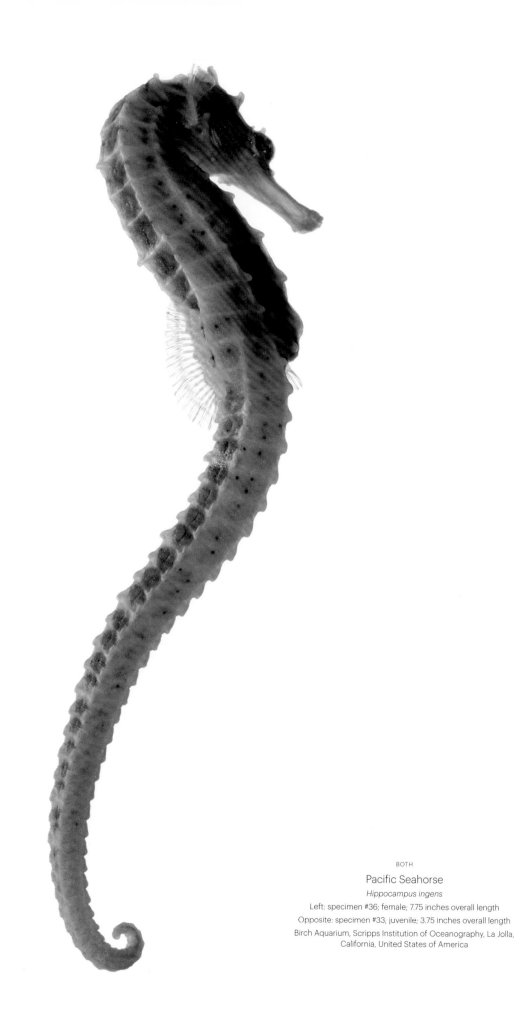

BOTH

Pacific Seahorse
Hippocampus ingens
Left: specimen #36; female; 7.75 inches overall length
Opposite: specimen #33; juvenile; 3.75 inches overall length
Birch Aquarium, Scripps Institution of Oceanography, La Jolla,
California, United States of America

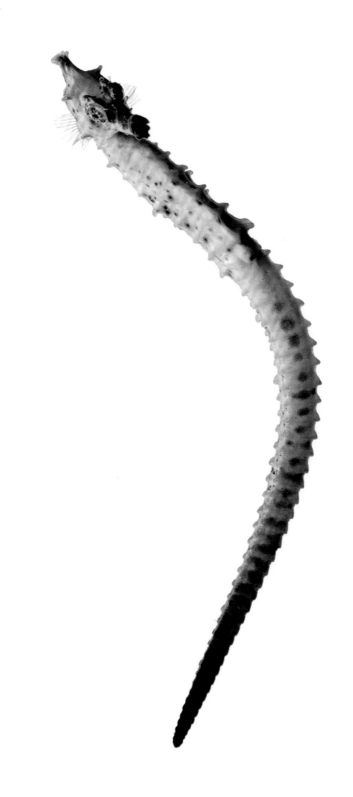

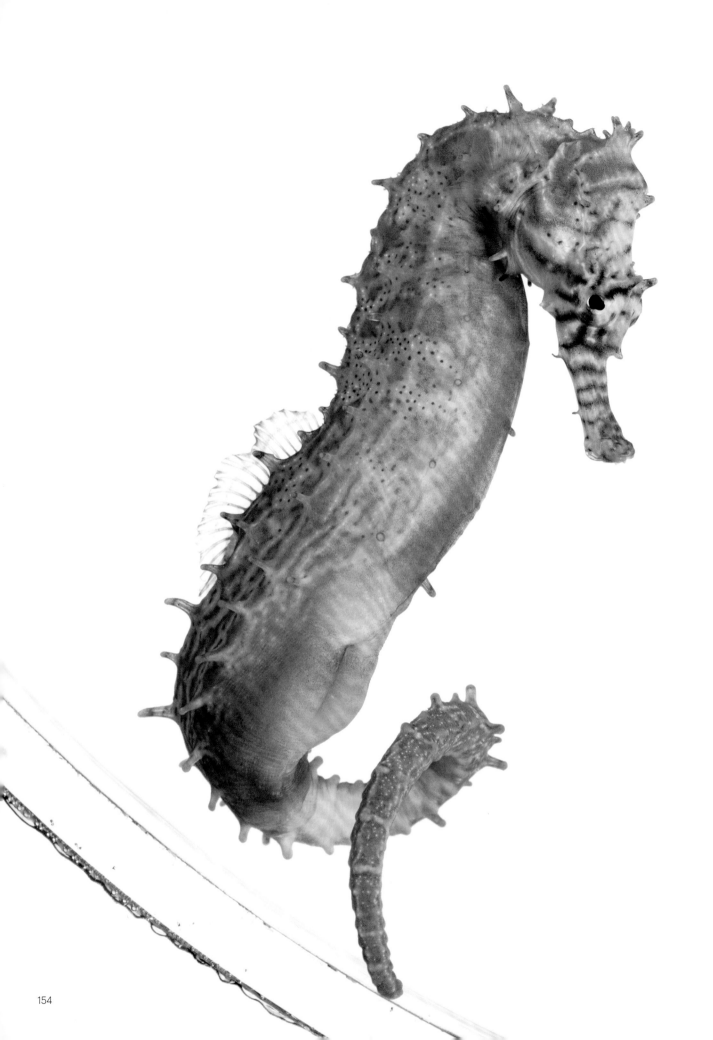

BOTH

Barbour's Seahorse

Hippocampus barbouri

Above: specimen #24; male; 5 inches overall length; Birch Aquarium, Scripps Institution of
Oceanography, La Jolla, California, United States of America

Opposite: specimen #81; male; 3 inches high; Seahorse World, Beauty Point, Tasmania, Australia

BOTH

Tiger Snout Seahorse
Hippocampus subelongatus
Above: specimen #60; male; 5 inches high
Opposite: specimen #58; male; frame is 2.5 inches high
Seahorse World, Beauty Point, Tasmania, Australia

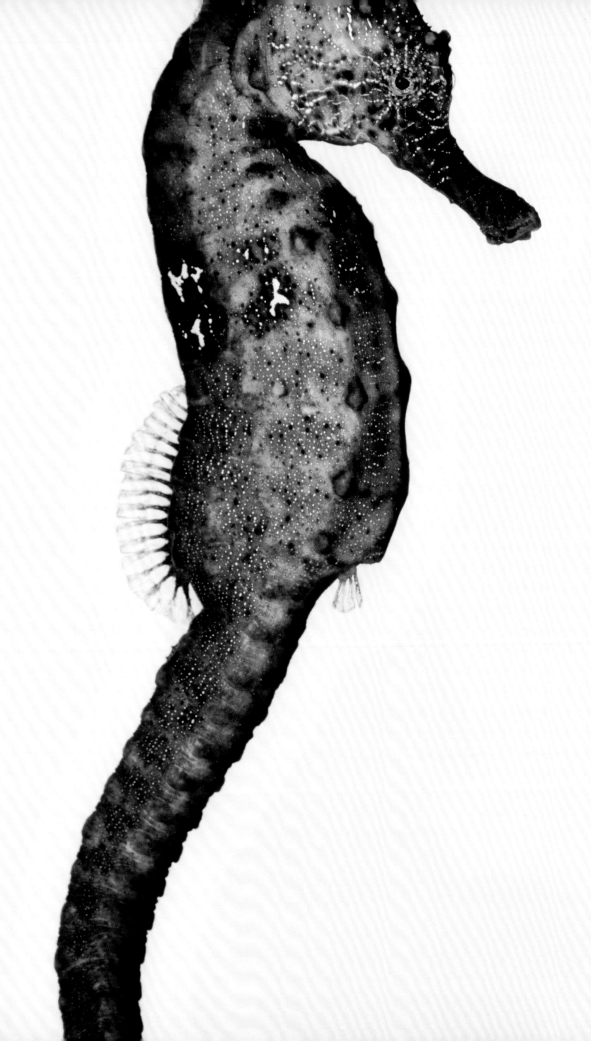

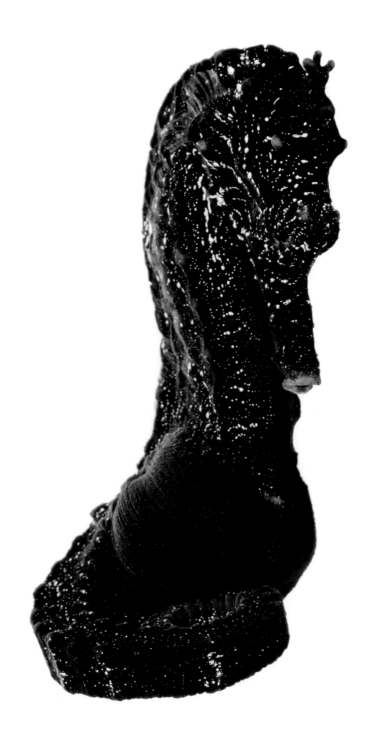

Yellow Seahorse
Hippocampus taeniopterus
Above: specimen #68; male; 3 inches high
Opposite: specimen #67; female; frame is 6 inches high
Seahorse World, Beauty Point, Tasmania, Australia

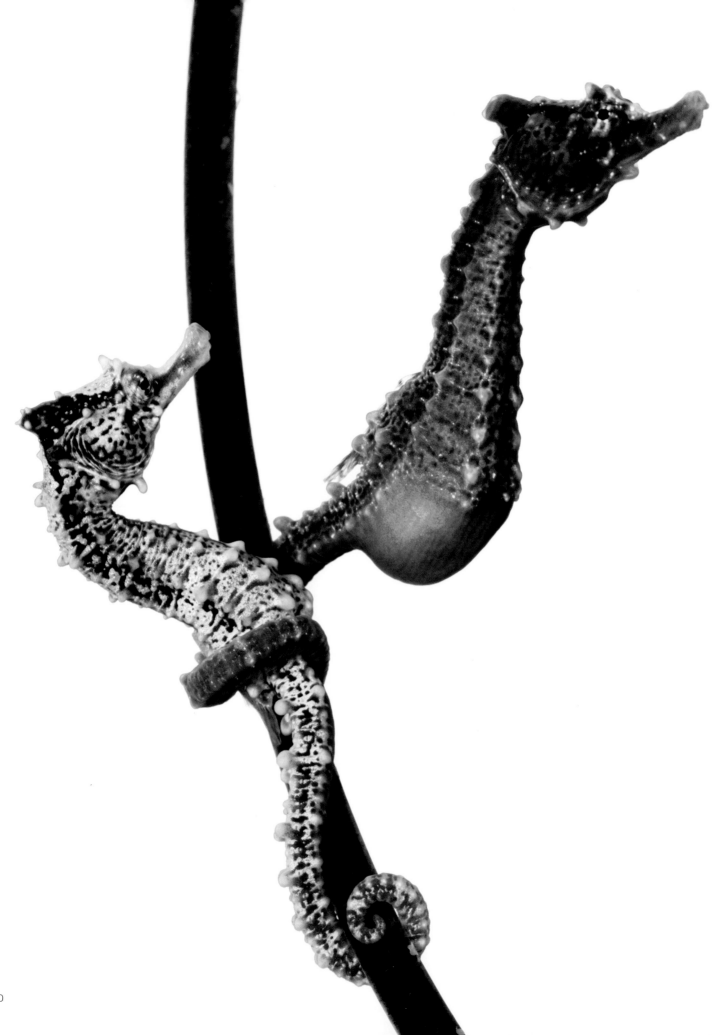

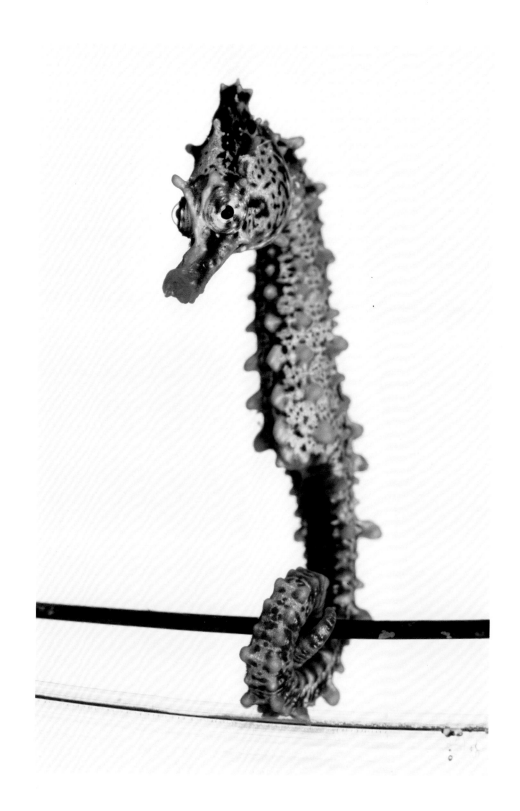

Knobby Seahorse
Hippocampus tuberculatus
Above: specimen #75; female; 1.25 inches high
Opposite: specimens #75 and #76; female and male; individuals are 2.5 inches overall length
Seahorse World, Beauty Point, Tasmania, Australia

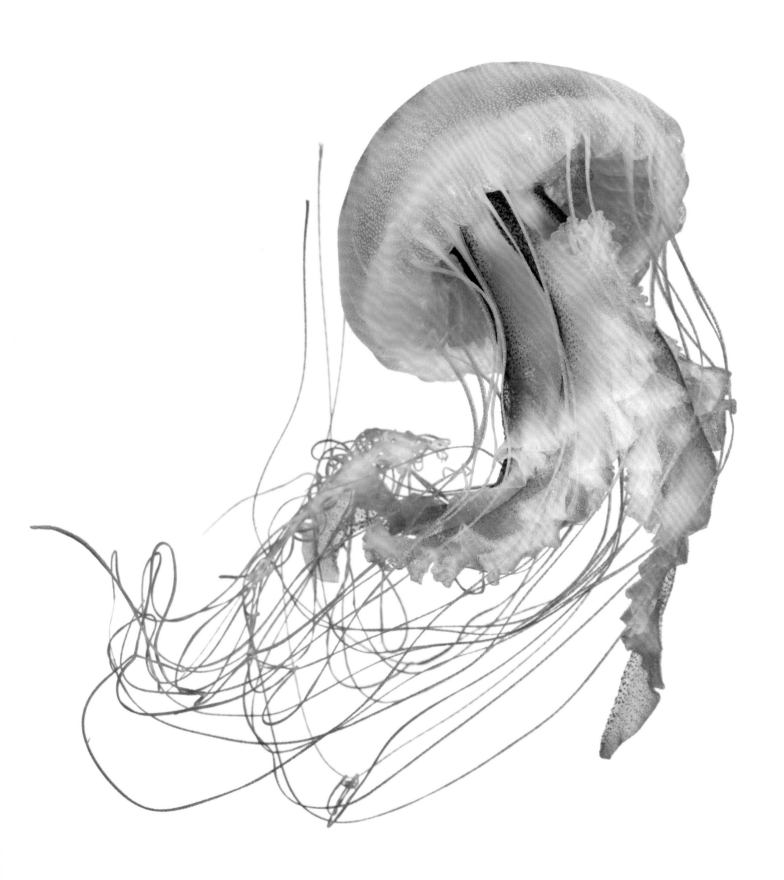

CHAPTER THREE

JELLYFISH

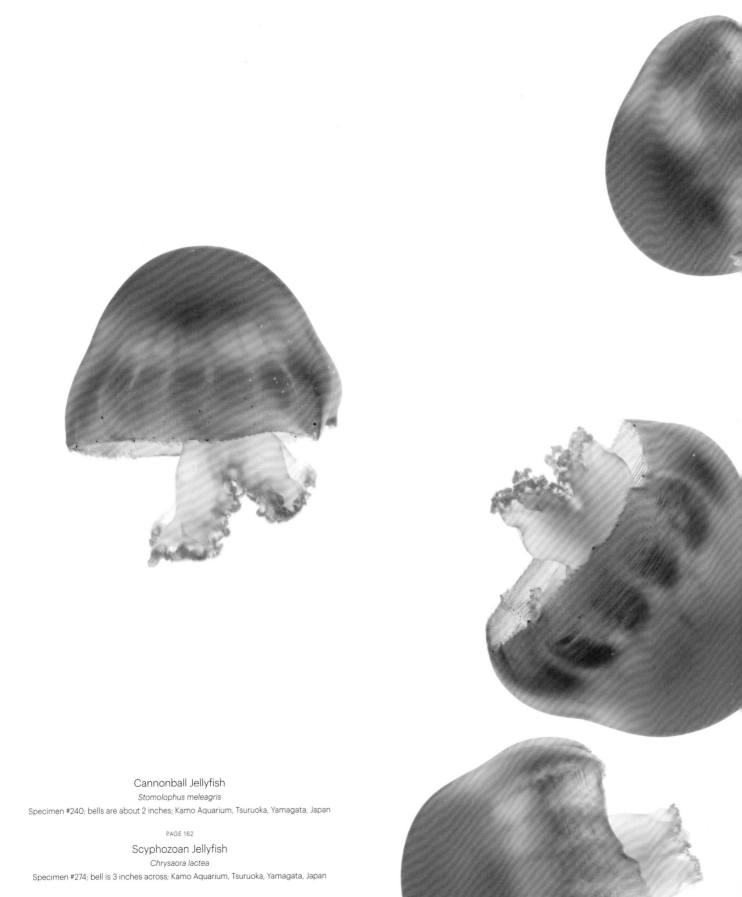

Cannonball Jellyfish
Stomolophus meleagris
Specimen #240; bells are about 2 inches; Kamo Aquarium, Tsuruoka, Yamagata, Japan

PAGE 162

Scyphozoan Jellyfish
Chrysaora lactea
Specimen #274; bell is 3 inches across; Kamo Aquarium, Tsuruoka, Yamagata, Japan

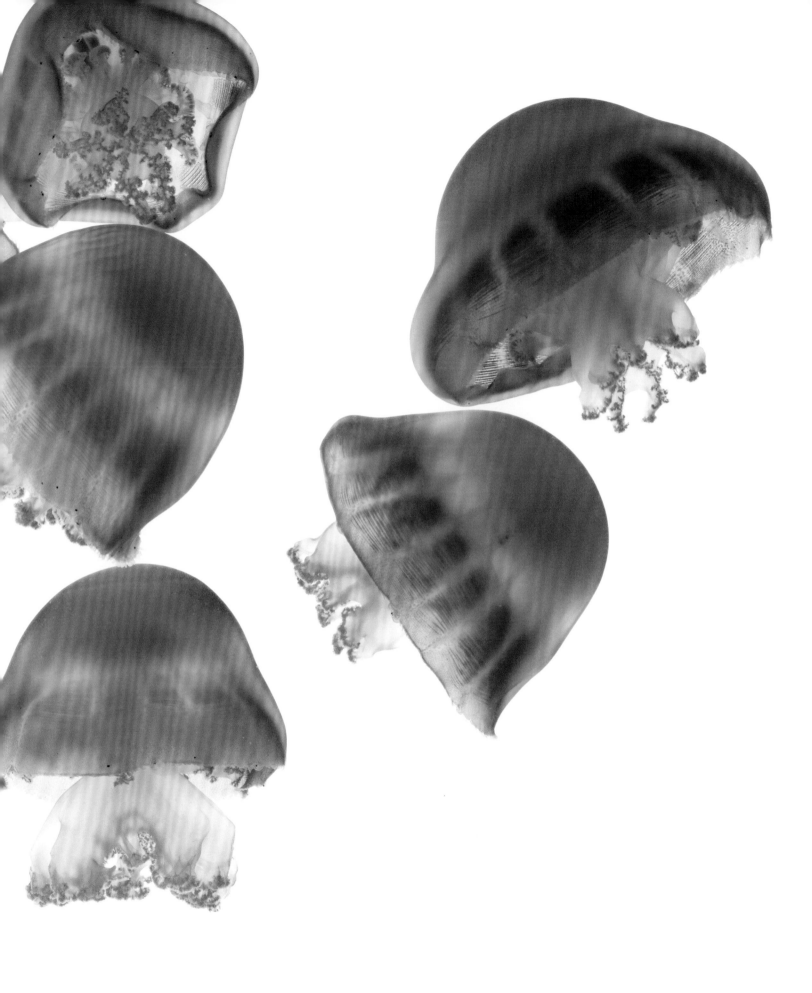

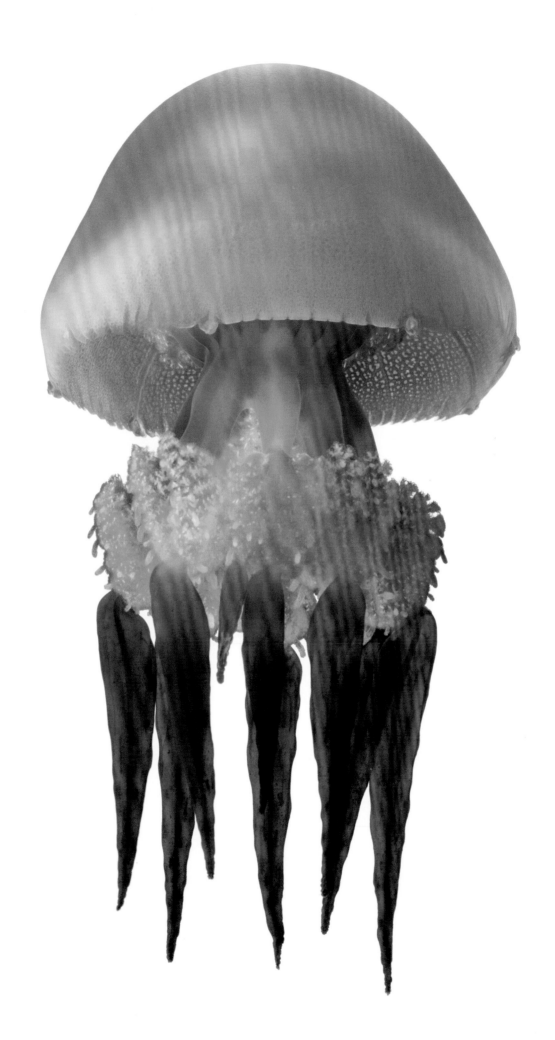

JELLYFISH
SCARY, SQUISHY, BRAINLESS, BEAUTIFUL
ELIZABETH KOLBERT

MOON JELLIES, WHICH ARE FOUND in shallow bays around the world, look like small, not entirely friendly ghosts.

They have translucent bells fringed with pale tentacles, and as they pulse along, it almost seems as if the water itself has come alive. At the National Aquarium in Baltimore, when visitors are invited to touch moon jellies, their first reaction is usually fear. Assured the jellies won't hurt them, the visitors roll up their sleeves and hesitantly reach into the tank.

"They're squishy!" I hear one boy squeal.

"They're cool!" a girl exclaims.

"I think they're just mesmerizing," Jennie Janssen, the assistant curator who oversees the care of the aquarium's jellyfish, tells me. "They don't have a brain, and yet they're able to survive—to thrive—generation after generation."

Scary, squishy, cool, brainless, mesmerizing—jellyfish are all of these and a whole lot more. Anatomically, they're relatively simple animals; they lack not just brains, but also blood and bones, and possess only rudimentary sense organs. Despite their name, jellyfish aren't, of course, fish. In fact, they aren't any one thing.

Many of the creatures lumped together as jellyfish are no more closely related than, say, horseflies are to horses. Not only do they occupy disparate

Scyphozoan Jellyfish
Rhopilema sp.
Specimen #256; 3.5 inches overall length;
Kamo Aquarium, Tsuruoka, Yamagata, Japan

ANATOMICALLY, JELLYFISH ARE RELATIVELY SIMPLE ANIMALS; THEY LACK NOT JUST BRAINS, BUT ALSO BLOOD AND BONES, AND POSSESS ONLY RUDIMENTARY SENSE ORGANS.

branches of the animal family tree, but they also live in different habitats; some like the ocean surface, others the depths, and a few prefer freshwater. What unites them is that they've converged on a similarly successful strategy for floating through life: Their bodies are gelatinous.

NOT SURPRISINGLY, given their diverse evolutionary history, jellies exhibit a fantastic range of shapes, sizes, and behaviors. When it comes to reproduction, they're some of the most versatile creatures on the planet. Jellyfish can produce offspring both sexually and asexually; depending on the species, they may be able to create copies of themselves by dividing in two, or laying down little pods of cells, or spinning off tiny snowflake-shaped clones in a process known as strobilation.

Most astonishing of all, some jellies seem able to reproduce from beyond the grave. The so-called immortal jellyfish resembles a tiny, hairy thimble, and lives in the Mediterranean Sea and also off Japan. Members of the species can reverse the aging process so that instead of expiring, they reconstitute themselves as juveniles. The juvenile then starts the jellyfish's life cycle all over again. It's as if a frog, say, were to revert to a tadpole or a butterfly to a caterpillar. Scientists call the near-miraculous process transdifferentiation.

Moon jellies and their cousins, which include lion's mane jellies and sea nettles, are known as true jellies. They belong to the class Scyphozoa, in the phylum Cnidaria, which also includes corals. (A phylum is such a broad taxonomic category that humans, fish, snakes, frogs, and all other animals with a backbone belong to the same one—the chordates—as do salps, which are sometimes lumped with jellies.) As adults, true jellies are shaped like upside-down saucers or billowing parachutes. They propel themselves through the water by contracting the muscles of their bells, and their tentacles are equipped with stinging cells that shoot out tiny barbed tubes to harpoon floating prey. To reel it into their mouths, they use streamer-like

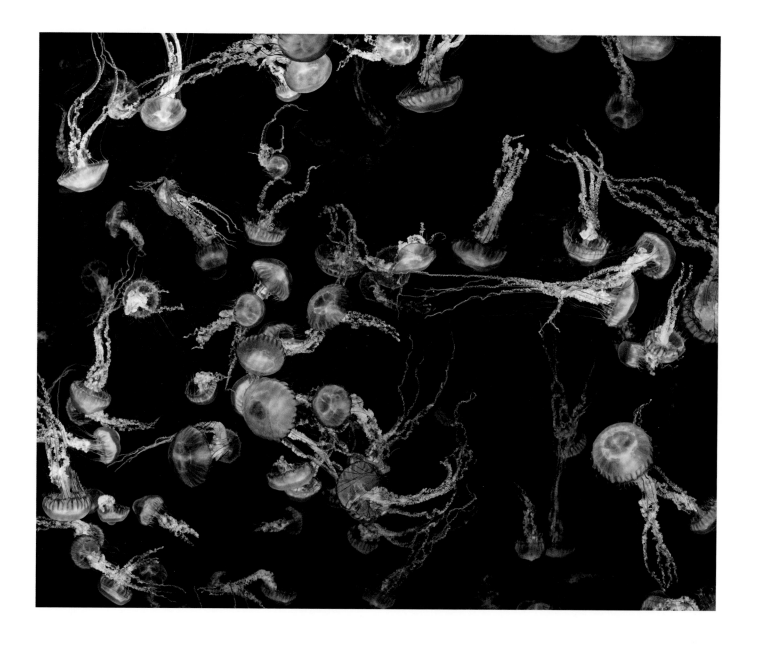

Pacific Sea Nettle
Chrysaora fuscescens
Specimen #233 group; up to 2 feet long;
Enoshima Aquarium, Fujisawa, Kanagawa, Japan

appendages known as oral arms. In some species the oral arms have mouths of their own.

Jellyfish like the dreaded Portuguese man-of-war are also related to corals, but they're part of a different subgroup, the siphonophores, which practice an unusual form of collective living. What looks like a single man-of-war is technically a colony that developed from the same embryo. Instead of simply growing larger, the embryo sprouts new "bodies," which take on different functions. Some develop into tentacles, for example; others become reproductive organs.

"In the human life cycle, our body, when we're born, has all the pieces that are going to be there as an adult," observes Casey Dunn, a professor

JELLYFISH SPECIES

Some 2,000 species are known to have a medusa (swimming) phase of their life cycle. A sample of their diversity is shown at right.

3 ft

6 ft

120 ft long

440 lb

- Lion's mane jellyfish
 Cyanea capillata
 The largest of this cold-water species live in Arctic waters.

- Nomura's jellyfish
 Nemopilema nomurai
 Swarms of these gigantic jellies have massed in Japanese waters.

HOW JELLYFISH FEED

Atlantic bay nettles only swim to find food. Currents help bring them in contact with their prey: zooplankton, crustaceans, and even other jellies.

1. Swimming

Like other jellies, the Atlantic bay nettle hunts not by sight but by direct contact, spreading its oral arms and tentacles wide. Vortices help draw in prey.

Rowers

Atlantic bay nettles and many other large medusozoans contract the rims of their bells, generating vortices as they swim with a rowing motion.

2. Stinging

Millions of stinging cells (A) line the tentacles and arms. Some have coiled, barbed tubules that, when triggered, (B) uncoil with enough force to pierce shells or flesh to (C) inject venom.

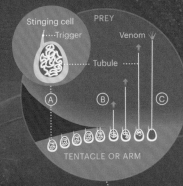

Stinging cell — Trigger — PREY — Venom — Tubule
(A) (B) (C)
TENTACLE OR ARM

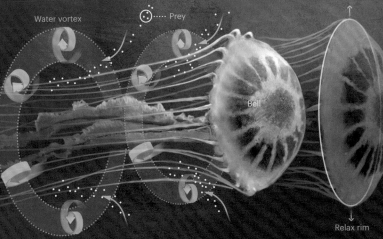

Atlantic bay nettle

Water vortex · · · · · Prey

Bell

Relax rim

Contract rim

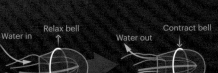

Water in — Relax bell — Water out — Contract bell

Jetters

Many smaller medusozoans contract the entire bell, expelling a jet of water that propels them forward.

Small prey
Zooplankton

Big prey
Mnemiopsis comb jelly

BONELESS BEAUTIES

Being 95 percent water and gelatinous is a good strategy on an ocean planet, which is why jellyfish have survived for hundreds of millions of years. The term covers thousands of species in two barely related categories: the comb jellies and the medusozoans, such as the Atlantic bay nettle, featured here. It's a familiar menace to

FAMILY TREE

CNIDARIA
- ANTHOZOA (sea anemones, corals, sea pens)
- ENDOCNIDOZOA (parasites)
- MEDUSOZOA
 - ● Staurozoa (stalked jellyfish)
 - ● Cubozoa (box jellies)
 - ◐ Scyphozoa (true jellies)
 - ● Hydrozoa (most species remain in polyp form)

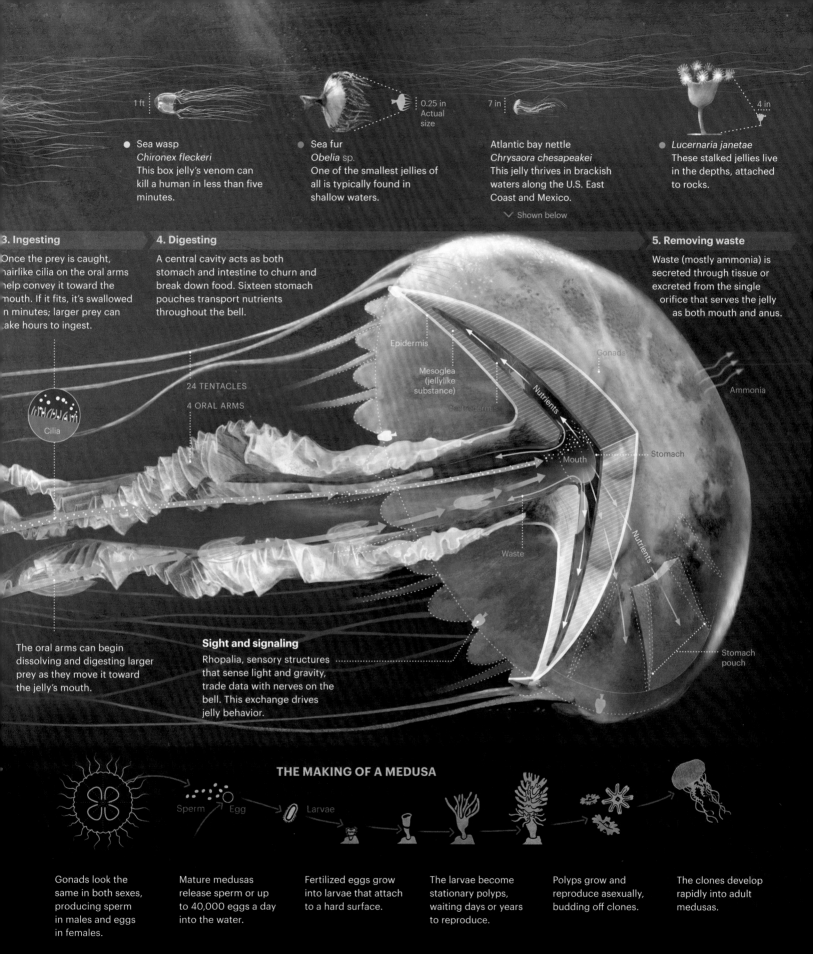

Sea wasp
Chironex fleckeri
This box jelly's venom can kill a human in less than five minutes.

1 ft

Sea fur
Obelia sp.
One of the smallest jellies of all is typically found in shallow waters.

0.25 in
Actual size

Atlantic bay nettle
Chrysaora chesapeakei
This jelly thrives in brackish waters along the U.S. East Coast and Mexico.

7 in

⌄ Shown below

Lucernaria janetae
These stalked jellies live in the depths, attached to rocks.

4 in

3. Ingesting

Once the prey is caught, hairlike cilia on the oral arms help convey it toward the mouth. If it fits, it's swallowed in minutes; larger prey can take hours to ingest.

Cilia

24 TENTACLES
4 ORAL ARMS

The oral arms can begin dissolving and digesting larger prey as they move it toward the jelly's mouth.

4. Digesting

A central cavity acts as both stomach and intestine to churn and break down food. Sixteen stomach pouches transport nutrients throughout the bell.

Epidermis

Mesoglea (jellylike substance)

Gastrodermis

Nutrients

Mouth

Waste

Sight and signaling
Rhopalia, sensory structures that sense light and gravity, trade data with nerves on the bell. This exchange drives jelly behavior.

5. Removing waste

Waste (mostly ammonia) is secreted through tissue or excreted from the single orifice that serves the jelly as both mouth and anus.

Gonads

Ammonia

Stomach

Nutrients

Stomach pouch

THE MAKING OF A MEDUSA

Sperm Egg Larvae

Gonads look the same in both sexes, producing sperm in males and eggs in females.

Mature medusas release sperm or up to 40,000 eggs a day into the water.

Fertilized eggs grow into larvae that attach to a hard surface.

The larvae become stationary polyps, waiting days or years to reproduce.

Polyps grow and reproduce asexually, budding off clones.

The clones develop rapidly into adult medusas.

GRAPHIC BY FERNANDO G. BAPTISTA, EVE CONANT, KATHERINE APPEL, AND ALISON HARFORD, NGM STAFF; LAWSON PARKER
SOURCES: KEITH BAYHA, REBECCA HELM, AND ALLEN COLLINS, SMITHSONIAN NATIONAL MUSEUM OF NATURAL HISTORY; JENNIE JANSSEN, NATIONAL AQUARIUM

MOST ASTONISHING OF ALL, SOME JELLIES SEEM ABLE TO REPRODUCE FROM BEYOND THE GRAVE.

of evolutionary biology at Yale University. "The really cool thing about siphonophores is they've gone about things in a very different way."

Then there are the ctenophores (pronounced TEH-nuh-fores), which are such oddballs that they've been placed in a phylum of their own. Also known as comb jellies, for the comblike rows of tiny paddles they use to swim, they tend to be small, delicate, and hard to study. They come in an array of weird body types: Some are flat and ribbonlike; others look more like pockets or little crowns. Most use an adhesive to nab their prey. "They have what's like exploding glue packets embedded in their tentacles," explains Steve Haddock, a senior scientist at the Monterey Bay Aquarium Research Institute.

IN RECENT DECADES, jellyfish populations in some parts of the world have boomed. In the 1980s, a comb jelly that's known formally as *Mnemiopsis leidyi* and informally as the sea walnut showed up in the Black Sea. A native of the western Atlantic, it presumably had been transported in a ship's ballast water and then been discharged. In the Black Sea, it reproduced so prolifically that by 1989, it had reached densities of up to 11 per cubic foot of water. Fish couldn't compete with the jellies for food—sea walnuts eat as much as 10 times their body weight a day—and many fish became food for the jellies. Local fisheries collapsed.

In other parts of the world, swarms of jellyfish have menaced swimmers and clogged fishing nets. In 2006, beaches in Italy and Spain were closed because of a bloom of jellyfish known as mauve stingers. In 2013 a Swedish nuclear plant temporarily shut down because moon jellies were blocking its intake pipes.

Situations like these led to a spate of reports that jellyfish were taking over the seas. One website warned of the "attack of the blob." Another predicted "goomageddon."

But scientists say the situation is more complicated than such headlines suggest. Jellyfish populations fluctuate naturally, and people tend to notice only the boom part of the cycle.

"A big jellyfish bloom makes the headlines, while a lack of a jellyfish bloom isn't even worth reporting," says Lucas Brotz, a marine zoologist at the University of British Columbia. Although some jellyfish species seem to thrive on human disturbance—off the coast of Namibia, for example, overfishing may have tipped the ecosystem into a new state dominated by compass and crystal jellyfish—other more finicky species appear to be declining. Researchers in a couple parts of the world have reported a drop in the number of jellyfish species they are encountering.

Meanwhile, if people are having more unpleasant encounters with jellyfish, is it because they're taking over the seas or because we are?

"Anytime we have an adverse encounter with jellyfish, it's because humans have invaded the oceans," Haddock says. "We're the ones who are encroaching into their habitat." Jellyfish are only doing what they've been doing generation after generation for hundreds of millions of years—just pulsing along, silently, brainlessly, and, seen in the right light, gorgeously. •

Hydrozoan Jellyfish
Zanclea sp.
Specimen #46; bell is 0.125 inch high; CIEE Research Station
Bonaire, Kralendijk, Caribbean Netherlands

Anthomedusae Jellyfish
Zancleopsis tentaculata
Specimen #2; 0.5 inch overall length; CIEE Research Station Bonaire, Kralendijk,
Caribbean Netherlands

OPPOSITE

Hydrozoan Jellyfish
Unidentified species
Specimen #19; bell is 0.125 inch across; CIEE Research Station Bonaire,
Kralendijk, Caribbean Netherlands

Cydippid Comb Jelly
Unidentified species
Specimen #15; 0.5 inch overall length; CIEE Research Station
Bonaire, Kralendijk, Caribbean Netherlands

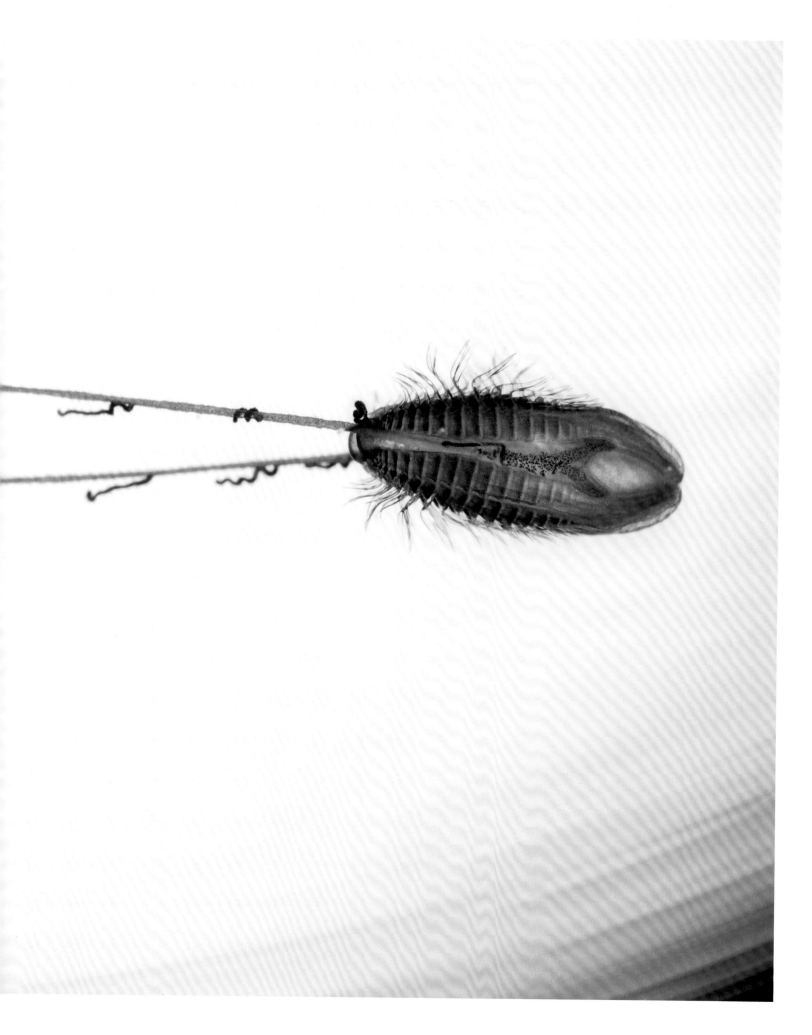

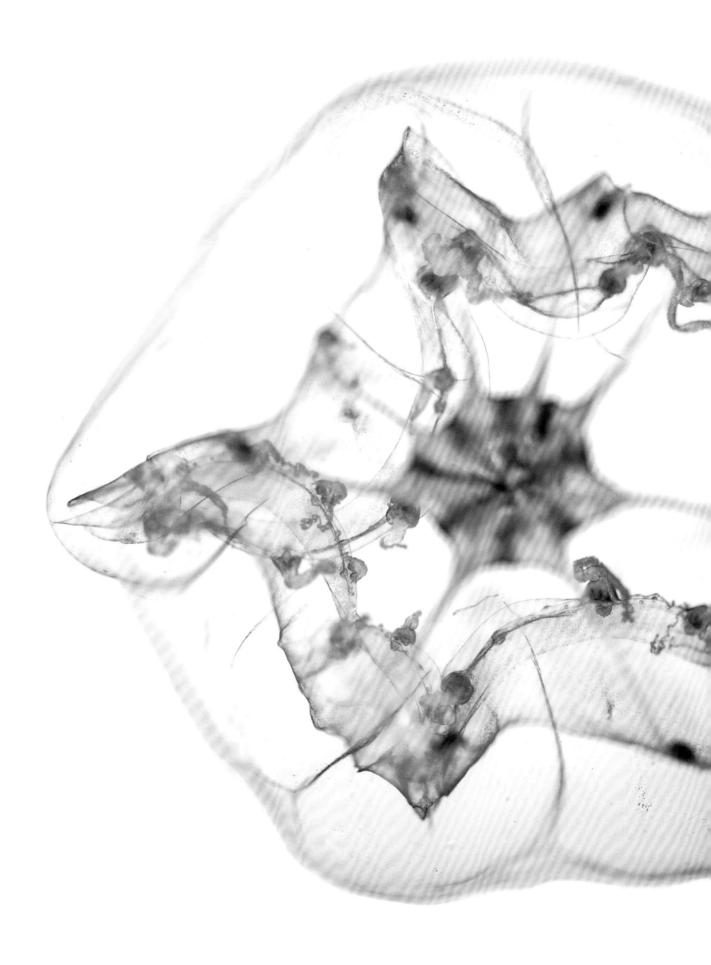

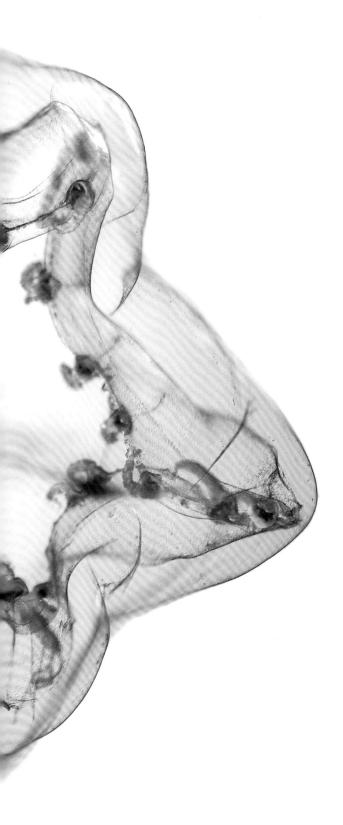

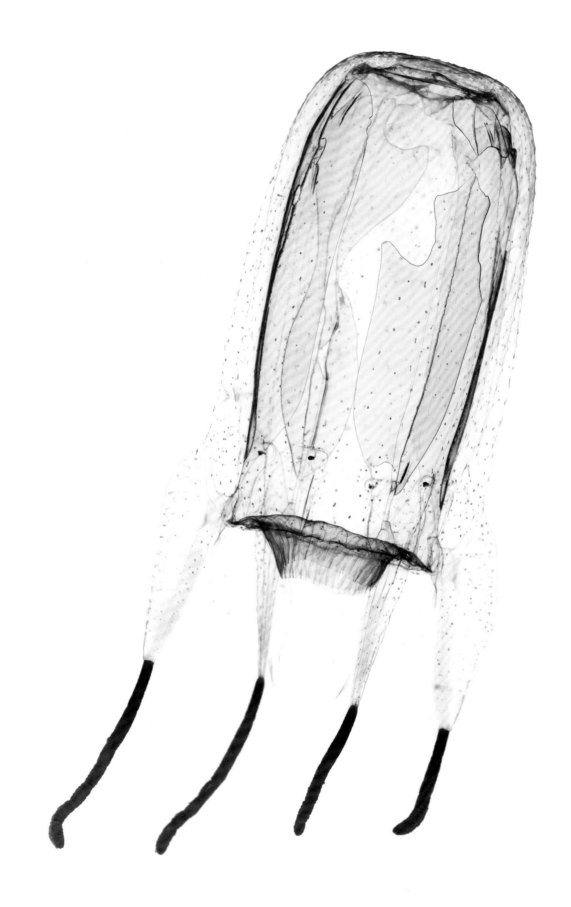

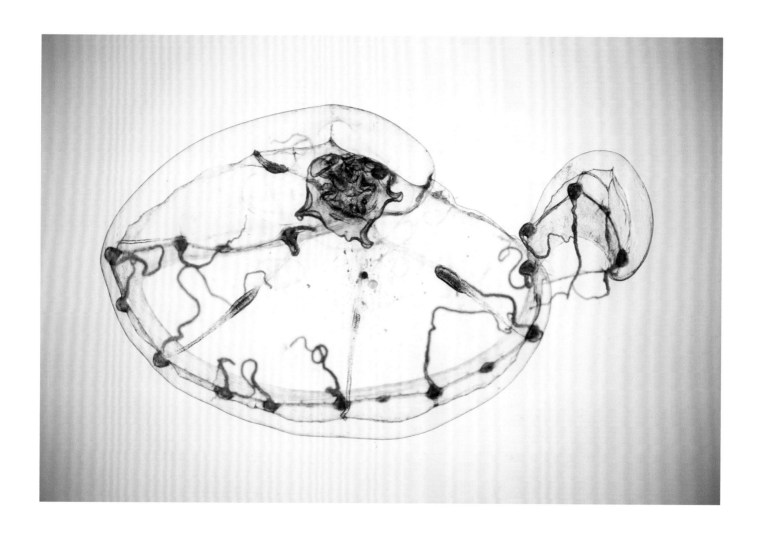

Hydrozoan Jellyfish

Dipleurosoma sp.

Specimen #15a; 0.375 inch across; CIEE Research Station Bonaire, Kralendijk, Caribbean Netherlands

This specimen is in the process of splitting itself into two individuals.

OPPOSITE

Box Jelly

Alatina alata

Specimen #39; spawning male; bell is 3.25 inches long; CIEE Research Station Bonaire, Kralendijk, Caribbean Netherlands

This species of box jellyfish is also commonly referred to as a "sea wasp," due to the ferocity of its sting.

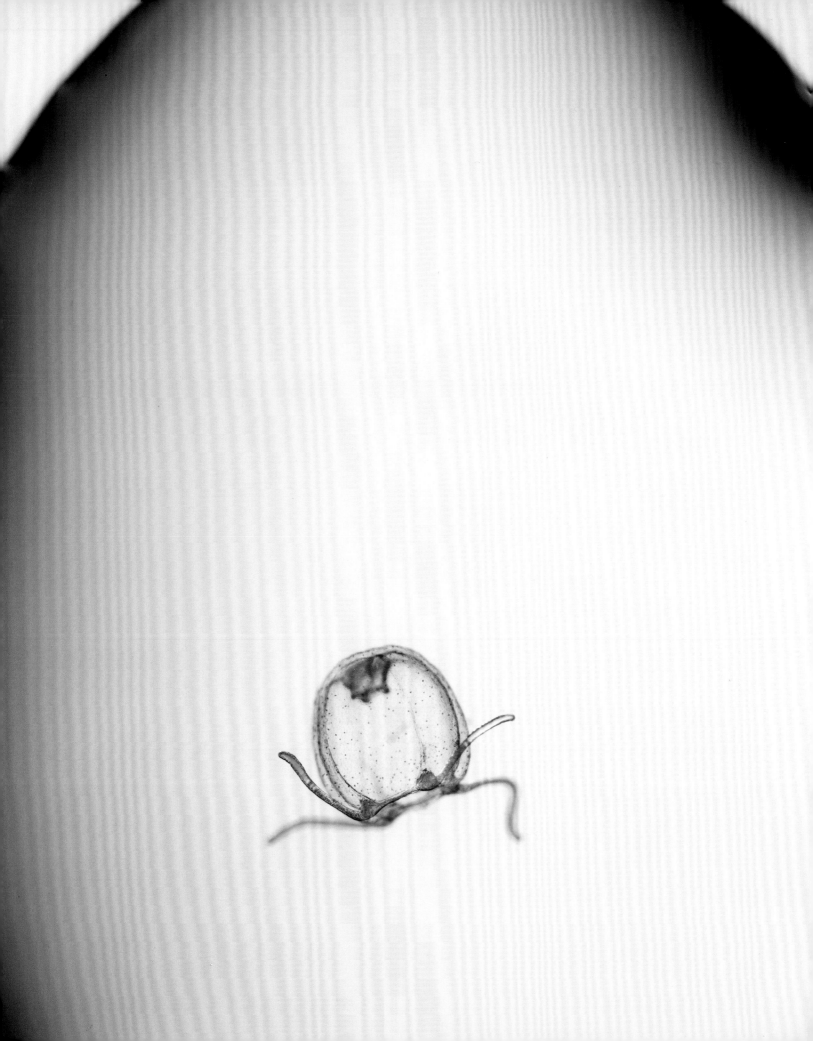

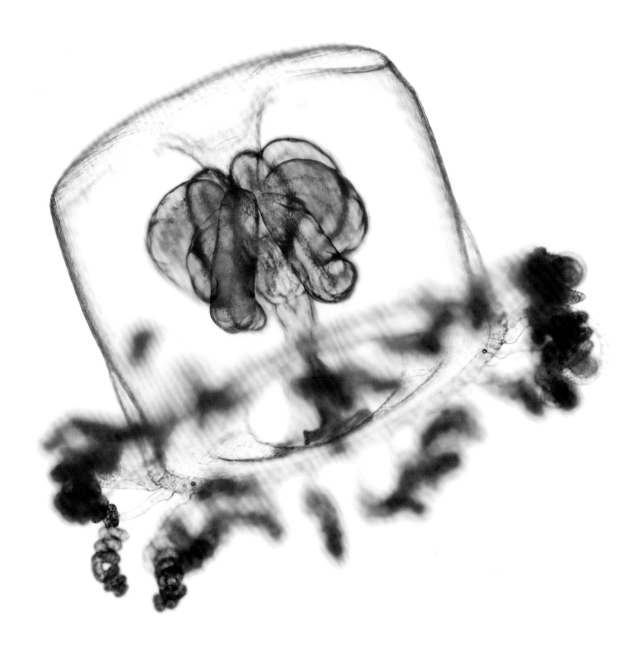

Epipelagic Trachymedusa Jellyfish

Aglaura hemistoma

Specimen #23; nearly 0.125 inch across; CIEE Research Station Bonaire, Kralendijk, Caribbean Netherlands

OPPOSITE

Hydrozoan Jellyfish

Unidentified species

Specimen #22; the bell is about 0.03125 inch across; CIEE Research Station Bonaire, Kralendijk, Caribbean Netherlands

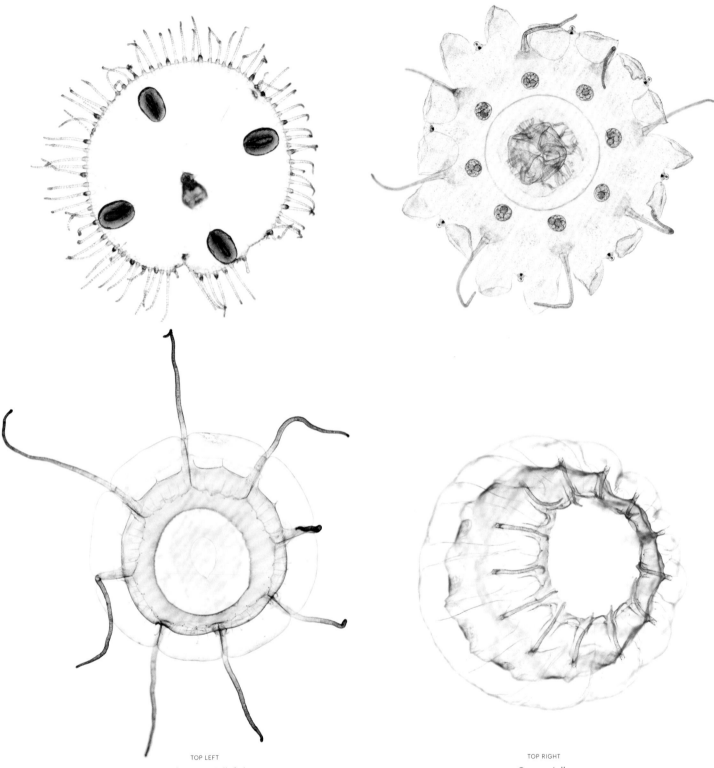

TOP LEFT

Hydrozoan Jellyfish

Obelia sp.

Specimen #120; 0.125 inch across; Smithsonian Marine Station,
Fort Pierce, Florida, United States of America

BOTTOM LEFT

Hydrozoan Jellyfish

Pegantha sp.

Specimen #42; 0.5 inch across including tentacles; CIEE
Research Station Bonaire, Kralendijk, Caribbean Netherlands

TOP RIGHT

Crown Jelly

Nausithoe sp.

Specimen #54; 0.25 inch across; CIEE Research Station Bonaire,
Kralendijk, Caribbean Netherlands

BOTTOM RIGHT

Hydrozoan Jellyfish

Solmaris sp.

Specimen #45; 0.25 inch across; CIEE Research Station Bonaire,
Kralendijk, Caribbean Netherlands

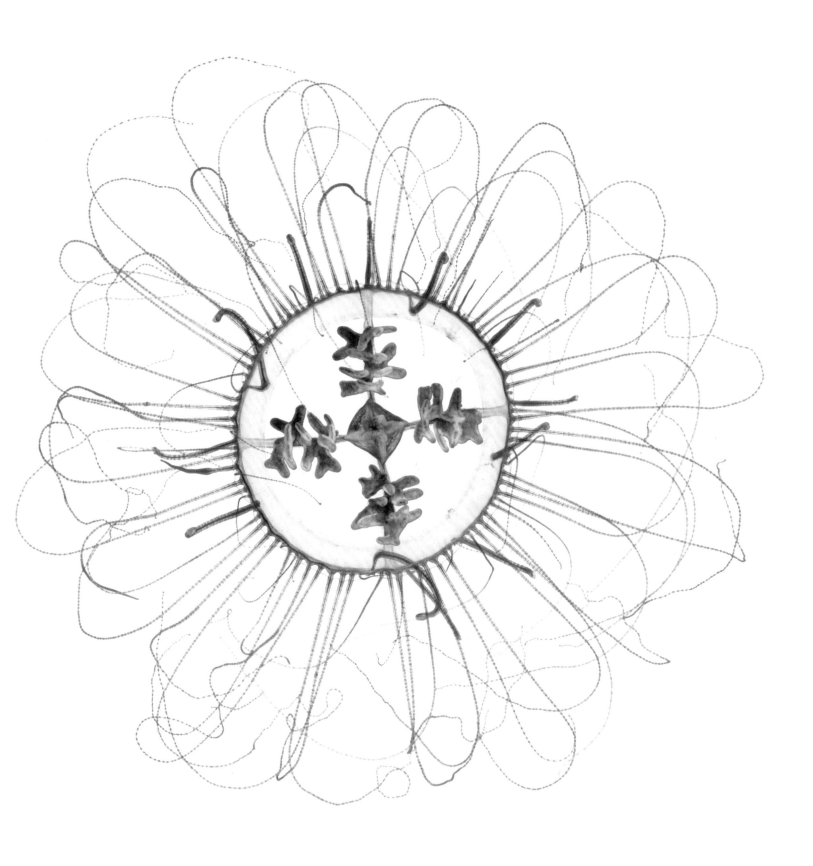

Marsh Jellyfish

Vallentinia gabriellae

Specimen #121; male; about 1 inch across including tentacles; Smithsonian Marine Station,
Fort Pierce, Florida, United States of America

Hydrozoan Jellyfish
Amphinema sp.
Specimen #130; 0.5 inch long including tentacle; Smithsonian
Marine Station, Fort Pierce, Florida, United States of America

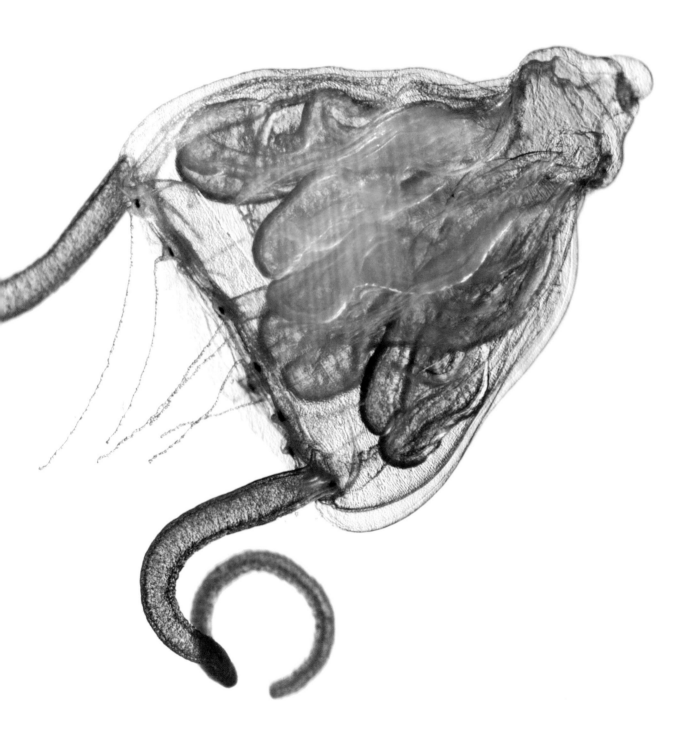

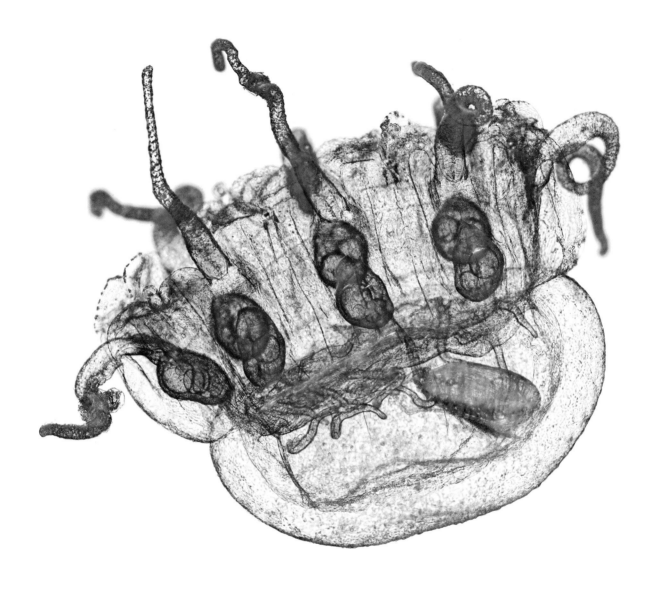

Hydrozoan Jellyfish

Unidentified species

Specimen #145; 0.125 inch across; Smithsonian Marine Station, Fort Pierce,
Florida, United States of America

OPPOSITE

Immortal Jellyfish

Turritopsis dohrnii

Specimen #130c; 0.375 inch across, including tentacles; Smithsonian Marine
Station, Fort Pierce, Florida, United States of America

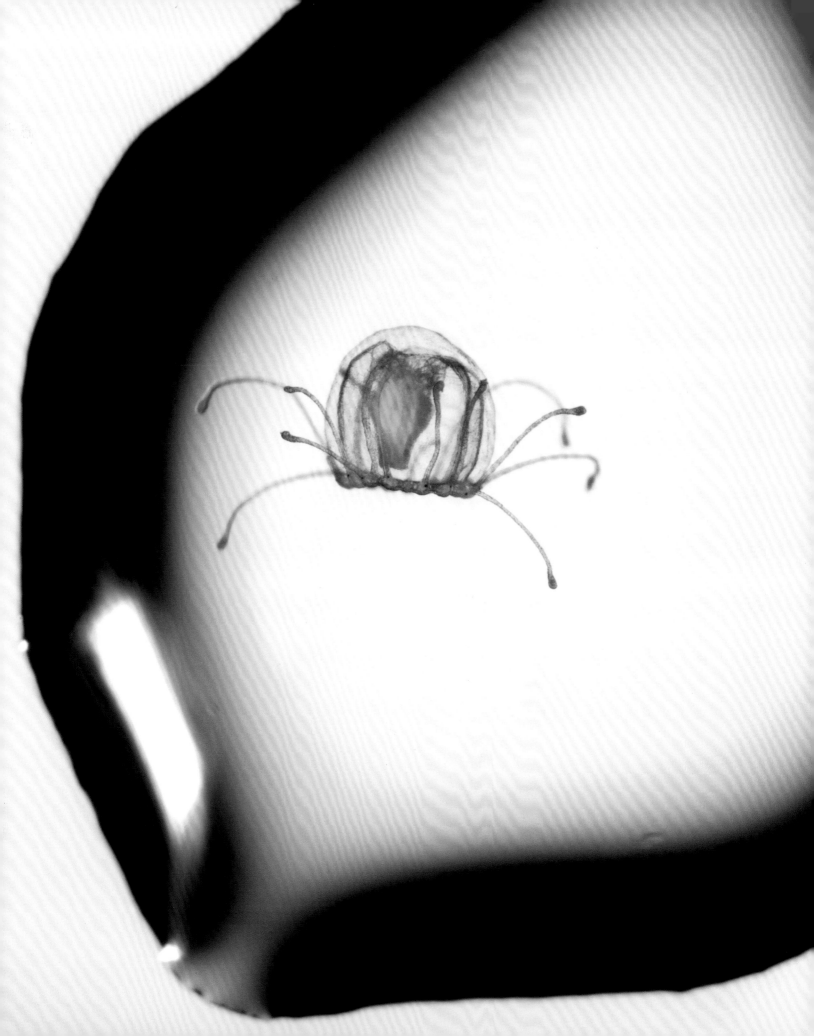

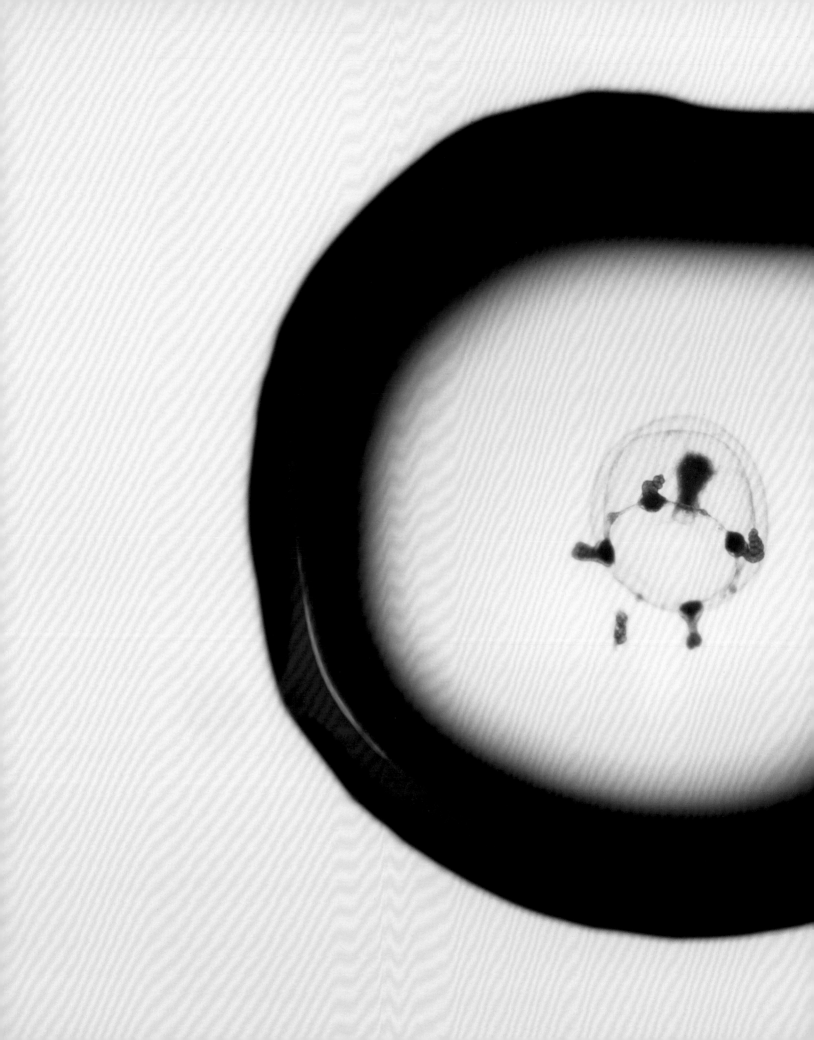

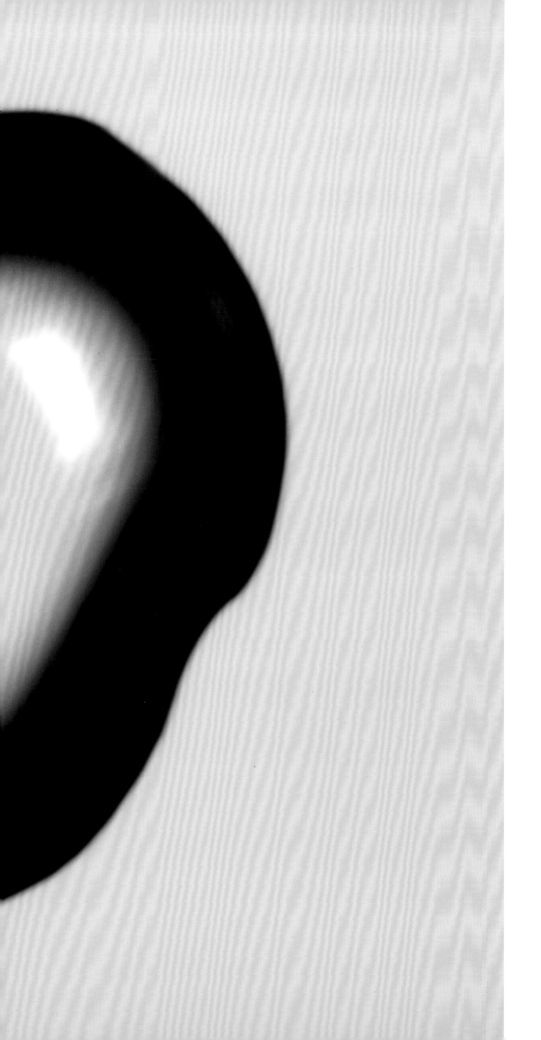

Crystal Jelly
Aequorea victoria
Specimen #222; 0.1875 inch across;
National Aquarium, Baltimore, Maryland,
United States of America

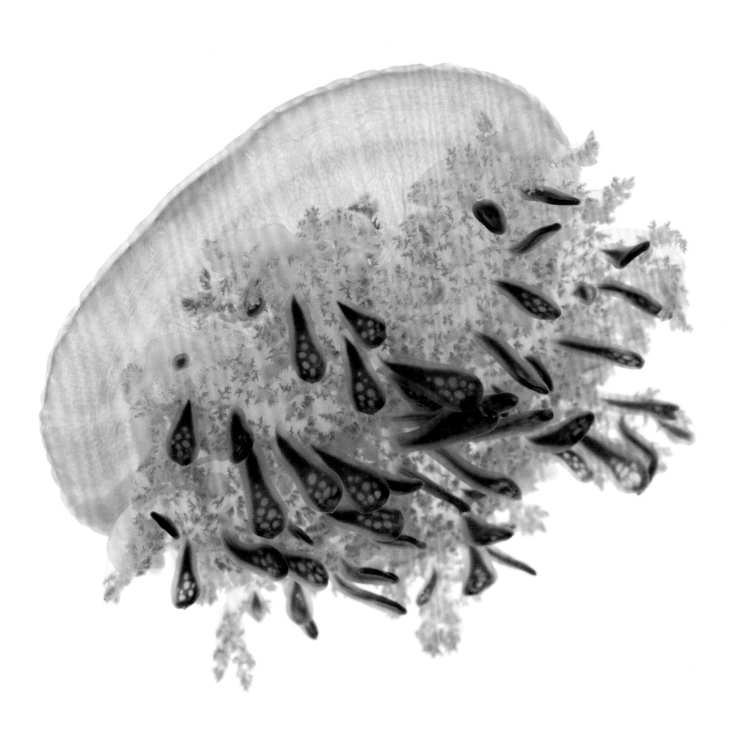

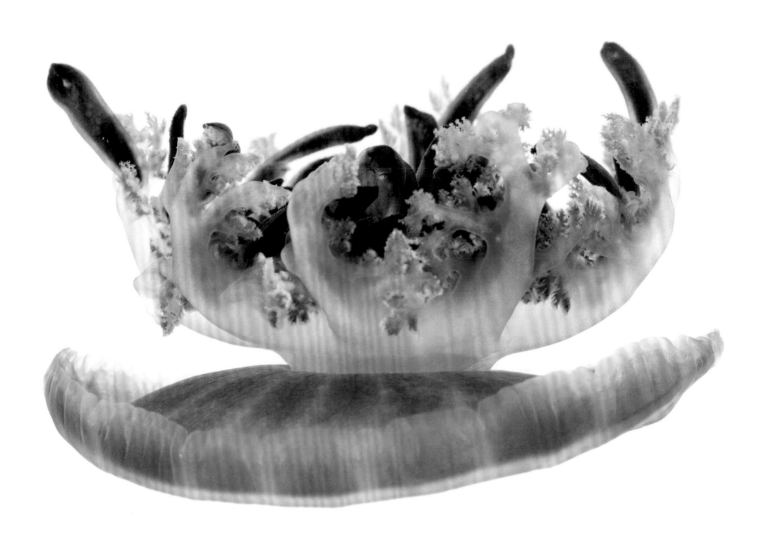

Upside-down Jellyfish

Cassiopea xamachana

Above: specimen #193; bell is 3 inches across

Opposite: specimen #191; bell is 3 inches across

Elizabeth Moore International Center for Coral Reef Research & Restoration,
Summerland Key, Florida, United States of America

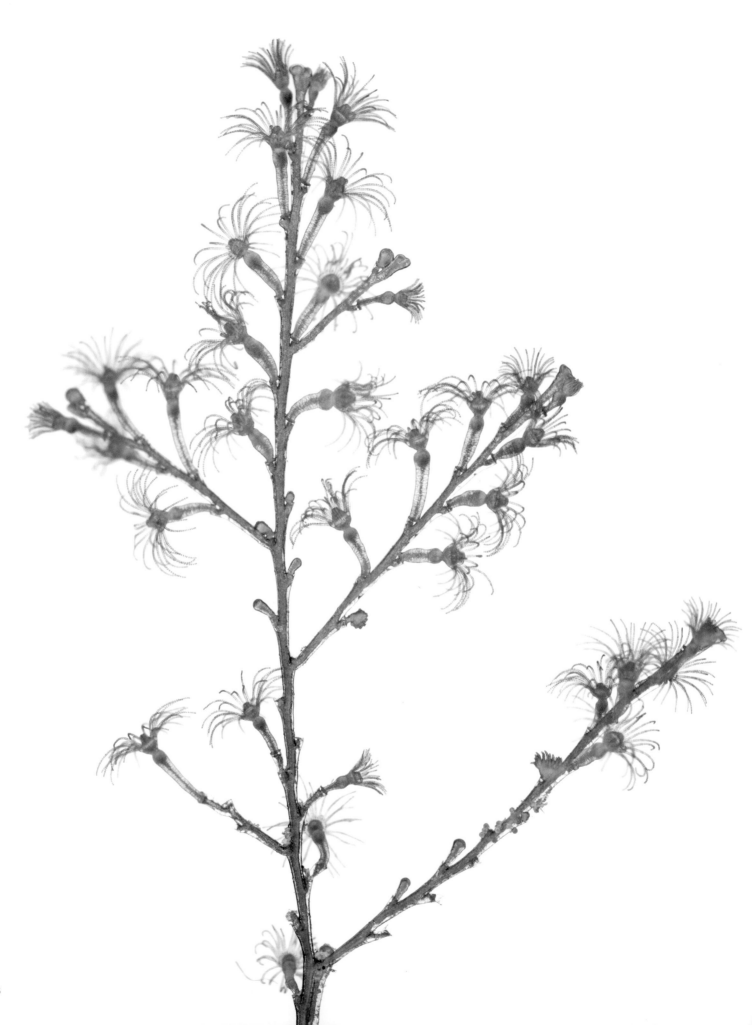

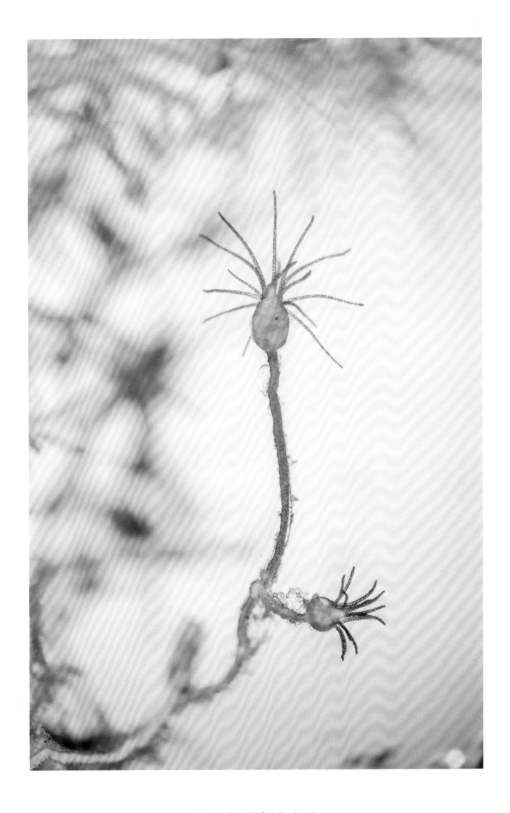

Umbrella Jellyfish hydroids
Eutonina indicans
Specimen #224; 0.25 inch long from base; National Aquarium, Baltimore, Maryland, United States of America

OPPOSITE
Hydroids
Nemalecium lighti
Specimen #55; 0.5 inch high; CIEE Research Station Bonaire, Kralendijk, Caribbean Netherlands

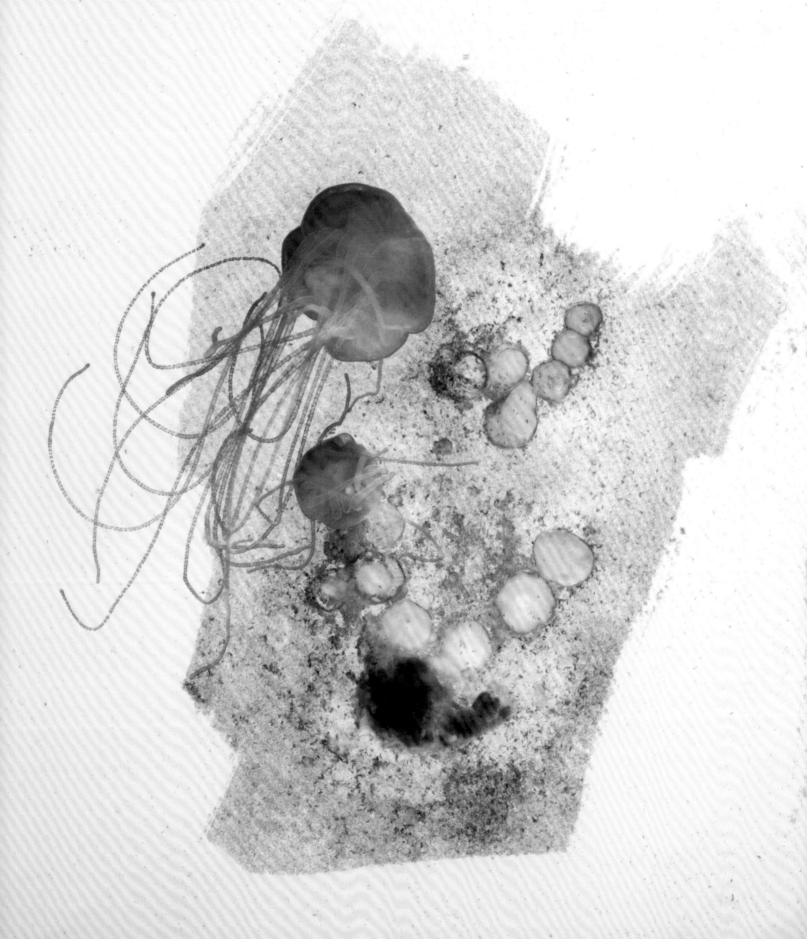

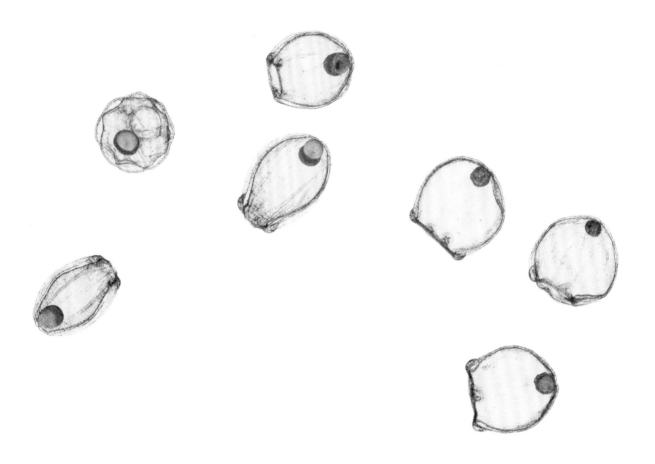

Hydrozoan Jellyfish medusoids
Unidentified species
Specimen #65; each individual is about 0.03125 inch across; CIEE Research Station Bonaire, Kralendijk, Caribbean Netherlands

Medusoids are autonomous jellyfish gonads—free-swimming carriers for eggs or sperm,
they have no mouth, and reproduction is the entirety of their existence.

OPPOSITE

Lion's Mane polyp and cyst
Cyanea capillata
Specimen #209; frame is 0.33 inch across; National Aquarium, Baltimore, Maryland, United States of America

The yellow sacs are cysts that polyps retreat into during poor conditions.
When conditions improve, they will become polyps again.

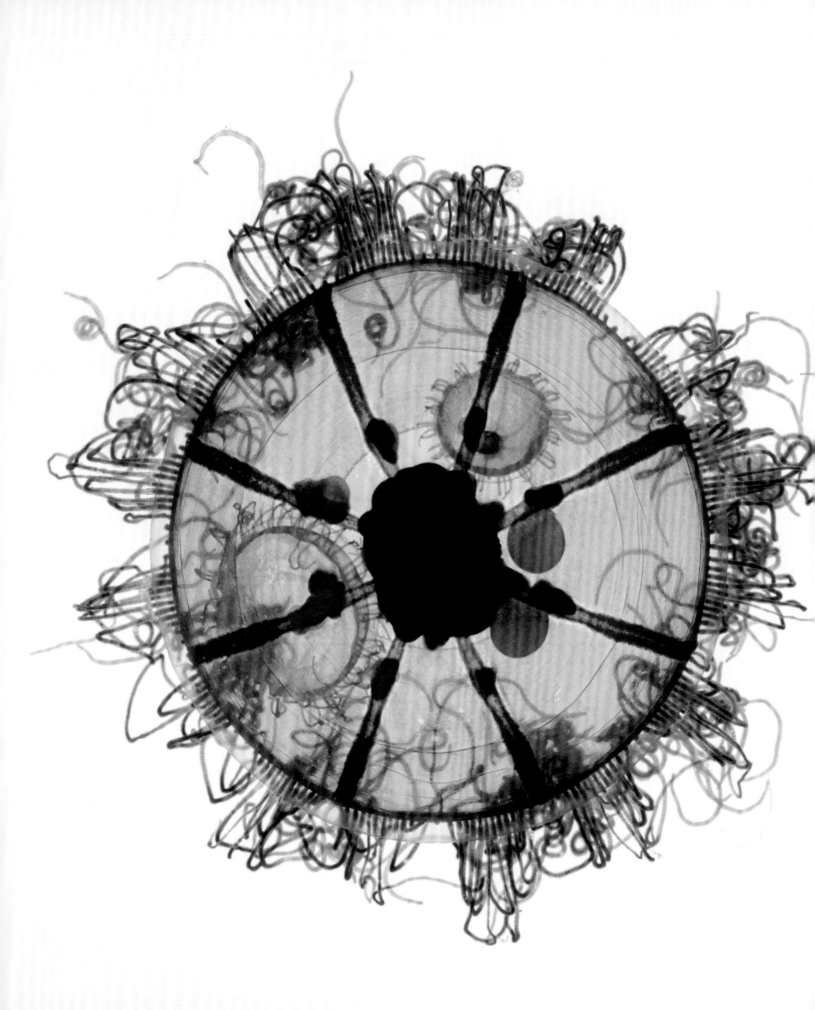

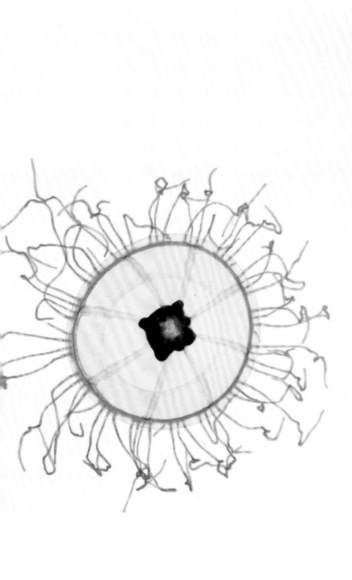

Jellyfish with young

Crossota millsae

Specimen #15; large bell is 1 inch across; aboard
the Monterey Bay Aquarium Research Institute
ship *Western Flyer* above the Monterey Canyon,
off the coast of Moss Landing, California,
United States of America

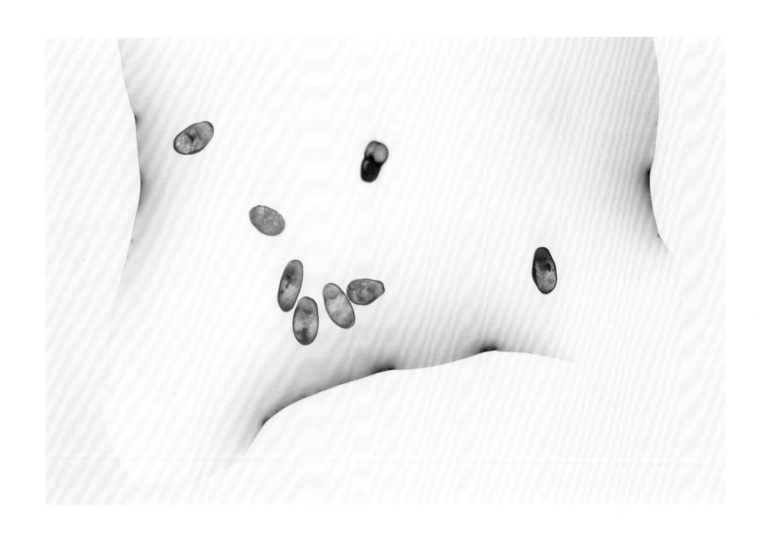

Mauve Stinger planulae
Pelagia noctiluca
Specimen #278; shown 30 times life size; Kamo Aquarium, Tsuruoka, Yamagata, Japan

Planulae are the free-swimming larvae of jellyfish.

OPPOSITE

Mauve Stinger
Pelagia noctiluca
Specimen #284; bell is 2 inches across; Kamo Aquarium, Tsuruoka, Yamagata, Japan

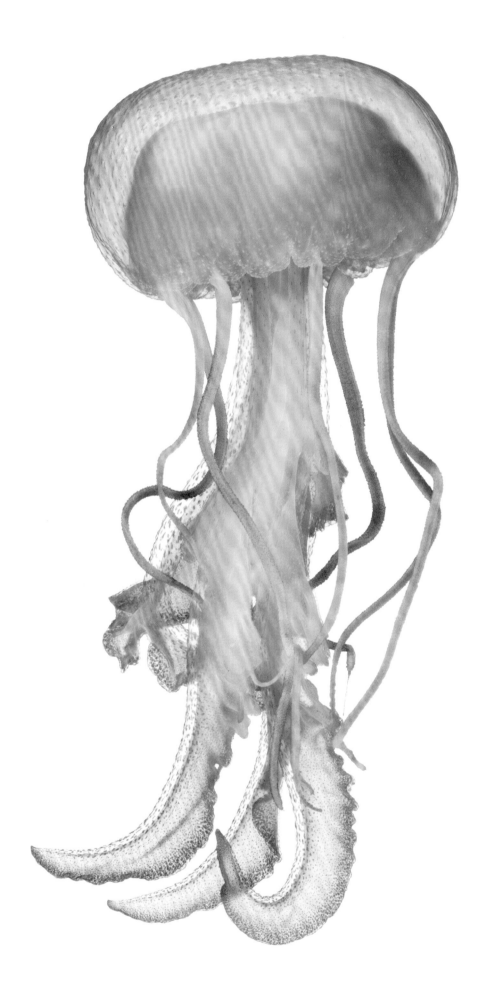

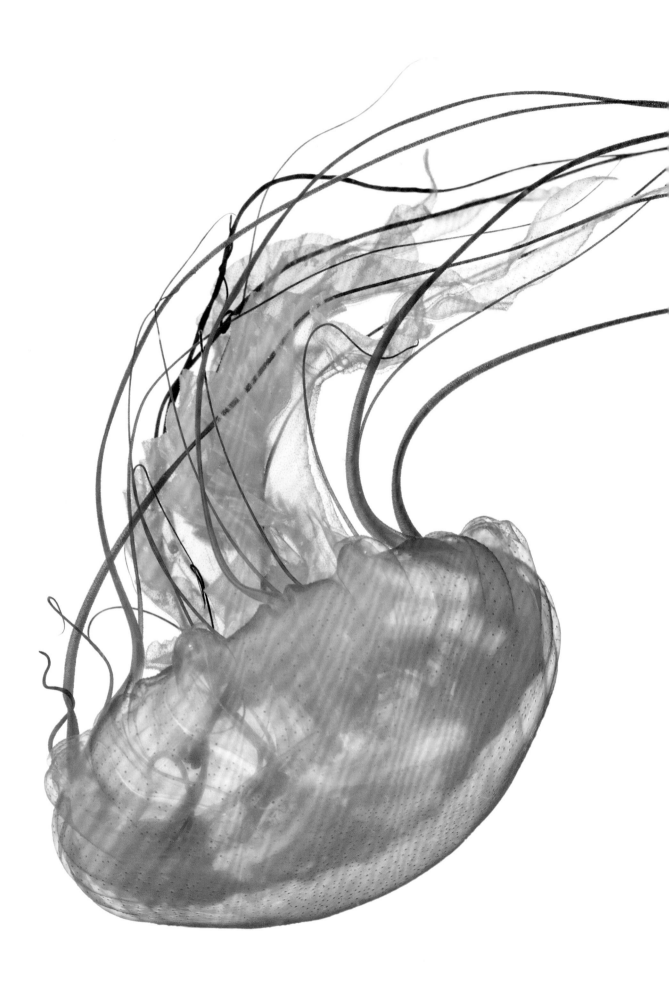

Brown Sea Nettle
Chrysaora fuscescens
Specimen #205; bell is 4 inches across; Monterey Bay
Aquarium, Monterey, California, United States of America

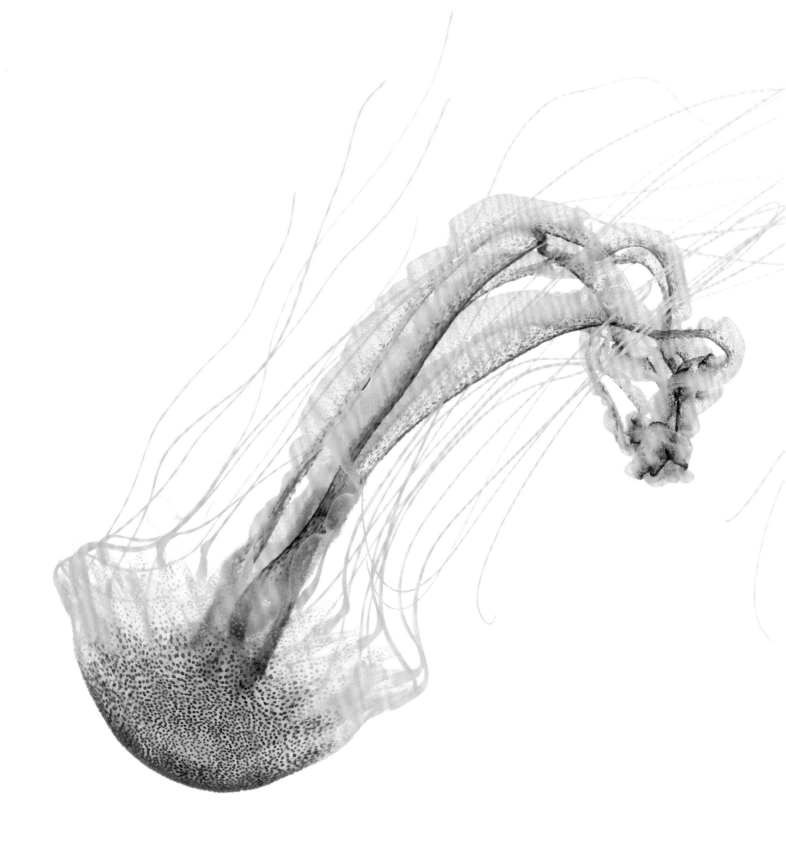

Atlantic Bay Nettle
Chrysaora chesapeakei
Specimen #231; bell is 2.25 inches across; National Aquarium, Baltimore, Maryland, United States of America

OPPOSITE

Purple-striped Jelly
Chrysaora colorata
Specimen #204; bell is 4 inches across; Monterey Bay Aquarium, Monterey, California, United States of America

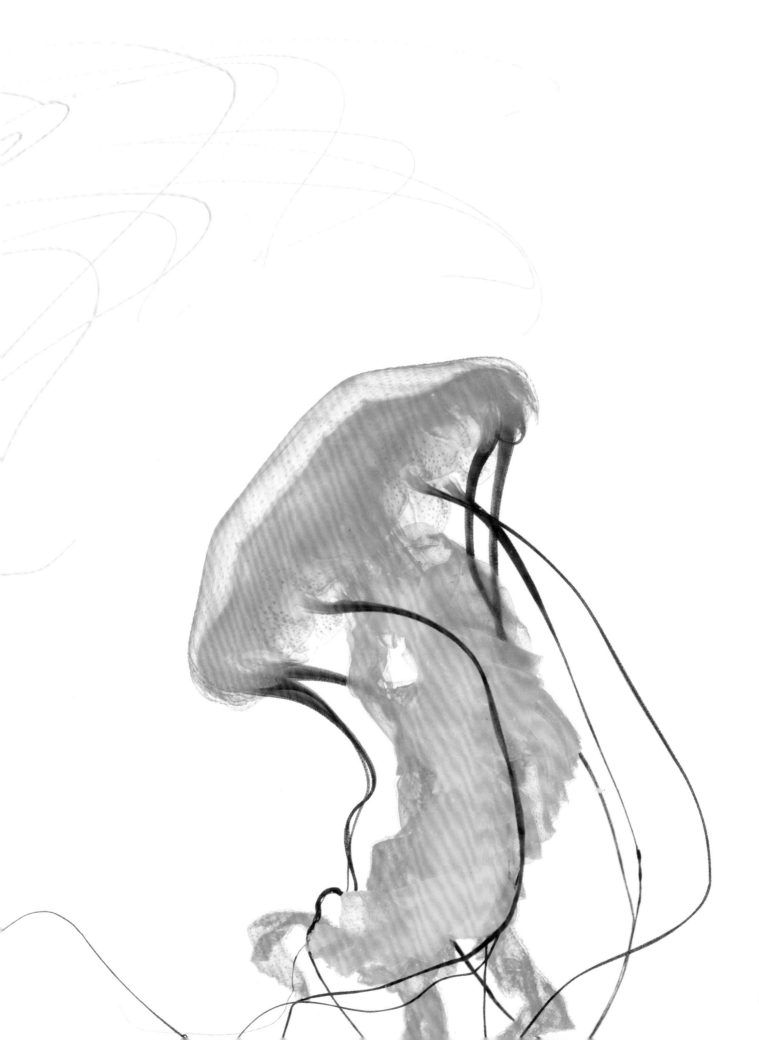

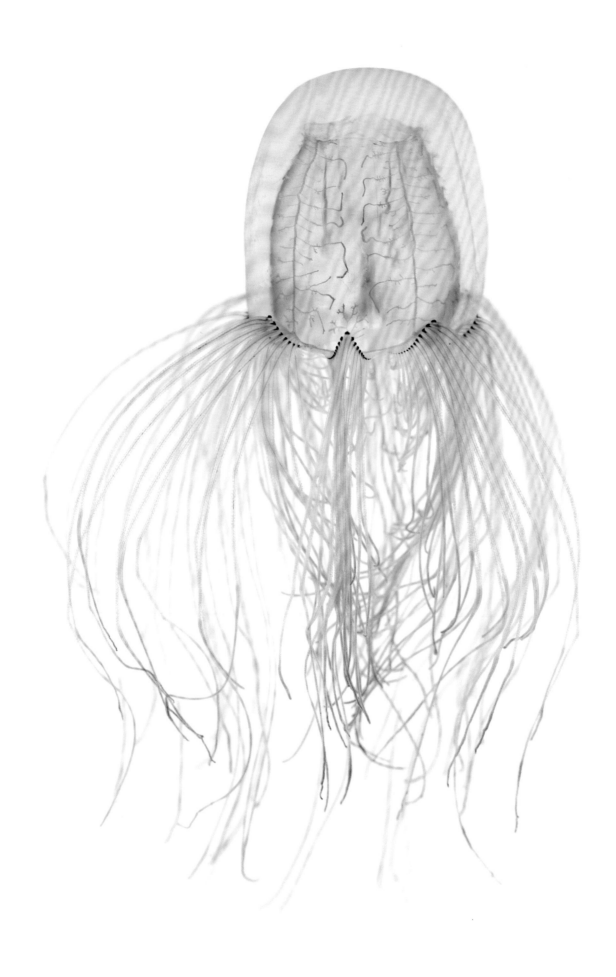

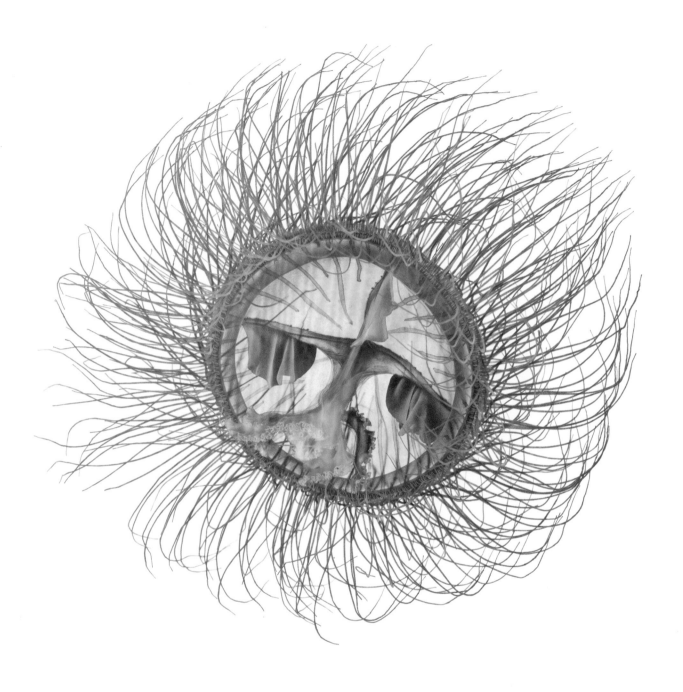

Black Sea Jellyfish

Maeotias inexpectata

Specimen #172; bell 2 inches across; Turning Basin, Petaluma River, Petaluma, California, United States of America

OPPOSITE

Hydrozoan Jellyfish

Spirocodon saltator

Specimen #239; bell is 1 inch across; Kamo Aquarium, Tsuruoka, Yamagata, Japan

FOLLOWING PAGES

Lion's Mane Jellyfish

Cyanea capillata

Specimen #227; bell is 6 inches across; National Aquarium, Baltimore, Maryland, United States of America

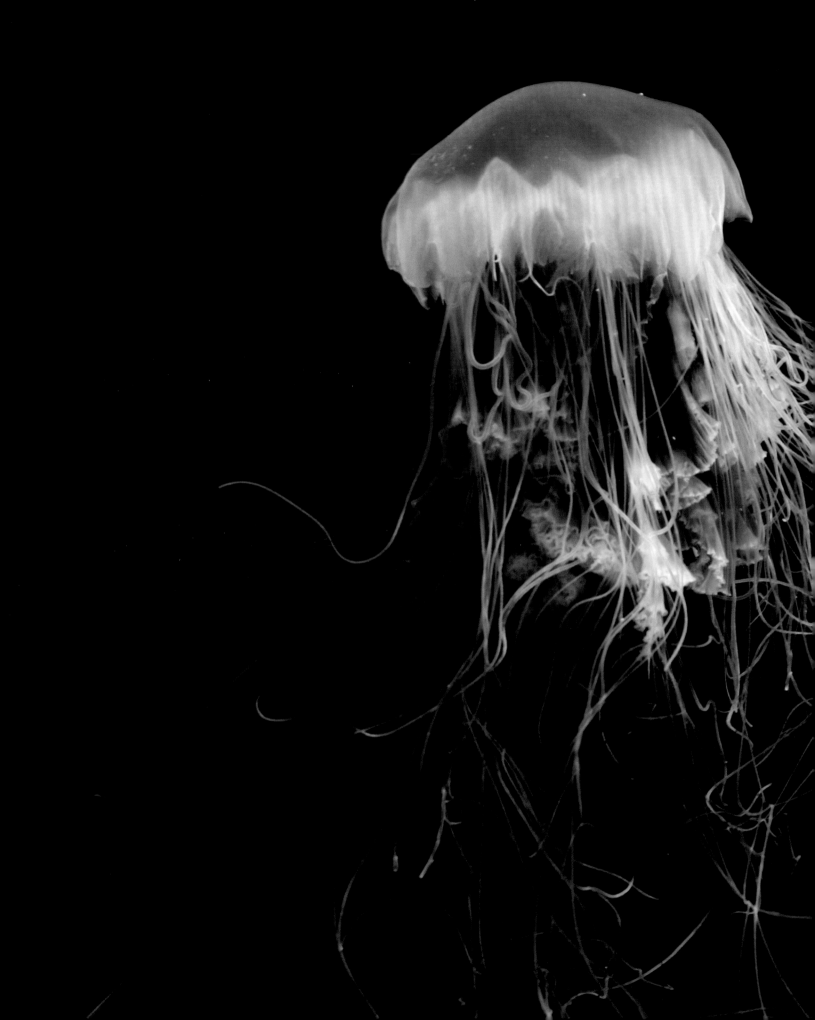

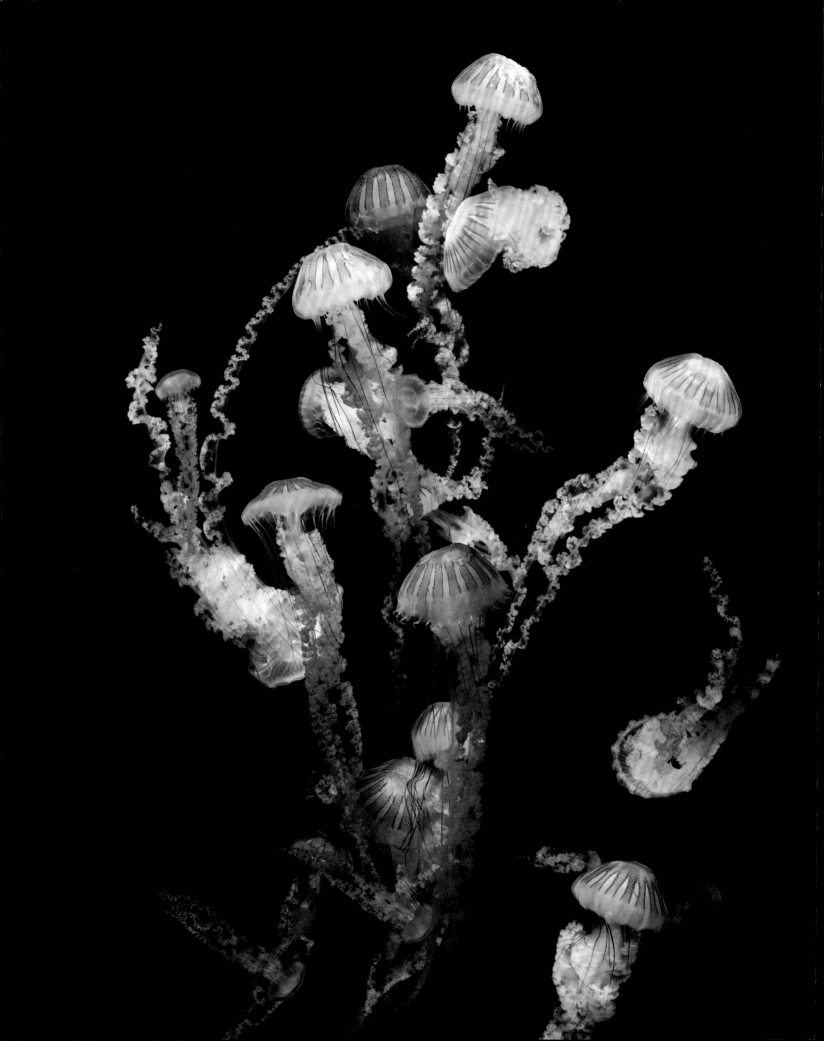

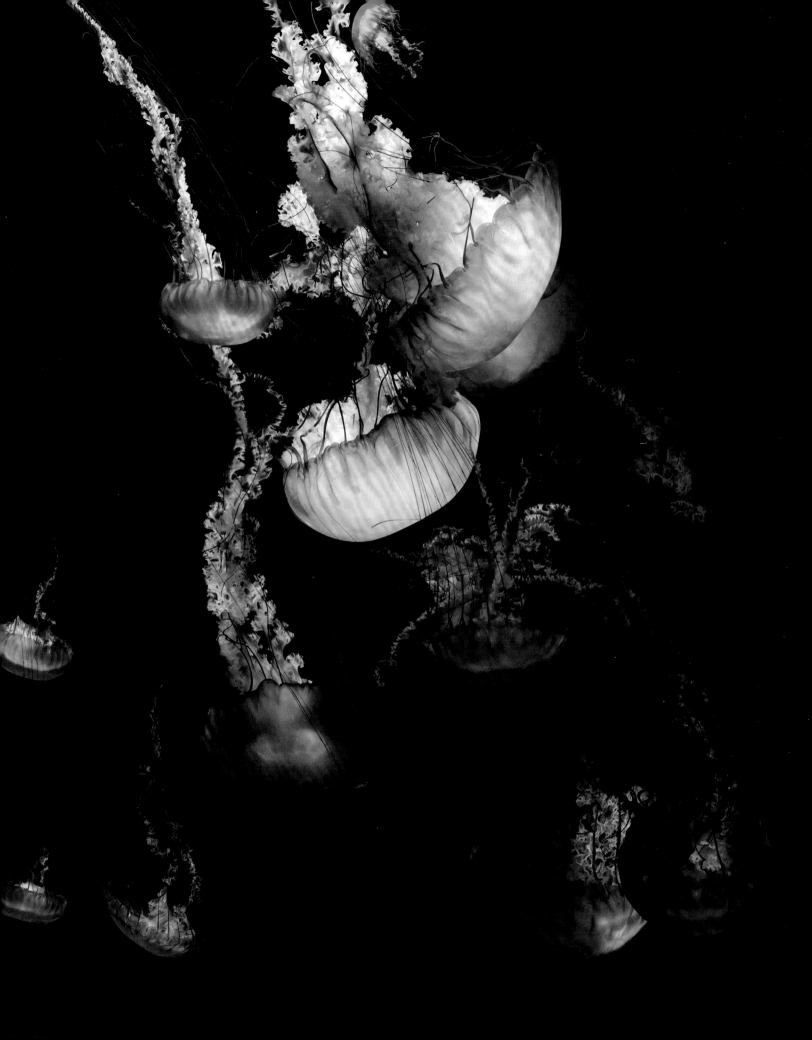

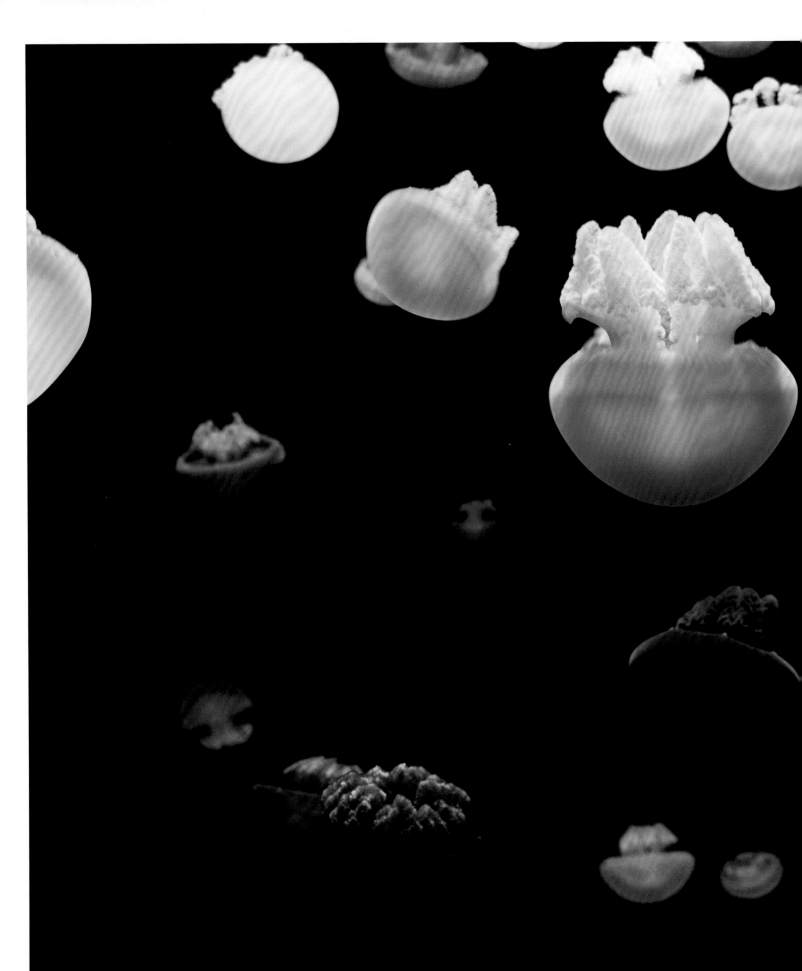

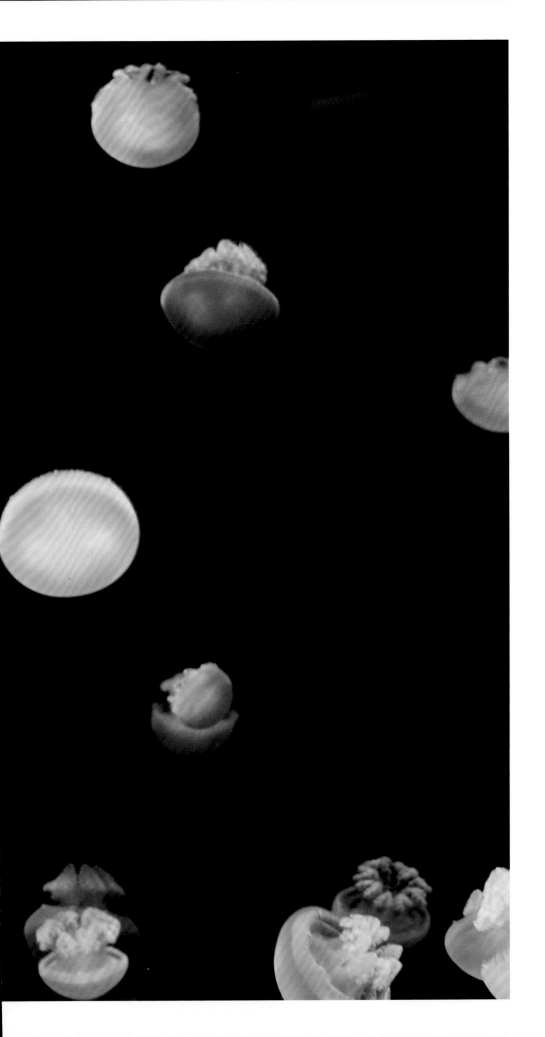

Blue Blubber Jellyfish

Catostylus mosaicus

Specimen #206; 1 to 3 inches across;
National Aquarium, Baltimore, Maryland,
United States of America

PAGE 212

South American Sea Nettle

Chrysaora plocamia

Specimen #241; bells are about 4 inches across;
Kamo Aquarium, Tsuruoka, Yamagata, Japan

PAGE 213

Pacific Sea Nettle

Chrysaora fuscescens

Specimen #249; bells are about 5 inches across;
Kamo Aquarium, Tsuruoka, Yamagata, Japan

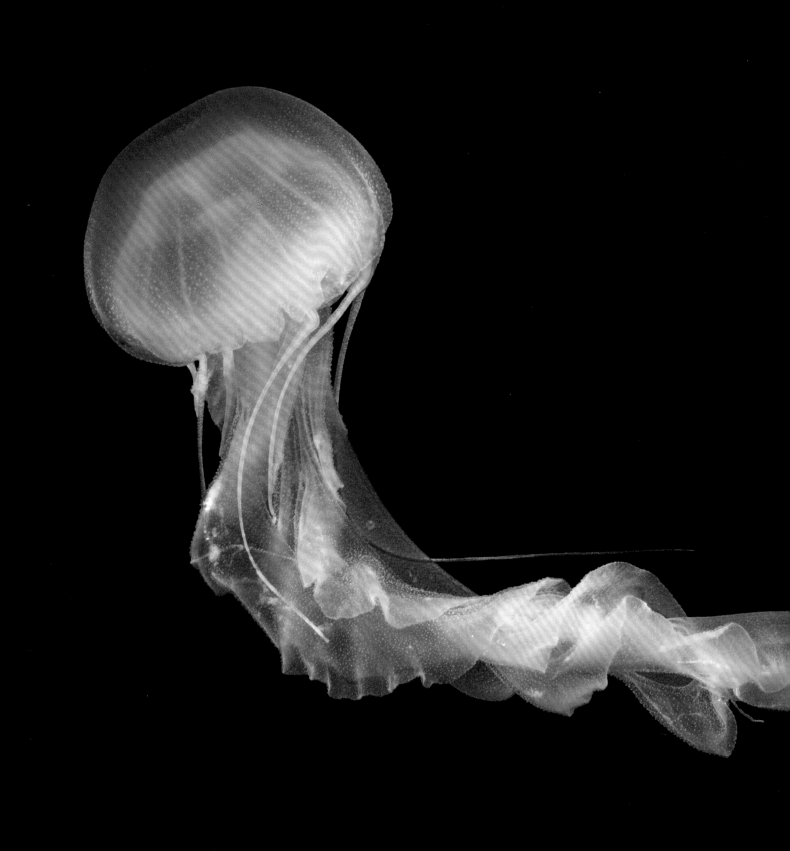

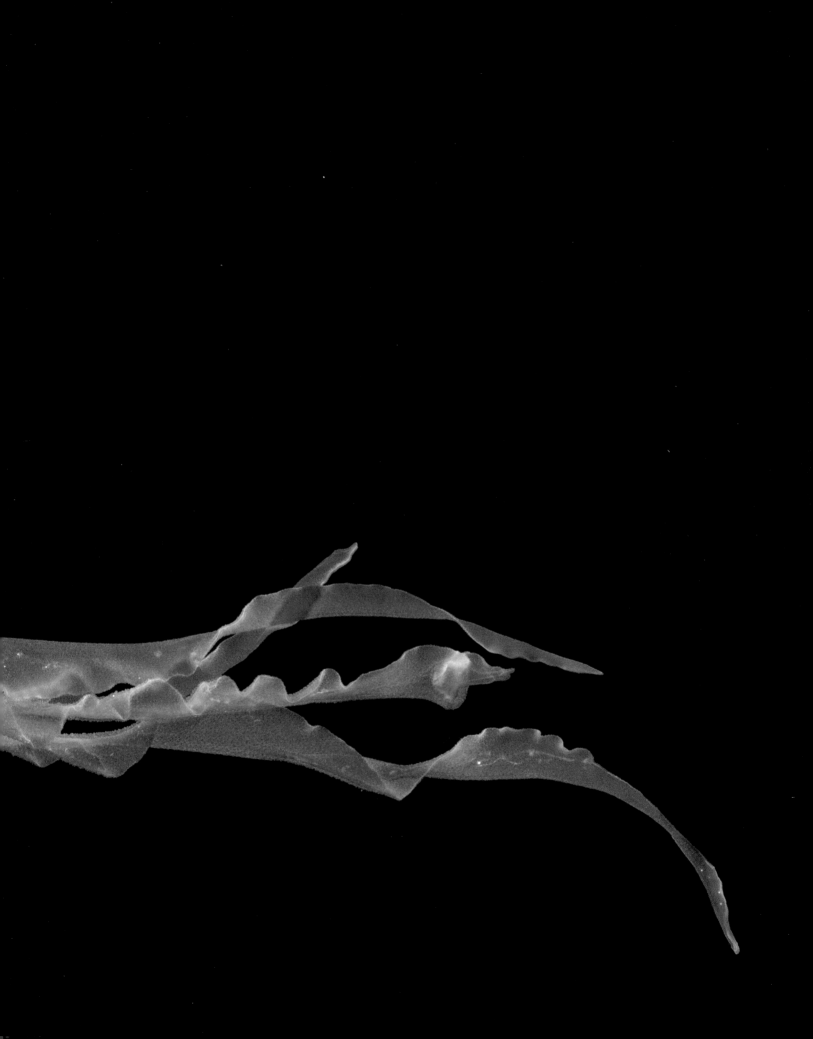

Scyphozoan Jellyfish
Rhopilema sp.
Specimen #256; 3.5 inches overall length; Kamo
Aquarium, Tsuruoka, Yamagata, Japan

PREVIOUS PAGES

Indonesian Sea Nettle
Chrysaora chinensis
Specimen #255; 8 inches long; Kamo Aquarium,
Tsuruoka, Yamagata, Japan

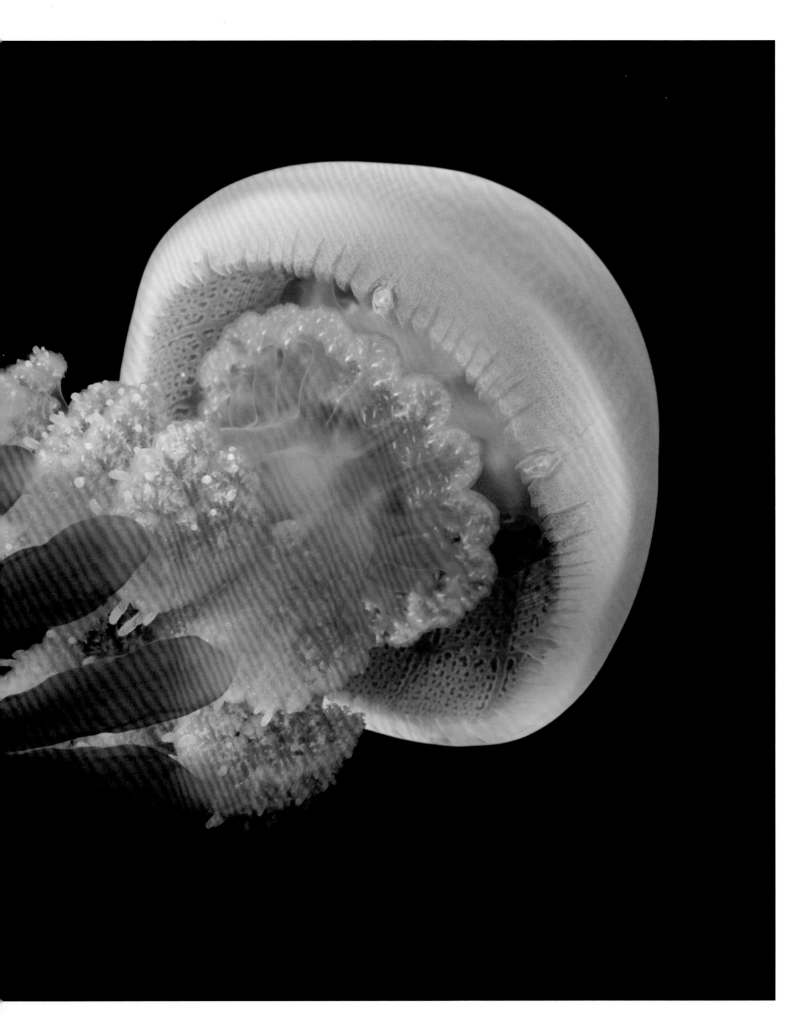

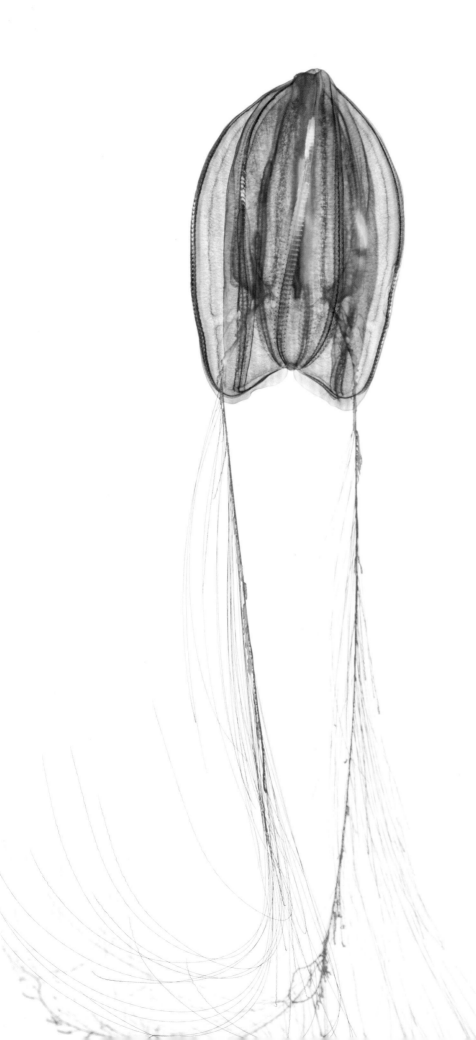

Ctenophore

Mertensia ovum

Specimen #251; 1.5 inches body length;
Kamo Aquarium, Tsuruoka, Yamagata, Japan

OPPOSITE

Ctenophore

Beroe abyssicola

Specimen #250; 3 inches overall length;
Kamo Aquarium, Tsuruoka, Yamagata, Japan

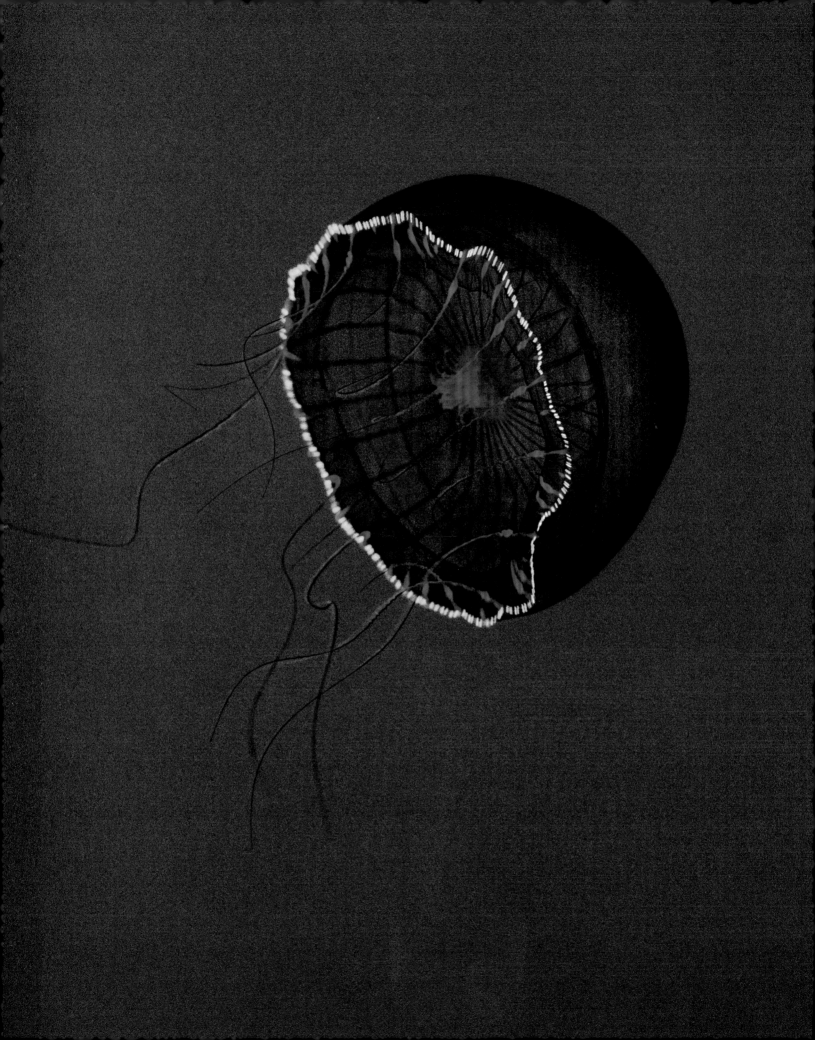

Crystal Jelly

Aequorea victoria

Specimen #259; bell is 1 inch across; Kamo Aquarium, Tsuruoka, Yamagata, Japan

Aequorea victoria is the source for green fluorescent protein, which is a marker used in molecular biology.

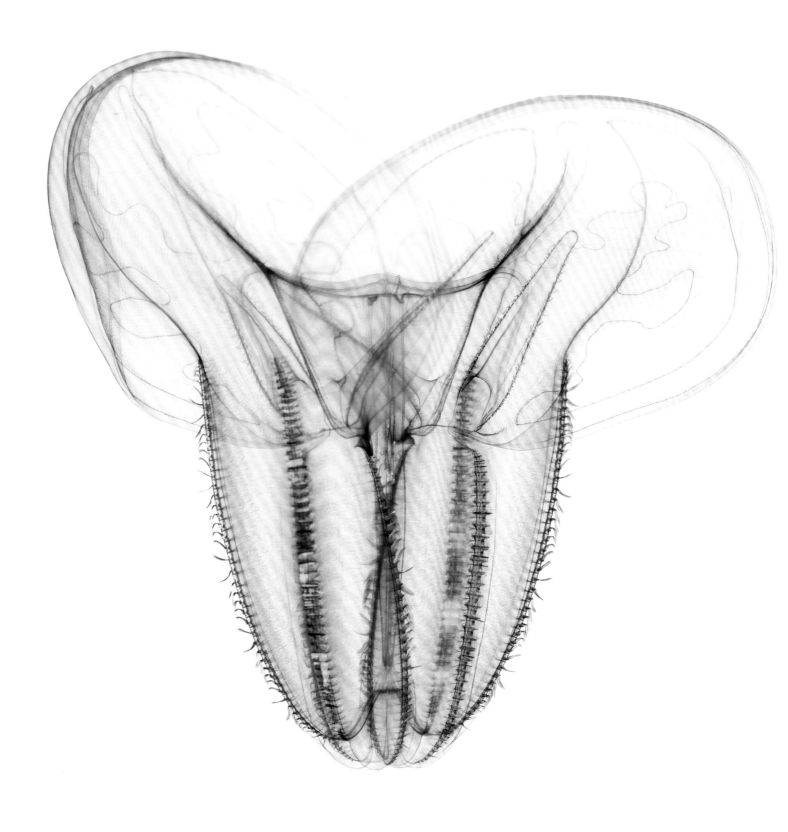

BOTH

Comb Jelly

Bolinopsis infundibulum

Specimen #258; 2.5 inches overall length; Kamo Aquarium, Tsuruoka, Yamagata, Japan

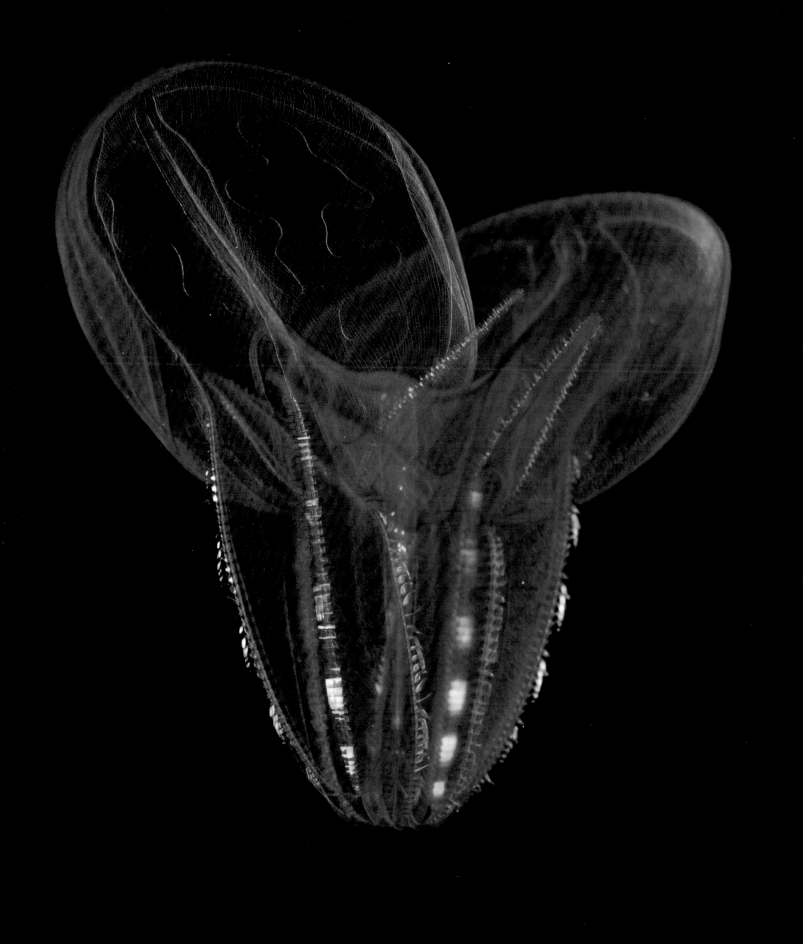

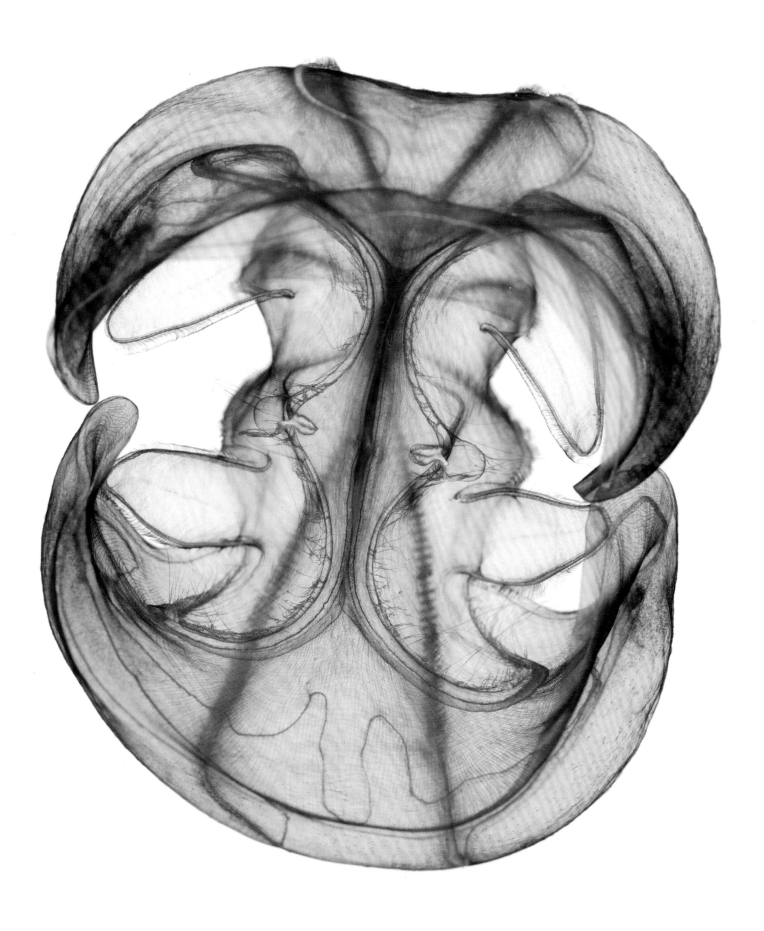

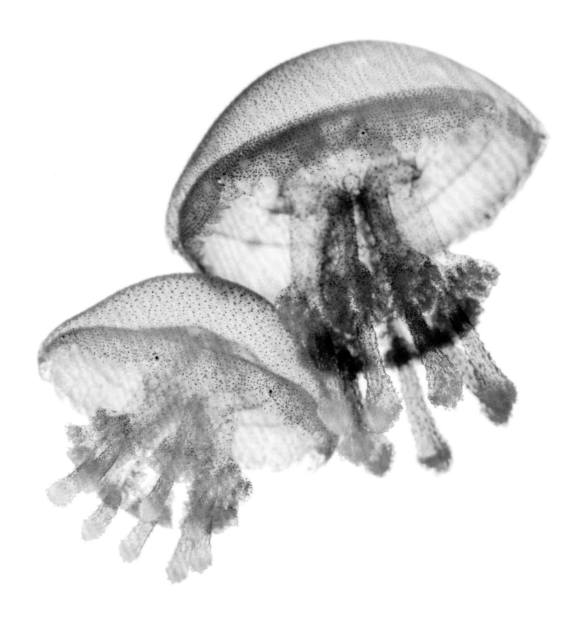

Scyphozoan Jellyfish

Mastigias sp.

Specimen #174; bell 0.5 inch across; Florida Keys Marine Life,
Big Pine Key, Florida, United States of America

OPPOSITE

Comb Jelly

Bolinopsis sp.

Specimen #264; about 1 inch across; specimen from Kagoshima
City Aquarium; Kamo Aquarium, Tsuruoka, Yamagata, Japan

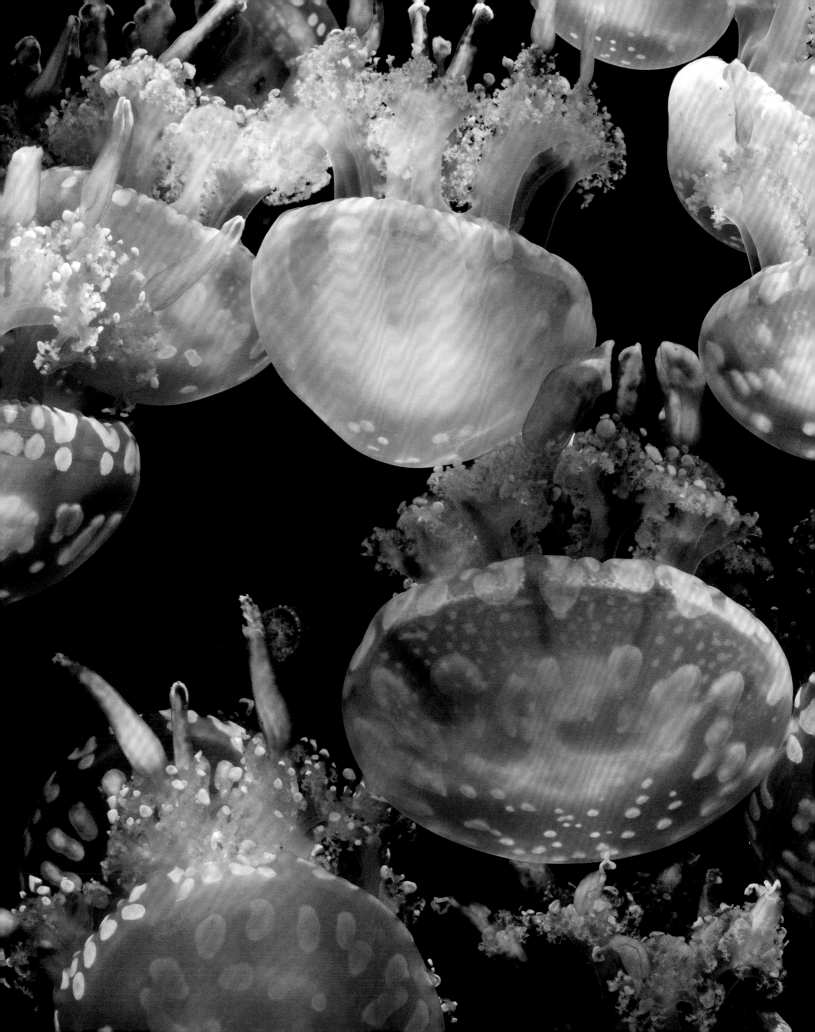

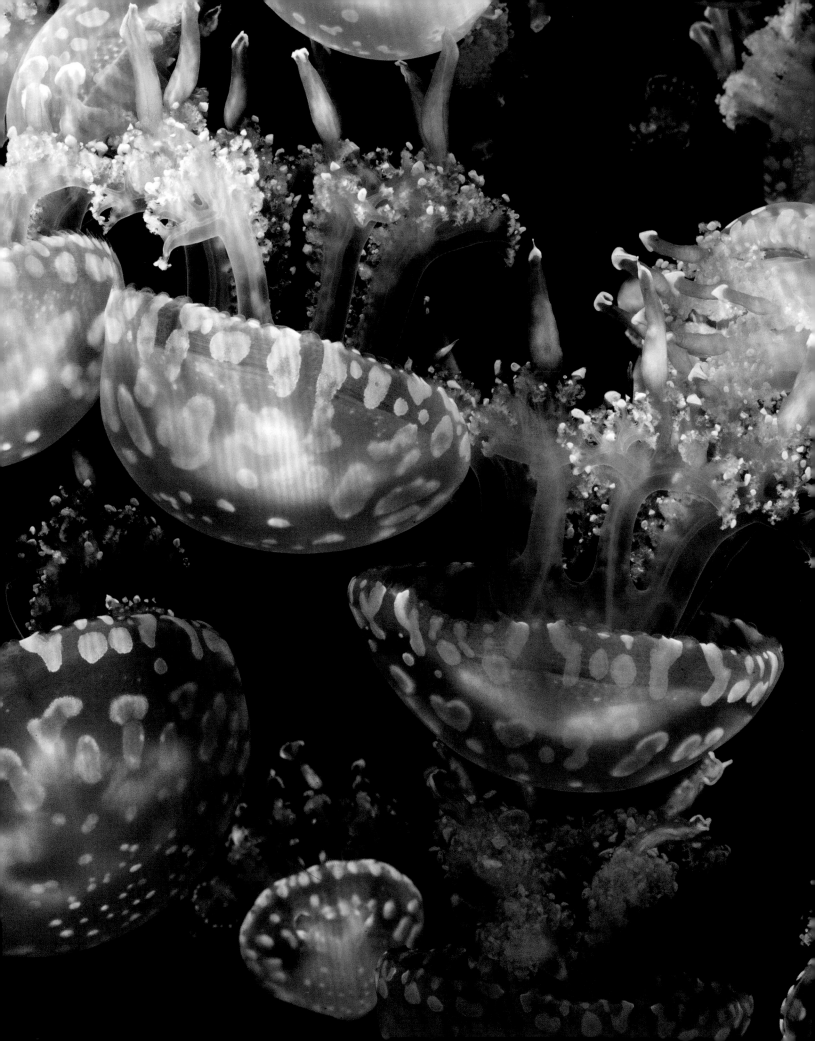

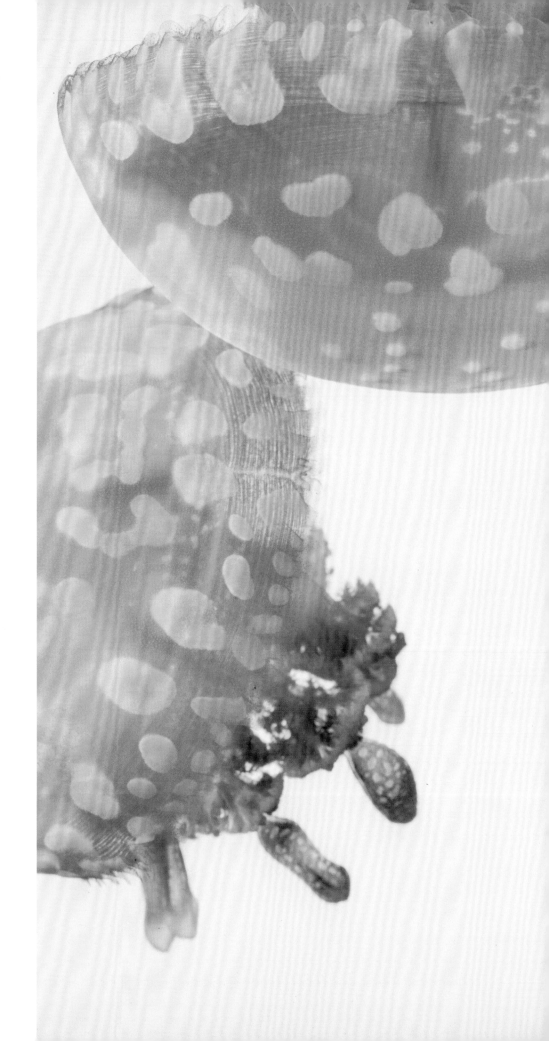

PREVIOUS PAGES AND RIGHT

Scyphozoan Jellyfish
Mastigias papua
Specimen #262; 2.5 to 4.5 inches across;
Kamo Aquarium, Tsuruoka, Yamagata, Japan

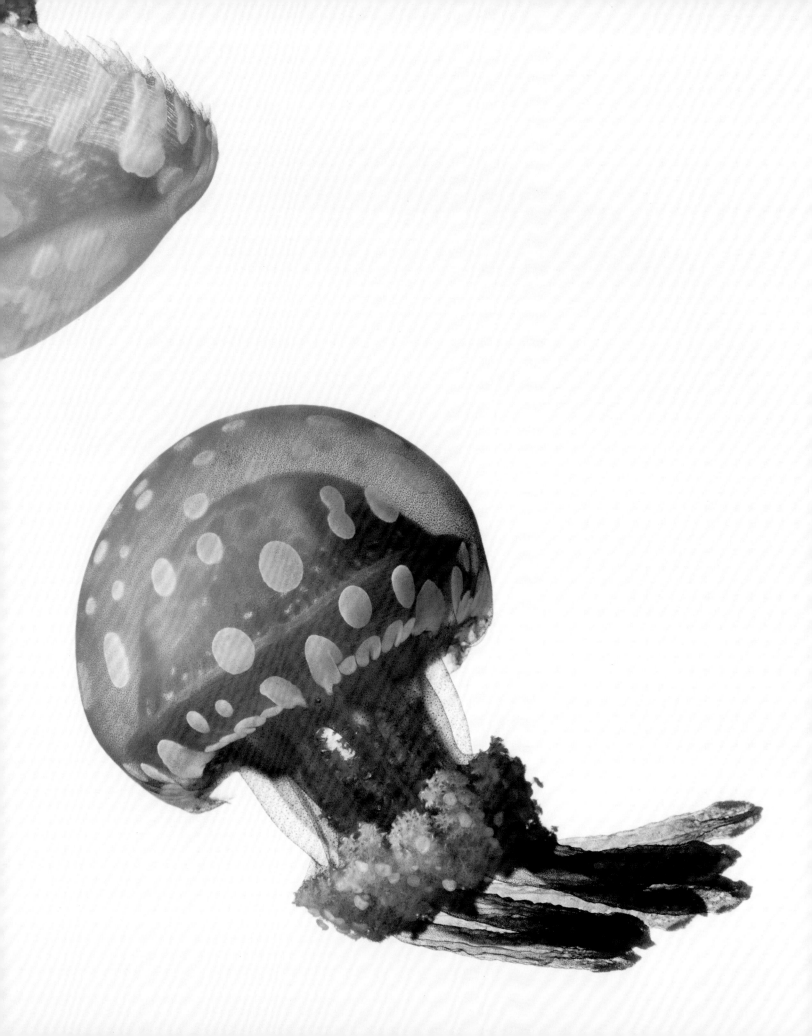

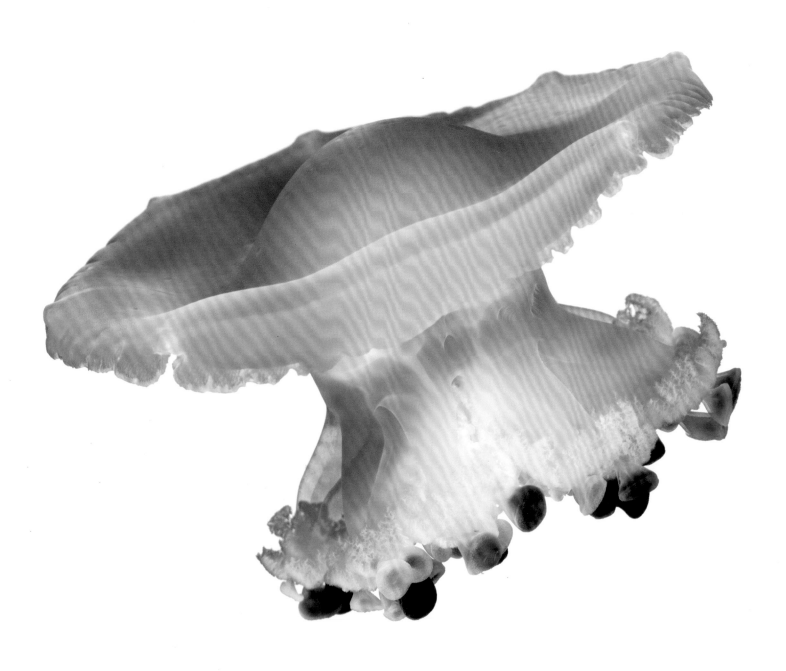

BOTH

Fried Egg Jellyfish

Cotylorhiza tuberculata

Specimen #254; about 4 inches across; Kamo Aquarium, Tsuruoka, Yamagata, Japan

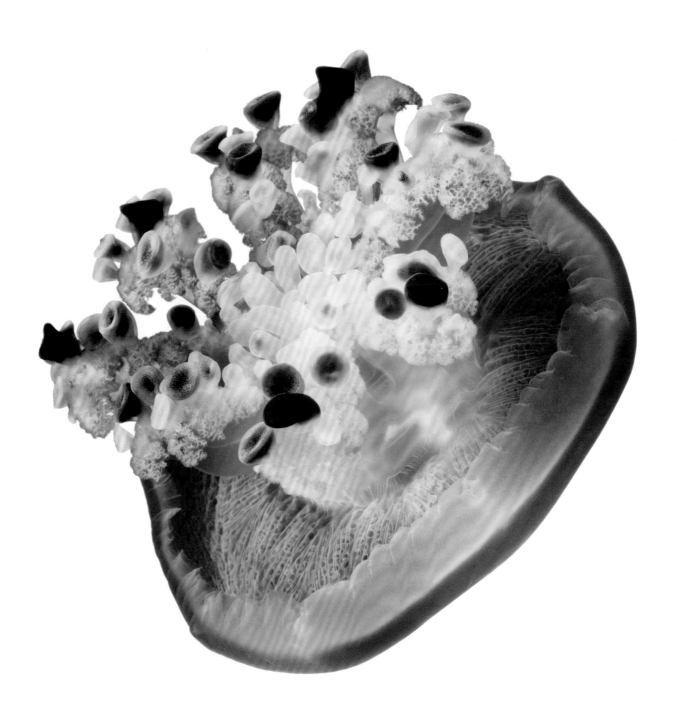

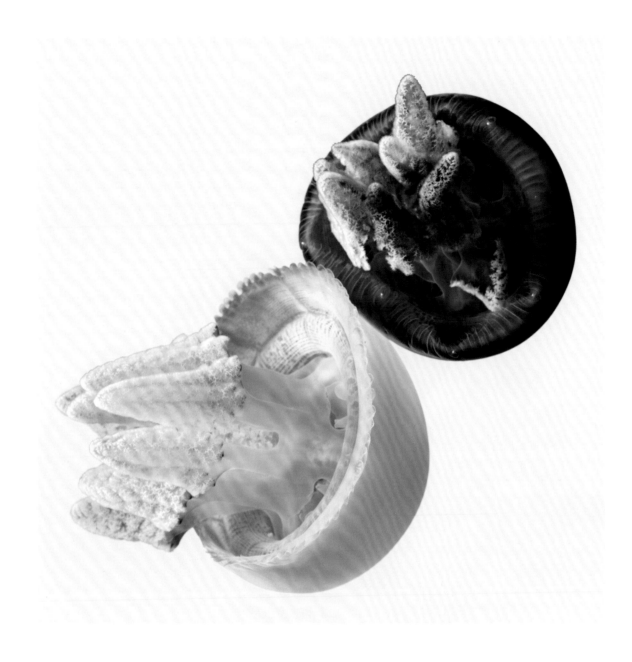

Blue Blubber Jellyfish

Catostylus mosaicus

Specimen #261; bells are 3 inches across; Kamo Aquarium, Tsuruoka, Yamagata, Japan

OPPOSITE

Cannonball Jellyfish

Stomolophus meleagris

Specimen #240; 3.5 inches across; Kamo Aquarium, Tsuruoka, Yamagata, Japan

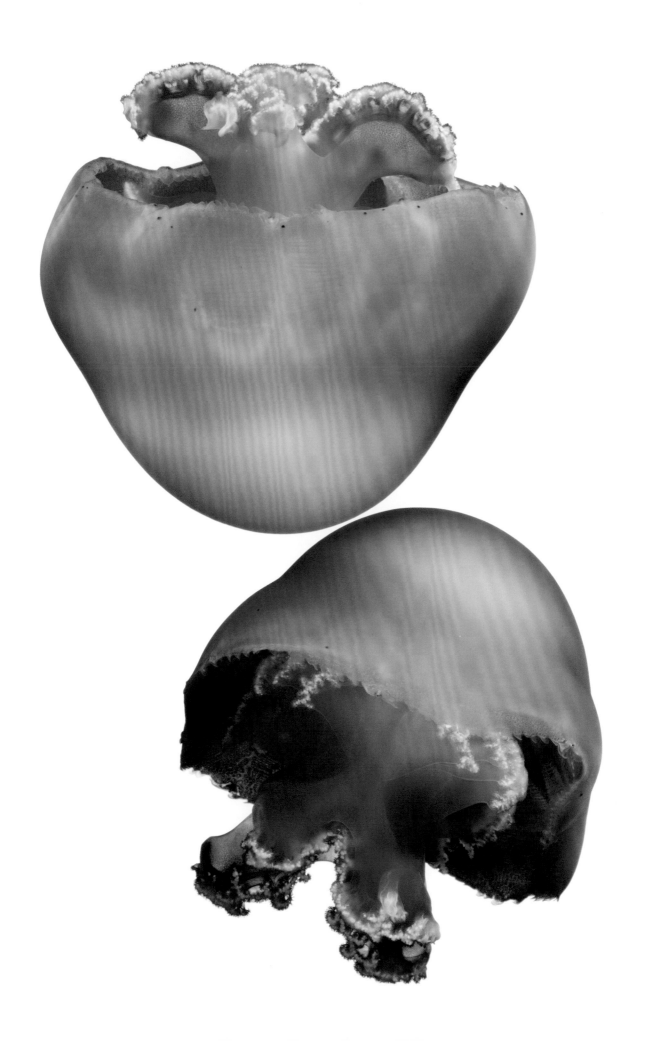

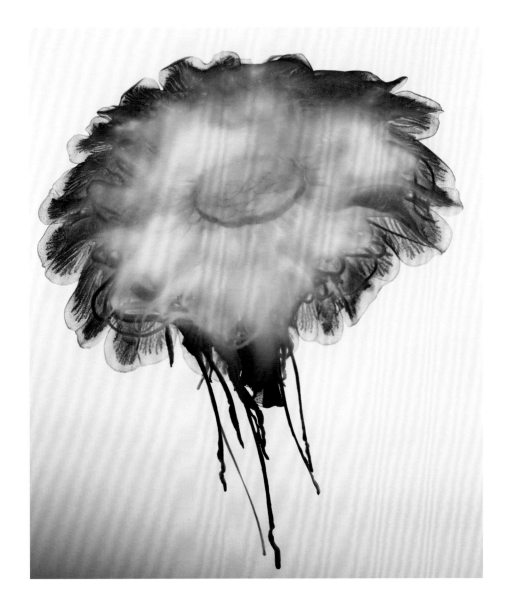

Bluefire Jellyfish
Cyanea lamarckii
Specimen #275; bell is 2 inches across; Kamo Aquarium, Tsuruoka, Yamagata, Japan

OPPOSITE

Black Jelly
Chrysaora achlyos
Specimen #271; bell is 4 inches across; Kamo Aquarium, Tsuruoka, Yamagata, Japan

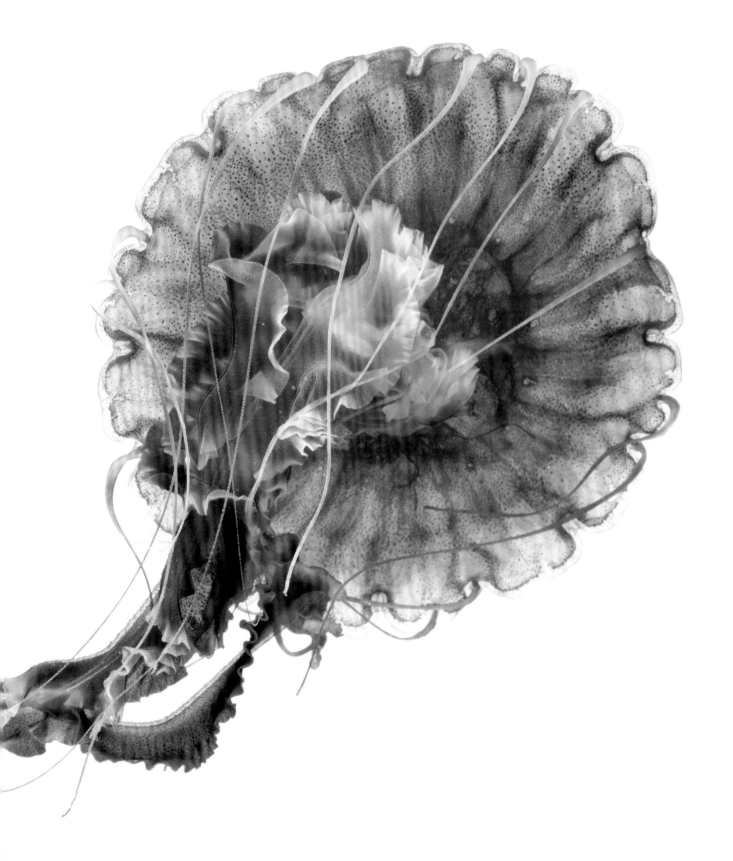

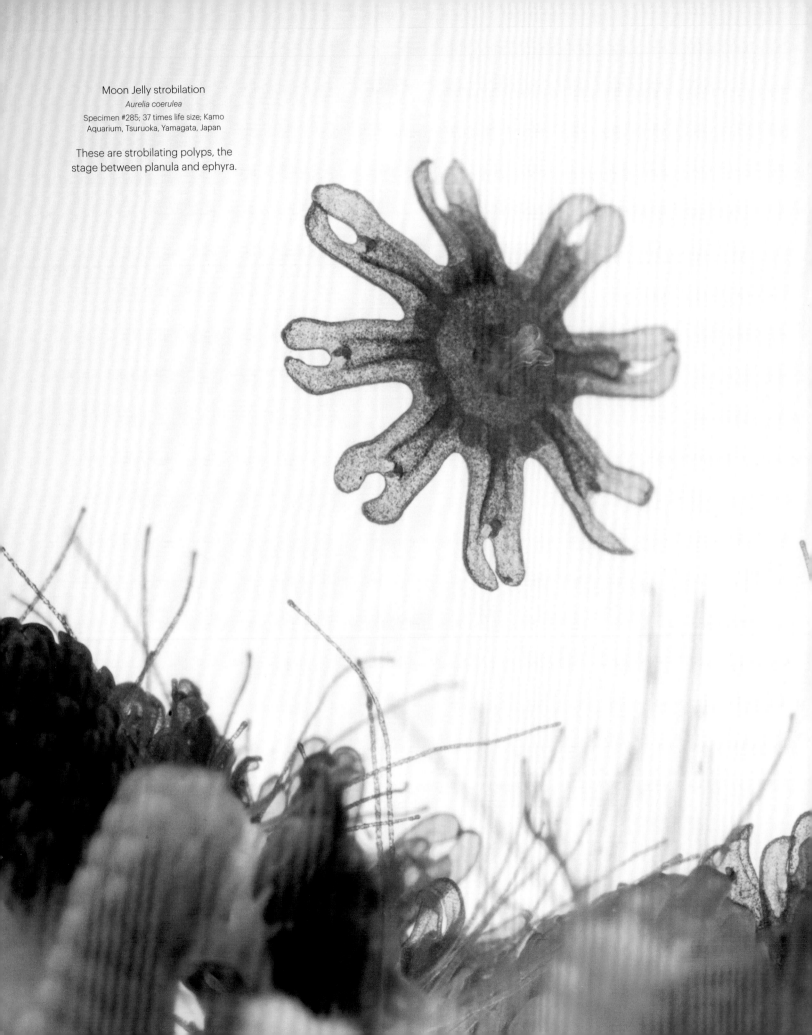

Moon Jelly strobilation
Aurelia coerulea
Specimen #285; 37 times life size; Kamo
Aquarium, Tsuruoka, Yamagata, Japan

These are strobilating polyps, the
stage between planula and ephyra.

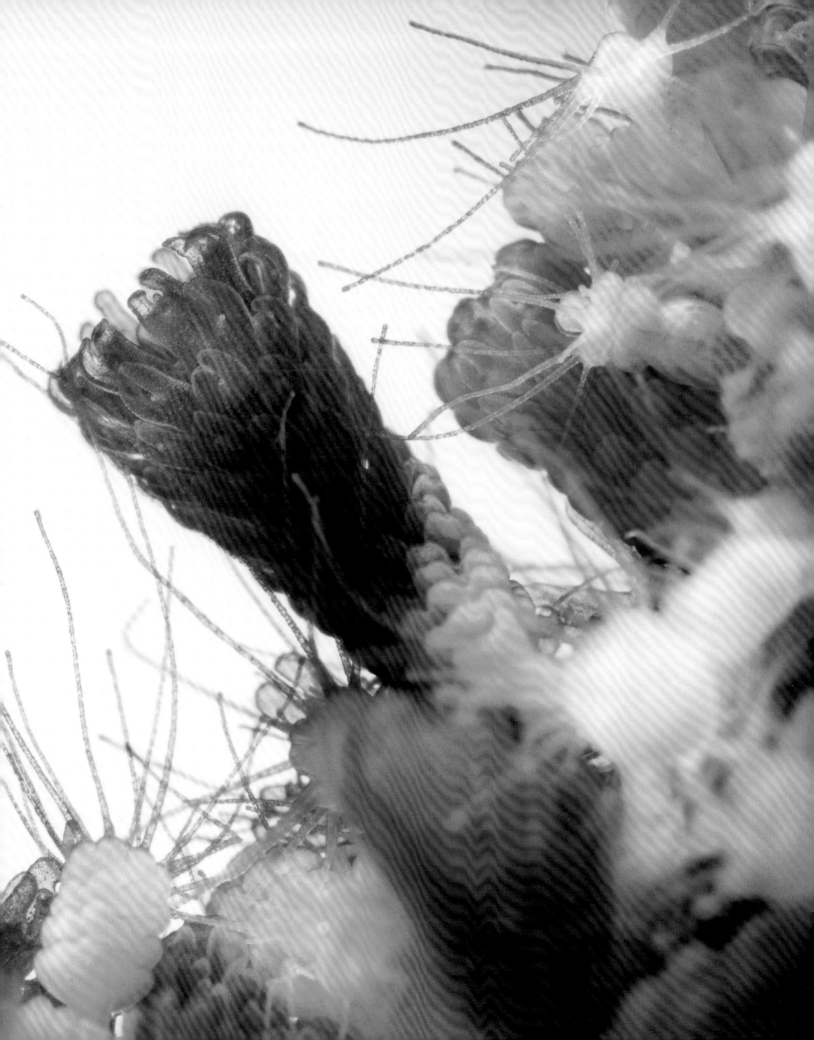

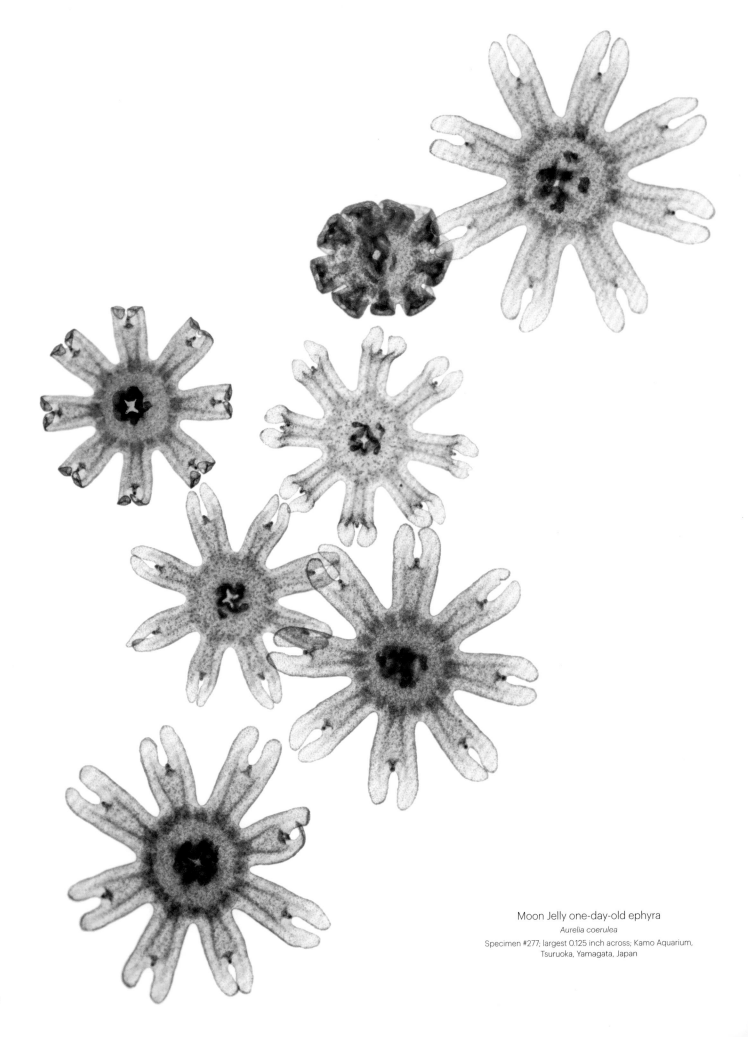

Moon Jelly one-day-old ephyra
Aurelia coerulea
Specimen #277; largest 0.125 inch across; Kamo Aquarium,
Tsuruoka, Yamagata, Japan

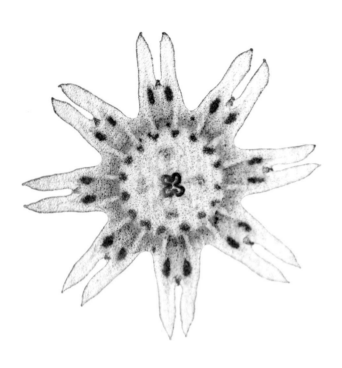

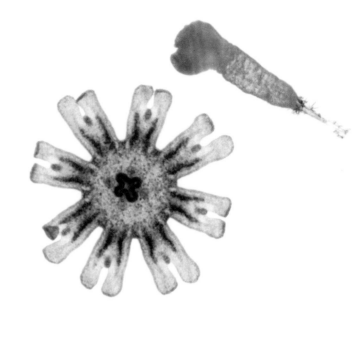

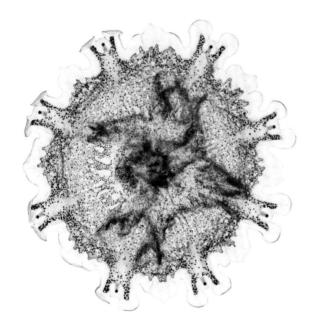

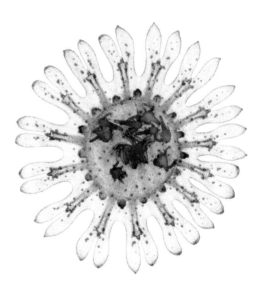

TOP LEFT

Black Sea Nettle ephyra

Chrysaora achlyos

Specimen #218; 0.125 inch across; National Aquarium, Baltimore, Maryland, United States of America

TOP RIGHT

Crown Jellyfish polyp and ephyra

Cephea cephea

Specimen #214; 0.0625 inch across; National Aquarium, Baltimore, Maryland, United States of America

BOTTOM LEFT

Crown Jellyfish ephyra

Cephea cephea

Specimen #216; several days old; 0.25 inch across; National Aquarium, Baltimore, Maryland, United States of America

BOTTOM RIGHT

Egg-yolk Jellyfish ephyra

Phacellophora camtschatica

Specimen #196; 0.25 inch across; Monterey Bay Aquarium, Monterey, California, United States of America

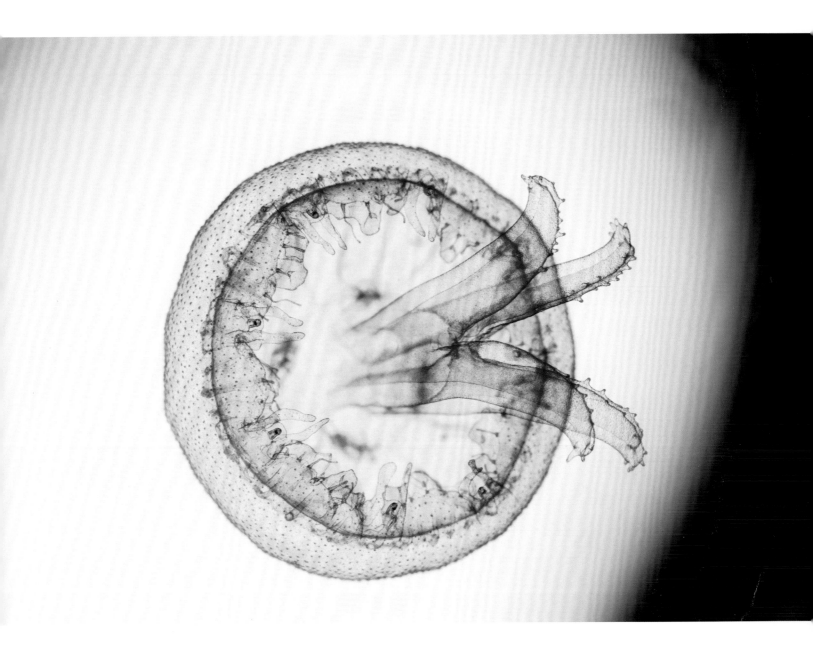

Moon Jelly
Aurelia coerulea
Specimen #281; 0.25 inch across; Kamo Aquarium, Tsuruoka, Yamagata, Japan

At around two weeks old, the ephyra becomes a medusa.

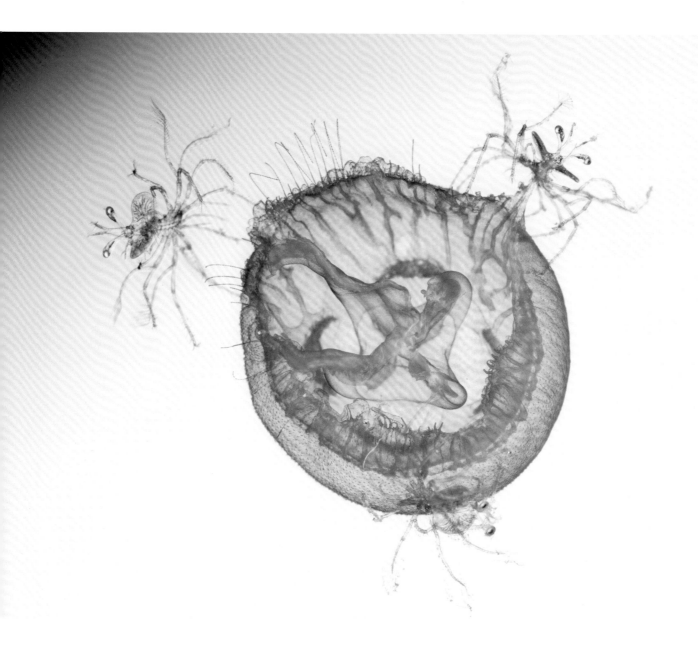

Moon Jelly with Jellyfish Rider
Aurelia coerulea with phyllosoma
Specimen #282; jellyfish is 0.5 inch across; Kamo Aquarium, Tsuruoka, Yamagata, Japan

Lobster larvae hitch a ride on the bell of this jellyfish. While receiving shelter and protection
from their larger host, they slowly devour it, beginning with the tentacles.

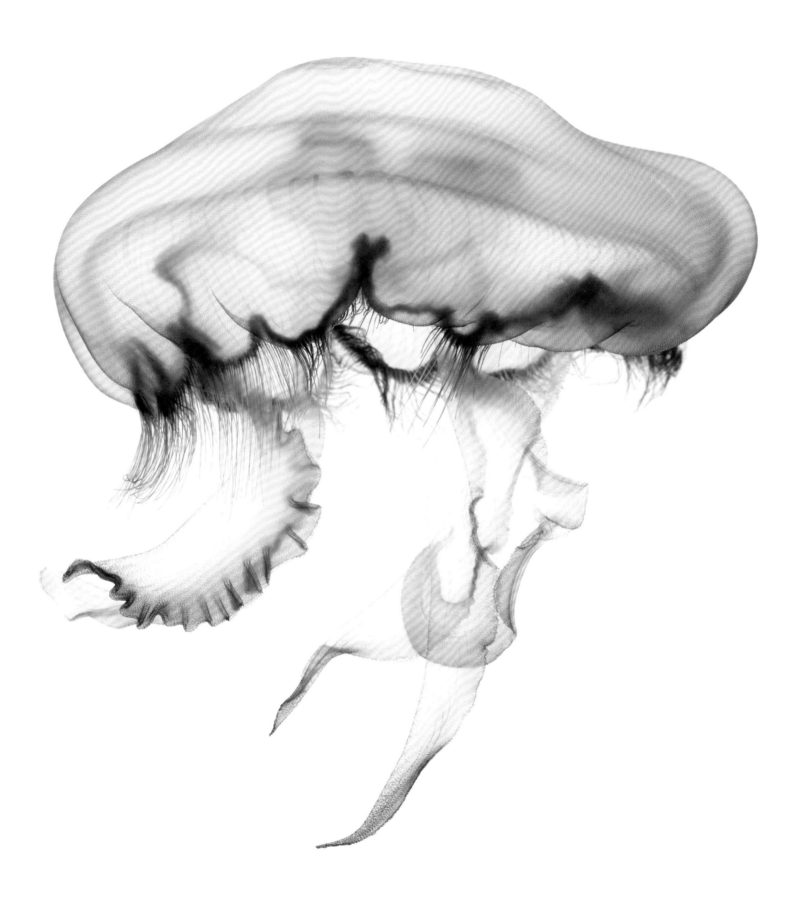

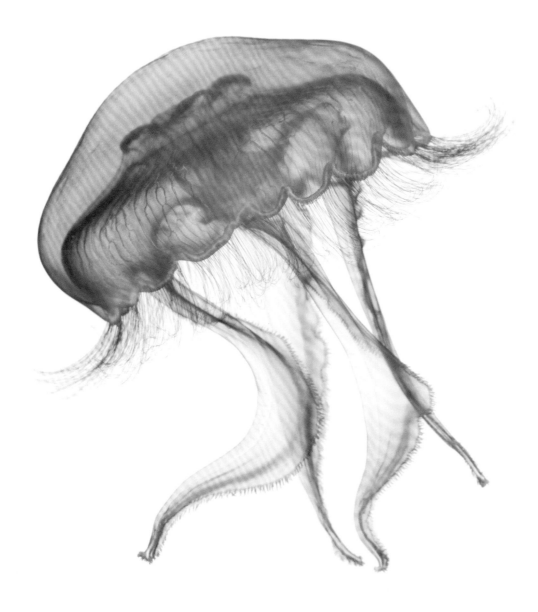

Moon Jelly
Aurelia sp.
Specimen #266; 4.5 inches across; from Palau; Kamo Aquarium, Tsuruoka, Yamagata, Japan

OPPOSITE
Moon Jelly
Aurelia aurita
Specimen #189; 7 inches across; Elizabeth Moore International Center for Coral Reef Research
& Restoration, Summerland Key, Florida, United States of America

FOLLOWING PAGES
Moon Jelly
Aurelia sp.
Specimen #265; largest 4.5 inches across; from Palau; Kamo Aquarium, Tsuruoka, Yamagata, Japan

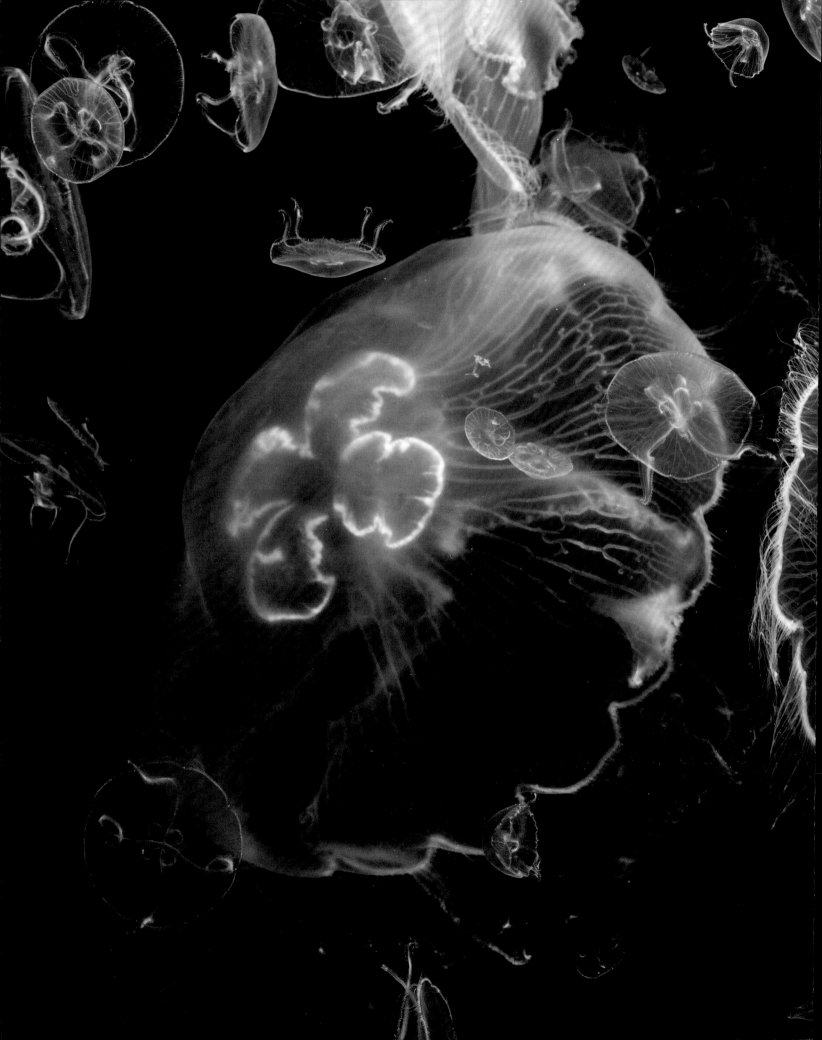

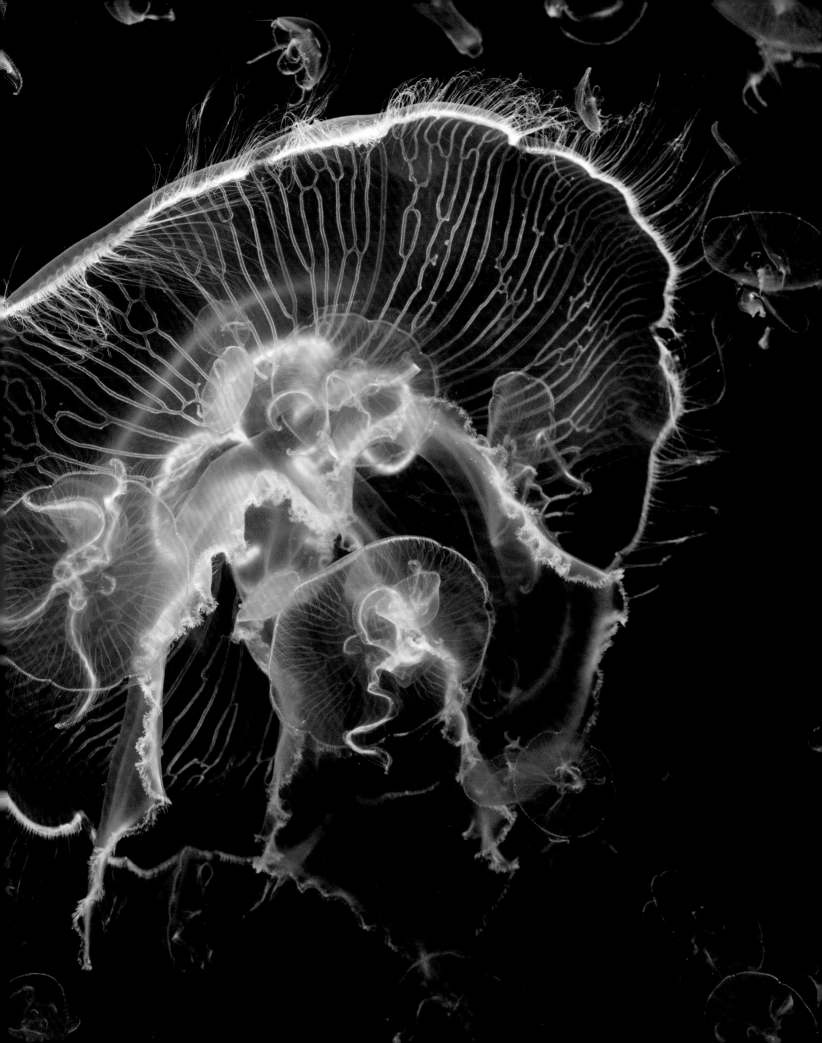

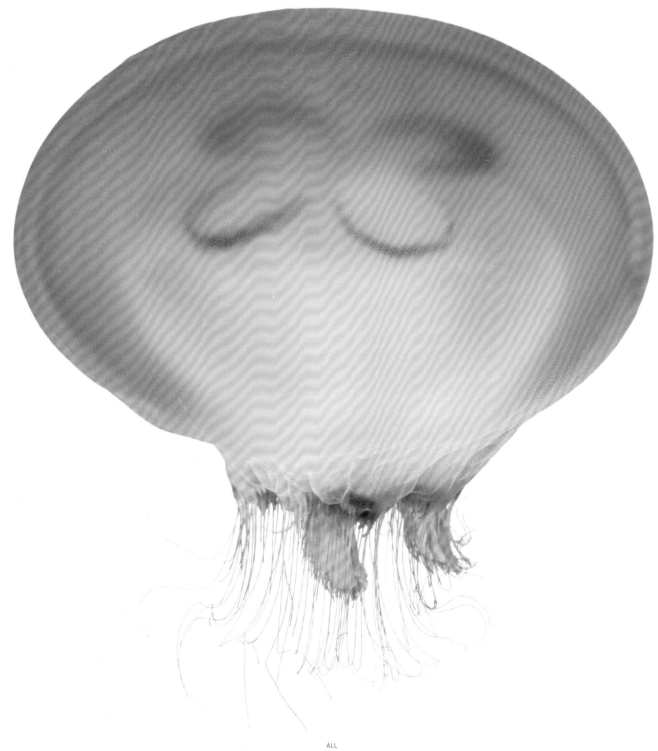

ALL

Brown-banded Moon Jelly

Aurelia limbata

Above: specimen #267; bell is 3 inches across

Opposite: specimen #269; bell is 4 inches across

Following pages: specimen #287 group; largest 4 inches across

Kamo Aquarium, Tsuruoka, Yamagata, Japan

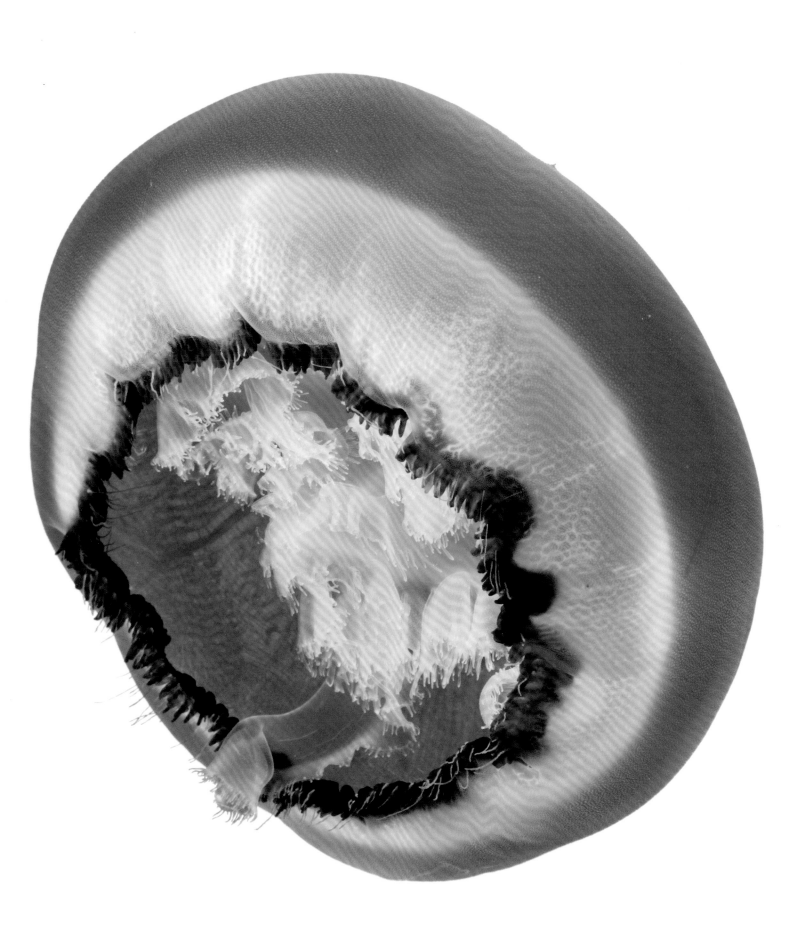

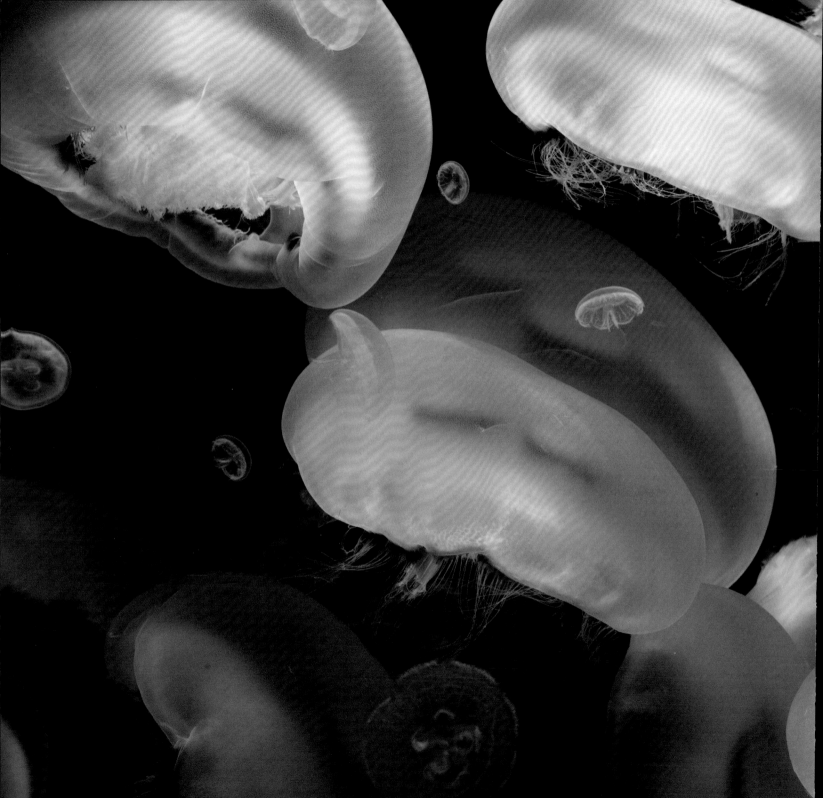

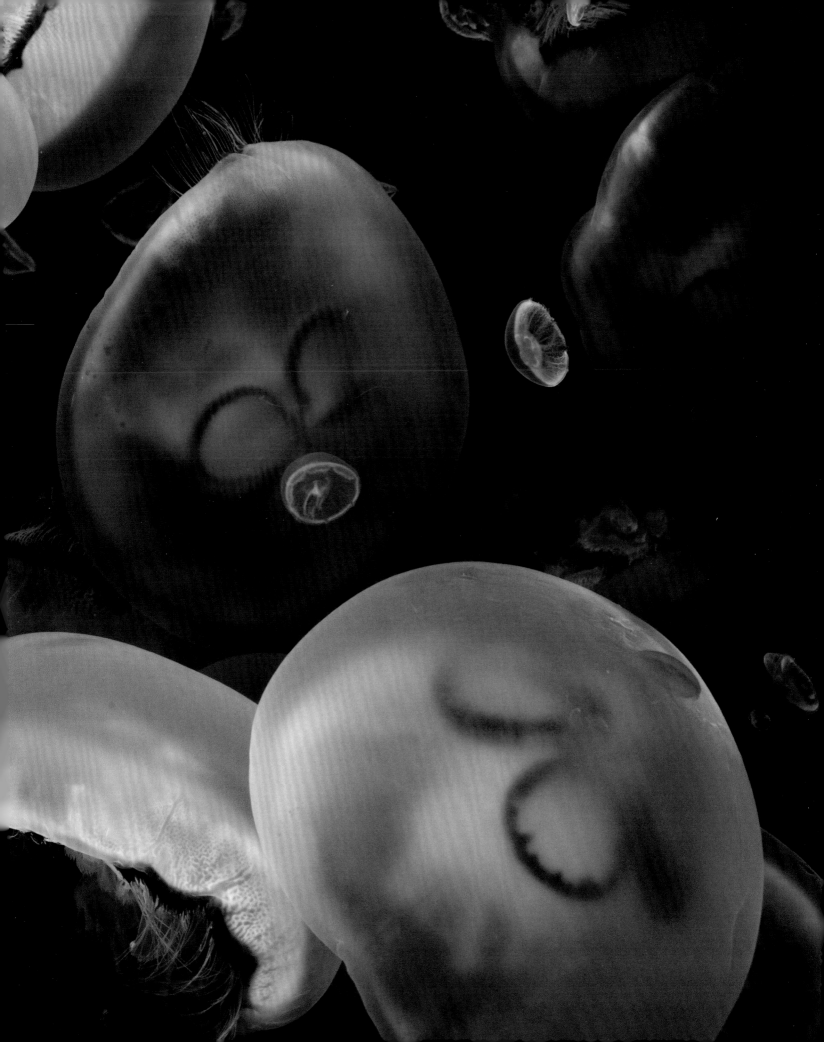

INDEX

Bold page numbers indicate illustrations.

A

Abdopus
 aculeatus 25, **80-81, 88-89, 90-91, 92, 93, 94-95**
 sp. **100-101**
 see also Algae octopus
Aequorea victoria **192-193, 222, 223**
Aglaura hemistoma **185**
Alatina alata **182**
Algae octopus 25, 29, **80-81, 88-89, 90-91, 92, 93, 94-95, 100-101**
Amba (Lembeh guide) 24
Amphinema sp. **188-189**
Amphioctopus
 aegina **84, 85**
 marginatus 21-22
Anthomedusae jellyfish **177**
Aoki, Shizuka 26
Appel, Katherine 171
Atlantic bay nettle 170-171, **170-171, 206**
Atlantic pygmy octopus **68-69**
Aurelia
 aurita **244**
 coerulea 12, **238-239, 240, 242, 243**
 limbata **248, 249, 250-251**
 sp. **245, 246-247**

B

Baptista, Fernando G. 26, 171
Barbour's seahorse **133, 154, 155**
Bayha, Keith 171
Benchley, Peter 13
Beroe abyssicola **220**
Black jelly **236-237**
Black sea jellyfish **209**
Black sea nettle **241**
Blue blubber jellyfish **214-215, 234**
Blue-ringed octopus **48, 49**
Bluefire jellyfish **236**
Bock's pygmy octopus 29, **34, 35, 75**
Bolinopsis
 infundibulum 224, 225
 sp. 226
Box jelly **182**
Brain, octopus 26, 29
Brotz, Lucas 173

Brown-banded moon jelly **248, 249, 250-251**
Brown sea nettle **204-205**

C

Caldwell, Roy 29
California two-spot octopus **60-61, 62, 64-65**
Callistoctopus
 alpheus **2-3, 38-39, 40, 42-43**
 aspilosomatis **41**
 ornatus **36-37**
Cannonball jellyfish **164-165, 235**
Capricorn night octopus **2-3, 38-39, 40, 42-43**
Cassiopea xamachana **194, 195**
Catostylus mosaicus **214-215, 234**
Cephalopods 23
Cephea cephea **241**
Chironex fleckeri 171, **171**
Chrysaora
 achlyos **236-237, 241**
 chesapeakei 170-171, **170-171, 206**
 chinensis **216-217**
 colorata **207**
 fuscescens 169, **204-205, 213**
 lactea **162**
 plocamia **212**
Coconut octopus 21-22
Collins, Allen 171
Comb jelly 170, 172, **178-179, 224, 225, 226**
Common octopus **20, 26, 27, 28-29, 63, 66-67**
Conant, Eve 171
Correia, Miguel 115-116, 117, 120
Cotylorhiza tuberculata **232, 233**
Crossota millsae **200-201**
Crown jellyfish **186, 241**
Crystal jelly **192-193, 222, 223**
Ctenophore 172, **220, 221**
Cuttlefish 24
Cyanea
 capillata 170, **170, 198, 210-211**
 lamarckii **236**
Cydippid comb jelly **178-179**

D

Day octopus 24, **102-103, 104, 105, 106-107, 108-109**
Dipleurosoma sp. **183**

Disguise, octopus 24-25, 27
Doryrhamphus pessuliferus **124**
Dunn, Casey 169, 172
Dwarf seahorse **133, 148-149**

E

East Pacific red octopus **30-31, 32, 33**
Egg-yolk jellyfish **241**
Eggs, octopus **70-71**
Endoceras giganteum 23
Enteroctopus dofleini 24
Epipelagic trachymedusa jellyfish **185**
Estuarine pipefish 13
Eutonina indicans **197**

F

Flower hat jelly **6-7**
Fossils, octopus 23
Foster, Sarah 117, 121
Fried egg jellyfish **232, 233**

G

Giant Pacific octopus 24
Godfrey-Smith, Peter 27-28

H

Haddock, Steve 172, 173
Hairy octopus 25
Haliichthys taeniophorus **125**
Hamilton, Healy 117, 120, 121
Hanlon, Roger 26
Hapalochlaena
 lunulata **48, 49**
 maculosa **46, 47**
Harford, Alison 171
Hatchlings, octopus **72, 73**
Hawaiian octopus **44**
Helm, Rebecca 171
Hippocampus 116, 117, 121
 abdominalis **112-113, 128, 129, 130, 131, 133, 144, 145**
 angustus **4-5**
 barbouri **133, 154, 155**
 erectus **110, 140, 141, 142, 143**
 guttulatus **114**, 115, **132**
 hippocampus 115, **134-135, 136, 137, 138-139**
 ingens **122-123, 132, 150, 151, 152, 153**

reidi **132, 146, 147**
subelongatus **156, 157**
taeniopterus **158, 159**
tuberculatus **133, 160, 161**
whitei **133**
zosterae **133, 148-149**
Hochner, Benny 26
Holland, Jennifer 115-121
Hydroids **196**
Hydrozoan jellyfish **174-175, 176-177, 183, 184, 186, 188-189, 190, 199, 208**

I

Immortal jellyfish 168, **191**
Indonesian sea nettle **216-217**
Intelligence, octopus 26, 28-29

J

Janssen, Jennie 167, 171
Jellyfish 162-251
 blooms 172-173
 family tree 170
 feeding 170-171
 oral arms 169
 reproduction 168, **199**
 species 170-171, **170-171**
 stinging 170
 swimming 170
 true jellies 168-169
 with young **200-201**
Jellyfish rider **243**
Judson, Olivia 21-29

K

Knobby seahorse **133, 160, 161**
Kolbert, Elizabeth 167-173

L

Leptomedusae jellyfish **180-181**
Levy, Guy 26
Liittschwager, David 13-15
Lined seahorse **110, 140, 141, 142, 143**
Linnaeus, Carl 134
Lion's mane jellyfish 168, 170, **170, 198, 210-211**
Lobster larvae **243**
Long-armed sand octopus **98-99**
Long-snouted seahorse **114**, 115, **132**

Longsnout seahorse **132, 146, 147**

Lucernaria janetae 171, **171**

M

Maeotias inexpectata **209**

Mantle, octopus 23

Marsh jellyfish **187**

Mastigias
 papua **228–229, 230–231**
 sp. **227**

Mauve stinger 172, **202, 203**

Medusoids **199**

Mertensia ovum **221**

Mnemiopsis **170**
 leidyi 172

Moon jelly **12,** 14–15, 167, 168, 172, **242, 243, 244, 245, 246–247, 248, 249, 250–251**
 one-day-old ephyra **240**
 strobilation **238–239**

N

Nausithoe sp. **186**

Nemalecium lighti **196**

Nemopilema nomurai 170, **170–171**

Nervous system, octopus 26, 27–28

Night octopus **36–37**

Nomura's jellyfish 170, **170–171**

Norman, Mark 27

O

Obelia sp. 171, **171, 186**

Octoconoides sp. **180–181**

Octopus
 berrima **16, 50–51, 52, 53, 54–55**
 bimaculoides **60–61, 62, 64–65**
 bocki 29, **34, 35, 75**
 cyanea 24, **102–103, 104, 105, 106–107, 108–109**
 gorgonus **82–83**
 hawiiensis **44**
 joubini **68–69**
 laqueus **96–97**
 oliveri **45**
 pallidus **56–57, 58–59**
 rubescens **30–31, 32, 33**
 sp. **74**
 vulgaris **20, 26,** 27, **63, 66–67** (*see also* Common octopus)
 wolfi 24, **76, 77, 78–79**

Octopuses 16–109
 arms 26, 27–28
 brain 26, 29
 disguise 24–25, 27
 with eggs **70–71**
 eyes **15**
 fossils 23
 hatchlings **72, 73**
 intelligence 26, 28–29
 nervous system **26,** 27–28
 parts 23
 pigments 23, 25
 post-larval **74**
 posture 25, 27
 predators 27
 reflecting cells 25
 skin texture 25

Olindias formosa **6–7**

P

Pacific sea nettle **169, 213**

Pacific seahorse **122–123, 132, 150, 151, 152, 153**

Pale octopus **56–57, 58–59**

Parker, Lawson 171

Pegantha sp. **186**

Pelagia noctiluca **202, 203**

Phacellophora camtschatica **241**

Phyllopteryx taeniolatus **126–127**

Phyllosoma **243**

Pigments, octopus 23, 25

Pipefishes **124, 125**

Plainbody night octopus **41**

Portuguese man-of-war 169

Pot-bellied seahorse **112–113, 128, 129, 130, 131, 133, 144, 145**

Project Seahorse 117

Purple-striped jelly **207**

R

Ragsdale, Cliff 26

Reflecting cells 25

Rhopalia 14–15

Rhopilema sp. **166, 218–219**

Ribboned pipefish **125**

Rock tako **45**

S

Salps 168

Sand bird octopus **84, 85**

Schumacher, Mesa 26

Scyphozoan jellyfish **162, 166, 218–219, 227, 228–229, 230–231**

Sea dragons **126–127**

Sea fur 171, **171**

Sea nettles 168

Sea wasp 171, **171, 182**

Seahorses 110–161
 color 116
 courtship 116
 fisheries management 121
 illegal trade 117, **118–119,** 120
 reproduction 116

Short-snouted seahorse 115, **134–135, 136, 137, 138–139**

Siphonophores 169, 172

Sodefuridako **96–97**

Solmaris sp. **186**

South American sea nettle **212**

Southern blue-ringed octopus **46, 47**

Southern keeled octopus **16, 50–51, 52, 53, 54–55**

Spirocodon saltator **208**

Star-sucker pygmy octopus 24, **76, 77, 78–79**

Statocysts 28

Stomolophus meleagris **164–165, 235**

Syngnathidae 124

T

Thaumoctopus sp. **98–99**

Tiger snout seahorse **156, 157**

True jellies 168–169

Turritopsis dohrnii **191**

U

Umbrella jellyfish hydroids **197**

Upside-down jellyfish **194, 195**

V

Vallentinia gabriellae **187**

Vincent, Amanda 117, 120

Vinther, Jakob 22–23

W

Weedy seadragon **126–127**

Western spiny seahorse **4–5**

White's seahorse **133**

Wilson, Nerida 13

Wonderpus octopus **18–19, 86–87**

Wunderpus photogenicus **18–19, 86–87**

Y

Yellow seahorse **158, 159**

Yellowbanded pipefish **124**

Z

Zanclea sp. **174–175**

Zancleopsis tentaculata **177**

ACKNOWLEDGMENTS

With deep gratitude I would like to acknowledge the individuals and institutions that made this work possible.

Suzie Rashkis for helping conceive these projects, lending affection and aesthetic support throughout.

Photographic assistants

I have Zachariah Kobrinsky to thank for helping with most of the octopus and the start of jellyfish, including being a camera operator on occasion. I am greatly appreciative to Kara Scherer for the lion's share of jellyfish and the early editing of the entire selection; Nathan Glendenning assisted me for much of the seahorse fieldwork; Anand Varma for what was the beginning of the octopus work in Moorea; Justin Schuetz for help with octopus in Hawaii; and Stephanie Colwell for extra hands during the jellyfish work in Bonaire.

Most of the images here were made on assignment for *National Geographic*. I am especially grateful to Chris Johns, Susan Goldberg, David Griffin, Susan Smith, Kurt Mutchler, Sarah Leen, Kathy Moran, Whitney Johnson, Todd James, and Kim Hubbard for supporting the photography.

And from National Geographic Books: Lisa Thomas, Hilary Black, Moriah Petty, Adrian Coakley, and Mike Lappin, thank you. It was a great pleasure to work again with David Griffin, who designed this book.

For the Octopus work

Chris Meyer, Neil Davies, Frank Murphy, and Hannah Stewart at the Richard B. Gump South Pacific Research Station

Eric Sanford and Sarah Ann Thompson at the Bodega Marine Laboratory, California

Leigh Morrison, Keoki Stender, Kaipo Perez, Heather Ylitalo, and Mike Nakachi while working with *Hana Hou!* magazine, Hawaii

Ryan Goldfinch and Ashley Roberts-Thomson at Queensland Sustainable Sealife

Pang Quong at PQ Aquatics, Australia

Desmond Ramirez and Todd Oakley at the Oakley Evolution Lab, University of California, Santa Barbara

Leah Gould and Phillip Gould at Florida Keys Marine Life

Forrest Young and Frank Young at Dynasty Marine Associates, Inc., Florida Keys

Roy Caldwell in his lab at University of California, Berkeley

Courtney Ross for introducing me to the Solomon Islands

Kerrie and Danny Kennedy at Dive Gizo, Solomon Islands

Thank you to field collector extraordinaire Christine Huffard for her help in the Solomon Islands.

For the Seahorse work

Leslee Matsushige, Amy Hudgins, and Mike Rinaudo at the Birch Aquarium, Scripps Institution of Oceanography, La Jolla, California

Miguel Correia, Carolina Mourato, Nuno Padrão, and João Reis of the Ramalhete Marine Station and the University of Algarve, Portugal

Lisa Larkin, Adam Atlas, Alexandra Lawlor, Lauren Samarov, Janet Monday, and Nate Jaros at the Aquarium of the Pacific, Long Beach, California

Dave Catania and Healy Hamilton at the California Academy of Sciences

Craig Hawkins and Chris Carey at Seahorse World, Tasmania

For the Jellyfish work

Steven Haddock and the scientists and crew of the *Western Flyer* of the Monterey Bay Aquarium Research Institute

Allen Collins, Cheryl Ames, Arjen van Dorsten, and Johan van Blerk while working at the CIEE Research Station Bonaire

Karen Osborn and Seabird McKeon at the Smithsonian Marine Station at Fort Pierce, Florida

Cathleen Cannon for leading me to the Petaluma River, California

Rüdiger Bieler, Petra Sierwald, Sarah Tweedt, Dave Vaughn, and Donna Vaughn while working at the Elizabeth Moore International Center for Coral Reef Research & Restoration, Florida Keys

Wyatt Patry, MacKenzie Bubel, and Michael Howard at the Monterey Bay Aquarium

Jennie Janssen, Hillary Hastings, Matthew Wade, and Rebecca Helm while at the National Aquarium, Baltimore

Aya Adachi at the Enoshima Aquarium, Japan

Tatsuo Murakami, Kazuya Okuizumi, Chika Sato, Michiko Yamaguchi, Shuhei Ikeda, Ayumu Honma, Yui Okawa, Hibiki Kanno, and Mr. and Mrs. Yamaguchi for the work at the Kamo Aquarium, Japan

Also, thank you to the writers Jennifer Holland and Olivia Judson for their essays, and Elizabeth Kolbert for her essay and thoughtful foreword. I am indebted to Simone Di Piero for helping me to explain myself.

My friend Elise Kroeber has provided a place to work for many years.

I am grateful,

David

Since 1888, the National Geographic Society has funded more than 14,000 research, conservation, education, and storytelling projects around the world. National Geographic Partners distributes a portion of the funds it receives from your purchase to National Geographic Society to support programs including the conservation of animals and their habitats.

Get closer to National Geographic Explorers and photographers, and connect with our global community. Join us today at nationalgeographic.org/joinus

For rights or permissions inquiries, please contact National Geographic Books Subsidiary Rights: bookrights@natgeo.com

Copyright © 2022 David Liittschwager Monograph. Foreword copyright © 2022 Elizabeth Kolbert. Compilation copyright © 2022 National Geographic Partners, LLC. All rights reserved. Reproduction of the whole or any part of the contents without written permission from the publisher is prohibited.

NATIONAL GEOGRAPHIC and Yellow Border Design are trademarks of the National Geographic Society, used under license.

ISBN 978-1-4262-2179-8

Printed in China

21/RRDH/1

FOLLOWING PAGE

Day Octopus

Octopus cyanea

Specimen #29; female; 6 inches across; Dive Gizo, Ghizo Island, Solomon Islands

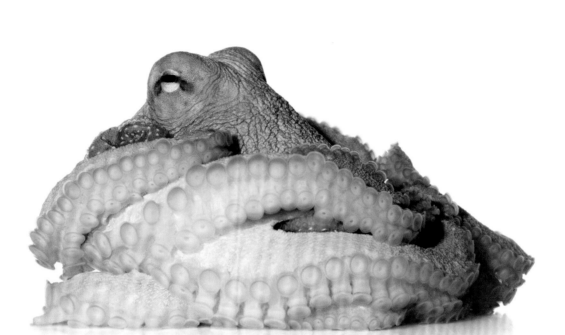